VARIETIES OF
CRIME FICTION

ALSO BY S. T. JOSHI

H. P. Lovecraft: Four Decades of Criticism (1980)
The Weird Tale (1990)
H. P. Lovecraft: The Decline of the West (1990)
John Dickson Carr: A Critical Study (1990)
Lord Dunsany: Master of the Anglo-Irish Imagination (1995)
A Subtler Magick: The Writings and Philosophy of H. P. Lovecraft (1996)
The Modern Weird Tale (2001)
God's Defenders: What They Believe and Why They Are Wrong (2003)
The Angry Right (2006)
Junk Fiction: America's Obsession with Bestsellers (2009)
The Removal Company (2009)
Conspiracy of Silence/Tragedy at Sarsfield Manor (2010)
I Am Providence: The Life and Times of H. P. Lovecraft (2010)
Unutterable Horror: A History of Supernatural Fiction (2012)
The Assaults of Chaos: A Novel about H. P. Lovecraft (2013)
What Is Anything? Memoirs of a Life in Lovecraft (2018)
21st-Century Horror (2018)
The Recurring Doom: Tales of Mystery and Horror (2019)

VARIETIES OF CRIME FICTION

S. T. JOSHI

WILDSIDE PRESS

CONTENTS

INTRODUCTION

There is no truly exhaustive or comprehensive history of crime/mystery/detective fiction, and by the nature of things there perhaps cannot be. Howard Haycraft's *Murder for Pleasure: The Life and Times of the Detective Story* (1941) was a valiant attempt, but the mere fact that Raymond Chandler (whose first novel, *The Big Sleep,* had appeared only two years earlier) was not mentioned at all points to the limitations of his study. Since then, all we have had are such things as Julian Symons's *Bloody Murder: From the Detective Story to the Crime Novel* 1972) and LeRoy Lad Panek's *An Introduction to the Detective Story* (1987)—but these slim treatises often end up reading more like annotated bibliographies than comprehensive analyses of the authors or motifs they choose to cover.

The overriding problem with writing a full history of crime fiction (let us call it that, as an umbrella term covering the multifarious subgenres that constitute the field) is the very prolificity of the authors who have worked in the genre since Poe published "The Murders in the Rue Morgue" in 1841. Among the genres that have emerged over the past century, crime fiction is probably the most voluminous, followed by science fiction; fantasy fiction and horror fiction are considerably to the rear, and the western has all but disappeared as a genre. (The love story—as embodied, say, in the Harlequin romances—probably outnumbers all these genres combined, but as no one grants much aesthetic value to these works, it can be disregarded in this context.)

We do not need to be reminded that such authors as John Creasey (more than 600 published novels) and Georges Simenon (nearly 500 novels) are among the most prolific authors in literary history. Creasey's work has little substance, but Simenon's is of a considerably higher grade. Even if we disregard these two writing machines, we still have to contend with such figures as Agatha Christie, John Dickson Carr, Ellery Queen, Ruth Rendell, and many others, who wrote anywhere from 40 to 80 novels and short story collections. And these are just the tip of the iceberg in a genre that has spawned dozens, perhaps hundreds, of writers who would need to be considered in any comprehensive survey of the field.

Perhaps it is not to be expected that a literary historian need read every single work by every single major figure in a given field to write a history

of that field. If that were the case, no one could capably write a history of the English novel or the American short story or the French drama. But the fact remains that the task of reading and analysing the enormous output of crime fiction extending back nearly two centuries is a formidable task—and that task is augmented by the painful fact that crime fiction, in its broadest parameters, is an aesthetically inferior genre.

Many devotees, and even some critics, of crime fiction are unprepared to accept that verdict. Over the decades they have taken umbrage when such critics as Edmund Wilson ("Who Cares Who Killed Roger Ackroyd?") have expressed disdain for the genre as a whole. Their standard riposte is that the critics in question have not read the right books—that they have been misled by poor specimens and have thereby falsely condemned the entire genre to the realm of hackwork. To some degree I am sympathetic to this argument, although Wilson himself responded ably to it, chiefly by declaring that even those authors who are highly touted by leading critics of the field are (in Wilson's judgment) not particularly good writers. But I think we have to face the fact that the overwhelming bulk of crime fiction falls into the deplorable realm of "popular fiction," riddled with ludicrously implausible or formulaic plots, uninteresting or unbelievable characters, and a fundamental unseriousness in the treatment of the most basic motifs of life and death. They are the literary equivalent of popcorn—and no one need be told what effect a steady or exclusive diet of popcorn will have on one's health.

What this means is that many critics of genuine acuity or distinction will avoid the reading or analysis of crime fiction, leaving that work largely to inferior hands. And even these latter will generally not have the time or devotion to read sufficiently widely in this field to generate a truly exhaustive study. What we now have, when crime fiction is studied at all, is an array of studies that examine the field for what it can tell us about the social, political, and cultural mores of the time in which it was written—especially in the currently fashionable areas of race and gender studies. These treatises are no doubt valuable in their way, but they fail to engender, even cumulatively, a full picture of the history and progression of the genre; and by design they are not in the business of passing aesthetic judgments on the works they discern, because such judgments have little relevance in the mining of the sociological data that the scholars are interested in.

This book is an initial attempt to contribute to an exhaustive and up-to-date history of crime fiction. Without arrogating to myself any lofty status as a critic or historian, I nonetheless believe I have presented a more comprehensive snapshot of the work of the thirteen authors I discuss than is generally available, and I have also suggested the aesthetic virtues—and deficiencies—of the authors in question. I shall have more to say on this lat-

ter point later; right now I wish to speak more detailedly about the different subgenres of crime fiction.

Edgar Allan Poe's three or four detective stories of the 1840s, followed by the immensely influential Sherlock Holmes stories of Sir Arthur Conan Doyle (extending from 1887 to 1927), established the parameters of crime fiction for decades. The template of the amateur detective—a detective largely unconnected with law enforcement, at least in an official capacity—became (in spite of its fundamental implausibility) cemented in readers' minds as the chief, perhaps the only, vehicle for crime fiction; and the fact that Agatha Christie, beginning with *The Mysterious Affair at Styles* (1920) and proceeding with dozens of novels all the way up to 1975, worked relentlessly within this template made it the very prototype of the "detective story." Although Wilkie Collins did introduce a professional detective, Sergeant Cuff, in *The Moonstone* (1868), this single novel could not buck the tide. Even if we disregard the notable but now largely forgotten American novelist Anna Katherine Green (*The Leavenworth Case*, 1878), the "cosy" mystery of Agatha Christie and her successors became the dominant mode of crime writing for the better part of a century. The list of those writers who contributed to it reads like a who's who of the field: Dorothy L. Sayers, John Dickson Carr, Margery Allingham, S. S. Van Dine, Rex Stout, Josephine Tey, Ngaio Marsh, Michael Innes, Nicholas Blake, P. D. James, Ruth Rendell, Mary Higgins Clark—and on and on and on. Some of these writers did feature professional, as opposed to amateur, detectives (in this book I study James's Adam Dalgliesh and Rendell's Inspector Wexford), but the general ambiance of their work remains well within the "cosy" tradition.

The central features of the "cosies" are well known: a crime (almost always murder), generally occurring in a rural or small-town setting; a variety of (usually middle- or upper-class) suspects, each of whom has (as investigation establishes) some compelling reason to commit the murder; and the fortuitous presence of the know-it-all amateur detective, who customarily solves the case while the bumbling police flounder in confusion. This may sound like a caricature, but it strikes me as a fairly precise generic description, although naturally some individual works will tweak the formula in one direction or another.

The aesthetic failings of this formula are too evident for discussion. First there is the overriding implausibility of the convenient presence of the amateur detective just at the time when a murder is committed; if this does not occur, the author often resorts to the scarcely less plausible tactic of having a major character be acquainted with the detective, so that he or she can be summoned to save the day. Second is the absurdity of the notion that a seemingly random group of individuals—who are outwardly friends or relatives, but who end up having secret motives (usually revolv-

ing around the basic emotions of greed, envy, jealousy, and so forth) for wishing harm upon the victim—have congregated in such a way as to be suspects in the case. Then there is the preposterously complex and unlikely *manner* in which the murder is often committed, relying on mistaken identity, ludicrous contrivances (a gun made to fire by the pulling of a string, for example), or the fabrication of an alibi. Devotees of the genre often vaunt this kind of trickery as a mark of cleverness, but its fundamental deviance from reality condemns it to the realm of hackwork—although no more so than the implausibilities of other genres (the scientific impossibility of the vampire, werewolf, or other creatures in horror fiction; the ease with which, in science fiction, human beings flit from planet to planet in spaceships, in spite of the immense technological difficulties involved in such an act).

It was in part as a rebellion against the stifling and aesthetically impoverishing conventions of the "cosy" mystery that at least two quite different subgenres emerged, beginning in the 1930s: the hard-boiled detective novel and what I have here called the psychological mystery.

It is an amusing fact that *Black Mask* was established in 1920 as a crude money-making venture by H. L. Mencken and George Jean Nathan—a means to support their highbrow magazine, the *Smart Set,* which continually operated at a loss. Mencken's disdain for popular fiction in general was abundantly expressed in his monthly *Smart Set* review columns (1908–23), where he championed the literature of social realism as practised by Sinclair Lewis, Joseph Conrad, Willa Cather, F. Scott Fitzgerald, and the like. For Mencken, *Black Mask* was a way of doling out popular trash to the "booboisie" so that genuine literature could be promoted. But when Joseph Shaw took over the magazine in 1926, he shifted the focus of the magazine to the authors of what became the hard-boiled school: Dashiell Hammett (whom, in fact, Mencken had published in the *Smart Set*), Erle Stanley Gardner (whose early hard-boiled stories and novellas have considerably greater literary value than his mechanical Perry Mason mysteries), Raymond Chandler, and so on. It was the novels of these writers, along with those by James M. Cain, Jim Thompson, Ross Macdonald, and John D. MacDonald, extending down to Elmore Leonard, James Ellroy, Sue Grafton, and many others, that have caused this subgenre to be perhaps the most aesthetically substantial within the entire realm of crime fiction.

The psychological mystery focuses not so much on physical "clues" to solve a crime but on the psychologies of the central characters. Whether Margaret Millar (wife of Ross Macdonald) should be regarded as a pioneer of this subgenre is unclear; but there is no doubt that she practised it in a way that lent considerable literary merit to her work. A few years after Millar began publishing, Patricia Highsmith emerged as an author who largely dispensed with the "mystery" element altogether: her work is *suspense*

fiction in the sense that there is frequently no doubt as to the identity of the criminal—we often see the criminal committing the deed; instead, the novel focuses on the psychological effect of the crime upon his or her psychological state, and upon other subsidiary characters. The Barbara Vine novels of Ruth Rendell generally fall into this class.

We can, if we wish, date the police procedural all the way back to Collins's *Moonstone;* Anna Katherine Green also featured a detective from the New York Metropolitan Police Force in some of her books. Perhaps the rather dry novels of Freeman Wills Crofts could also be considered important predecessors; but in reality the genre probably dates no earlier than the 87th Precinct novels of Ed McBain (the first was published in 1956). He has been followed by such writers as Elizabeth Linington, Joseph Wambaugh, Patricia Cornwell, and Tony Hillerman. I do not, however, find this a sufficiently distinctive subgenre to merit treatment here.

I also have avoided discussion of the espionage story here, chiefly because in most instances geopolitical concerns overwhelm the "crimes" that occur in the works, causing them to be much closer to mainstream fiction than the standard crime story. There is no denying the substantial aesthetic status of such spy writers as Eric Ambler, Len Deighton, and preeminently John le Carré. For the less sophisticated, the potboilers of Ian Fleming, Tom Clancy, Robert Ludlum, and their ilk have proven very popular.

* * * *

The aesthetic value of the crime story has been under debate since at least the 1920s. One of the more perspicacious commentators was Dorothy L. Sayers, who in the introductions to her three-volume anthology series *Great Short Stories of Detection, Mystery and Horror* (1928–34; published in the U.S. as the *First, Second,* and *Third Omnibus of Crime*) pondered the matter in some detail. The introduction to the first volume includes an entire section on the "Artistic Status of the Detective Story," in which she delivers this magisterial judgment:

> It does not, and by hypothesis never can, attain the loftiest level of literary achievement. Though it deals with the most desperate effects of rage, jealousy, and revenge, it rarely touches the heights and depths of human passion. It presents us only with the *fait accompli,* and looks upon death and mutilation with a dispassionate eye. It does not show us the inner workings of the murderer's mind—it must not; for the identity of the murderer is hidden until the end of the book. The victim is shown rather as a subject for the dissecting-table than as a husband and father. A too violent emotion flung into the glittering mechanism of the detective-story jars the movement by disturbing its delicate balance. (37)

Sayers was, of course, speaking largely, perhaps exclusively, of the "cosy" mystery (or, more generally, the standard puzzle story), since that was virtually the only mode of detective fiction being practised at this juncture. It is amusing to note that much of the above criticism was (perhaps unwittingly) adapted by Raymond Chandler in his condemnation of the "cosy" mystery in the course of his validation of the hard-boiled crime story as something aesthetically superior to it.

In her introduction to the third volume of her series (1934) Sayers puts forth one of the central arguments for the aesthetic value of the crime story—the notion of mystery stories as fables of redemption. But even when she does so she speaks of the matter with surprising flippancy, enclosing her remark in derisive parentheses:

> (Detective authors, by the way, are nearly all as good as gold, because it is part of their job to believe and to maintain that Your Sin Will Find You Out. That is why Detective Fiction is, or should be, such a good influence in a degenerate world, and that, no doubt, is why so many bishops, school masters, eminent statesmen, and others with reputations to support, read detective stories, to improve their morals and keep themselves out of mischief.) (2)

Not exactly a ringing endorsement. But Sayers's single-minded fixation on the puzzle story has hamstrung her analysis: she had already admitted, as early as the introduction to the second volume (1931), that "The old formulae are nearing exhaustion" (20), but makes no mention of the (admittedly nascent) hard-boiled story in the introduction of her third volume.

Haycraft's *Murder for Pleasure* is not much better in this regard. Although acknowledging the revolutionary work of Dashiell Hammett, he nonetheless states that the detective story is nothing more or less than "a conflict of wits between criminal and sleuth, in which the detective is traditionally victorious by out-thinking his adversary" (258). This conception unwittingly underscores the disturbing suggestion that the standard "fair play" detective story is nothing more than the literary equivalent of a crossword puzzle (perhaps a jigsaw puzzle is a more apt analogy), given the evident intention of detective writers to "out-think" their own readers by clouds of obfuscation, red herrings, and so on. Even Julian Symons, in *Bloody Murder* (1972), can say no more than that the detective story "is an inferior thing, but a thing with its own particular and unique merits" (24)—merits that he conveniently fails to specify.

There is a kind of unspoken assumption among many defenders of the standard detective story that its cleverness in the execution of the plot is a backhanded validation of its aesthetic status. But the ingenious manipulation of a plot does not rank high as a literary virtue; if it did, John Dickson

Carr, Dan Brown, and the like would rank higher than Faulkner or Dostoevsky. The plots that are so deftly weaved together are so preposterously artificial that they abandon all relation to the mundanities of the real world; they in effect become fantasies in which readers maintain their interest (if, indeed, they actually do so) merely to see how the story pans out. We are, in effect, dealing with a particularly complex jigsaw puzzle.

In this sense, the emergence of the hard-boiled detective story was an immensely salutary influence. In the hands of its leading practitioners, it truly did achieve its purpose of underscoring the grimly violent nature of crime—kidnapping, burglary, and preeminently murder—whatever the social status of the criminal may be. Even if the hard-boiled story itself became to some degree stylised—in its tough-guy prose, its somewhat monotonous first-person narration by the cynical but valiant private eye, and its relentless focus on the underside of civilisation—it broadened the scope of the crime story by presenting an alternative to the "cosy" mystery with its frequently rural or exotic settings and its own refusal to take much notice of the lower classes (except for the invariable presence of servants—who, by explicit rules, were excluded from the start as potential suspects).

Sayers's admonition that the detective story could not, by its very nature, focus on the "inner workings of the murderer's mind" is contradicted by both the suspense story as propounded by, say, Patricia Highsmith (where the very point of the narrative, in many instances, is the kaleidoscopic shifting of the criminal's mental state as he or she seeks to evade capture) or the psychological mystery of Margaret Millar. It is for this reason that the Barbara Vine novels of Ruth Rendell, which focus relentlessly on the psychology of crime (although clever twists and turns reminiscent of the puzzle story are not absent), are generally superior to her Inspector Wexford novels, which are "cosy" mysteries pure and simple.

It is here, and perhaps only here, that the crime story can claim a legitimate, even if relatively humble, aesthetic status. Putting aside deftness in story construction, it can be said that character portrayal—especially as it relates to the specific traumas associated with death, violence, and the concomitant emotions of jealousy, hate, betrayal, and so on—constitute the central means by which a crime story can escape relegation to the level of hackwork or formula writing. Even if the incidents of the standard crime story tend to be fundamentally implausible (especially if multiple murders occur in a compressed chronological time-frame), there is ample room for a psychological analysis that can provide genuine illumination into the thoughts, acts, and feelings of representative human beings. And a straightforward facing of the central fact of existence—death—can (if it does not descend into a pornography of gruesomeness) also shed light on what it is to be human.

The fact that relatively few crime writers can be said to have excelled at these features is only one more testament to the rarity of literary genius, or even competence. Genre writing is no worse than mainstream writing in this regard, for the overwhelming bulk of the latter also falls by the wayside and fails to endure as a vital aesthetic entity. Readers of crime fiction, indeed, appear to be rather more respectful of the history of their genre than readers of mainstream fiction: no one reads such former mainstream luminaries as Louis Bromfield or Edna Ferber, but enthusiasm for Agatha Christie, Dorothy L. Sayers, and other old-time authors of the "cosy" mystery remains high, to say nothing of the unending thirst for all manner of permutations of the Sherlock Holmes persona.

The authors I have chosen for discussion here are, in all frankness, largely those who have appealed to my own predilections as a longtime reader of crime fiction; but I do think that each of them represents a distinctive phase of the crime story. In my selection of these thirteen writers—exclusively British and American—I do not in any sense intend to suggest that a great many others do not deserve similar treatment; indeed, it is precisely my hope that other critics follow my lead to writer detailed and exhaustive analyses of many worthy authors I have bypassed. In some cases (I refer specifically to Margery Allingham, Philip MacDonald, and L. P. Davies) I myself have chosen authors who have not heretofore received much criticism or analysis; in the case of Davies, his obscurity appears to rest on his deliberate mingling of genres seemingly so disparate as crime fiction, horror, and even science fiction. For a corresponding reason I have avoided the work of Agatha Christie, whose mundane prose and ultimately formulaic plots have long made me wonder at her continuing popularity. Mary Higgins Clark may be a kind of contemporary Agatha Christie—both in terms of her popularity and in the fundamental mediocrity of her work.

In some cases my choices have been guided by the need to address the initiators of a given subgenre. It is difficult to discuss the history and progression of the hard-boiled novel without talking about Hammett and Chandler, even if well-reasoned arguments could be made for the equal aesthetic status of James M. Cain and Jim Thompson, who were their contemporaries or immediate successors. Similarly, Margaret Millar and Patricia Highsmith were such pioneers in the subgenres of psychological and suspense fiction that I could not avoid an analysis of their work.

Among contemporary writers, the popularity of P. D. James and Ruth Rendell have compelled me to address both their intrinsic merits and the reasons for their popularity; I seem to be alone in finding James's work deficient from a purely literary perspective. Grafton I have treated both because she is popular but because (to my own surprise, I confess) her work proves to be highly meritorious. But more, it is one of the relatively few bodies of

work—especially in the subgenre of the hard-boiled crime story—not only written by a woman but featuring a female detective.

The issue of how—or whether—to discuss works written by women writers or minority writers or gay or lesbian writers needs to be addressed. While it has become fashionable (especially among academic critics) to treat such bodies of work because they have largely been neglected in the past, I believe we need to resist the temptation to study such works all apart from their intrinsic merits. Nothing is to be gained by vaunting literary works merely because they are written by women or minority or gay writers, if their literary substance does not justify such treatment. (There is of course plenty of mediocrity in the work of male or Caucasian or straight writers.)

Any genre in which Agatha Christie, Dorothy L. Sayers, P. D. James, and Ruth Rendell are heralded as among the leading figures in more than a century of writing can scarcely be said to be hostile to the work of women writers. And yet, it is worth noting that even these figures rarely featured female detectives, with the exception of Christie's Miss Marple and the two Cordelia Gray novels of P. D. James. This is, as I have stated, another reason why Sue Grafton's work merits discussion.

Chester Himes and Walter Mosley set a high standard for crime fiction by African American writers—or any writers—and their work has been followed by dozens of others who have followed in their wake. Rita Mae Brown is a pioneering writer of crime fiction that features L.G.B.T.Q. characters, and other writers such as Laurie R. King and Mark Richard Zubro have done analogous work. If I have focused, then, on three contemporary (female) writers of a quite different sort, it is largely because their substantially greater popularity has at times been equated with literary stature, and I felt that that equation needed to be addressed.

It should now be evident that my broader purpose is to make some attempt at establishing a canon of crime writing, offering suggestions (and they are no more than that) as to the relative merits or demerits of the authors I have treated. Such a winnowing process seems a vital necessity, especially for writers of the past few decades who have not attained the quasi-canonicity (largely based, however, on unquestioned reputation and/or popular appeal) of the Christies and Carrs and Sayerses of the world. Posterity itself is generally ruthless in preserving those authors or works who continue to speak to subsequent generations and in condemning to merited oblivion those who do not; but the critic has a role to play in this process, and we ought not to abdicate our function by a pusillanimous reluctance to cast aesthetic judgments where warranted. Such judgments—offered by those who are, in principle, endowed with critical judgment and are well versed in the history and aesthetic foundations of the genre—can and should have some influence on what survives and what falls to the wayside.

I. THE GOLDEN AGE

DOROTHY L. SAYERS:
LORDS AND SERVANTS

Much nonsense has been written about Dorothy L. Sayers (1893–1957). Like several other genre writers, she has attracted a cadre of fanatically devoted supporters who sift through her works as if they were religious texts; and now this attention is seeping up into the academic community, so that Sayers is coming to be regarded as the premier writer of the "literate" detective story in the twentieth century. I shall have more to say about the Sayers critical industry later; but I may suggest here that part of the reason for its proliferation is that Sayers herself is virtually the only detective writer, excluding Edgar Allan Poe, who has gained an independent reputation for works other than detective stories. Even Sir Arthur Conan Doyle, who put so much stock in his historical novels and other writing, never gained much critical acclaim for them; but Sayers, after finishing with detection in 1937, went on to translate Dante and write two volumes of papers about him, wrote several volumes of essays defending Anglo-Catholicism, and wrote and staged several religious plays. True, nobody reads much of this material nowadays—even her Dante translation for the Penguin Classics has now been replaced by another one—and still fewer pause to study or write about it; but Sayers nonetheless becomes a more daunting figure because of all this impressive-looking output.

If Sayers's literary career is a peculiar one—from light-hearted, even iconoclastic thrillers perfectly capturing the waywardness of the 1920s to the deadening halo of Christian apologetics—her career solely as a detective writer is still more curious. Her first four novels are slight, even frothy (*Whose Body?* [1923], *Clouds of Witness* [1926], *Unnatural Death* [1927], *The Unpleasantness at the Bellona Club* [1928]), and seem to exist principally as a stage for her beloved Lord Peter Wimsey. After her only non-Wimsey novel, *The Documents in the Case* (1930; with Robert Eustace), she concluded her career with seven large (some awesomely large) novels, four of which—*Strong Poison* (1930), *Have His Carcase* (1932), *Gaudy Night* (1935), and *Busman's Honeymoon* (1937)—have as their focus the gradual love affair and eventual marriage of Wimsey and Harriet Vane, the detective novelist whom we first see harrowingly in the dock for murder in

Strong Poison. These four novels constitute a saga exactly in the manner of Trollope, Galsworthy, or Delderfield, and must be read sequentially. The other three novels—*The Five Red Herrings* (1931), *Murder Must Advertise* (1933), and *The Nine Tailors* (1934)—have their moments of brilliance, but are essentially interruptions or interludes in the Wimsey-Vane saga. These twelve novels, plus three collections of short stories, constitute the whole of Sayers's detective work: no writer save Poe and Conan Doyle has gained such celebrity on such a small body of work.

Does Sayers deserve this attention? Is she, in fact, a great mystery writer? To be quite honest, no one would make such a claim based on her early work: *Whose Body?* is quite ephemeral and labours under its initial premise of an unknown man found in someone's bathtub; *Clouds of Witness* relies on a stupendous use of coincidence; in *The Documents in the Case* and *Strong Poison* no especial effort is made to conceal the identity of the criminal, and—as is the case with much of her work—few characters aside from two or three principals are described in any sort of detail, so that there is not even the attempt to cast suspicion on them. There is a certain frivolity or flippancy in the very construction of these works: I do not refer to style, for Sayers's style throughout her career aims for a charming flippancy that is one of her most engaging traits; rather, one senses that no real care has been taken to set up the mystery as such; we are here only to watch—and admire—Wimsey.

Sayers has had no shortage of detractors; and the charge leveled at her most frequently is a simple one: she is a snob. This was the brunt of Martin Green's article, "The Detection of a Snob" (*Listener,* March 14, 1963). Neither this piece or a much earlier attack by Q. D. Leavis ("The Case of Miss Dorothy Sayers," *Scrutiny,* December 1937), where Sayers is accused of producing mere pseudo-literature (i.e., work that casts only the illusion of profundity), has been successfully refuted by her admirers. Both charges are fundamentally true; but in the matter of snobbishness care must be taken in elaborating and defining the conception.

Lord Peter Wimsey is of the English aristocracy. True, he is a younger son and therefore not a peer, but he is an aristocrat nonetheless. This fact in itself does not make Wimsey a snob: many critics have failed to make a distinction between Wimsey's attitude and Sayers's attitude—a distinction of great importance. Wimsey, in fact, is not a snob at all—he gets along quite well with all classes of society. But Sayers, in making Wimsey an aristocrat, takes care to allay criticism of him on this count by making him appear to break the mould. His celebrated first utterance, "Oh, damn!," is a not very subtle attempt to show that he is no stuffed shirt (like his elder brother, Gerald, Duke of Denver). Moreover, although he feigns an air of foolishness, he is nevertheless the one who solves the crime. No idle aristocrat he!

The trump card in all this is that Wimsey is smart—he belongs not only to the aristocracy of blood, but the aristocracy of intellect. Sayers lets us know this in very blunt and sometimes silly ways: Wimsey is a knowledgeable collector of incunabula; he plays Bach and Scarlatti effortlessly on the piano (but of course would prefer a harpsichord); at one point he even "whistles a complicated passage of Bach under his breath" (not a simple passage and not out loud); his knowledge of the arcane art of bell-ringing serves him well in *The Nine Tailors;* he seems a born advertising copywriter in *Murder Must Advertise;* and his knowledge of chemistry helps him solve the mystery in *Strong Poison.*

The degree to which Wimsey differs from one's average (and contemptuous) conception of the British aristocrat can be gauged by the degree to which he differs from his obvious inspiration, P. G. Wodehouse's Bertie Wooster. Sayers makes no secret of this inspiration: in *Murder Must Advertise* a character explicitly compares Wimsey to Wooster as the type of the dim-witted scion of ageing blood; a few paragraphs later we are given the perfectly irrelevant detail that another character is reading a Wodehouse novel. And although Wimsey himself declares in *The Five Red Herrings,* "I was born looking foolish and every day in every way I am getting foolisher and foolisher," all this is only on the surface. It is not merely his intelligence that segregates him from the Woosters of the world; it is that his every motion testifies to his good breeding. Wimsey's knowledge of wines (like that of James Bond) brings a criminal to justice in "The Bibulous Business of a Matter of Taste"; his clothing is always impeccable; he always behaves like a gentleman, but never obtrusively so.

In this delicate balance Wimsey's manservant, Mervyn Bunter, plays an important role. Bunter is Jeeves, pure and simple (Wimsey's remark— "Well then, don't talk like Jeeves. It irritates me"—only confirms the identification); it is by his inflexible adherence to the aristocratic code of behavior that we can gauge Wimsey's (supposedly charming) derelictions from it. Bunter is not a character, he is a function; and the slight and feeble attempts Sayers makes to humanize him fail pitifully: Wimsey once hints that Bunter may have gallivanted with the ladies in Italy; in *The Nine Tailors* he contrives to steal a letter from the post office; and, in one lone instance in *Strong Poison,* he gives way to a coarse expression when no one is listening.

So here we are: Wimsey, though an aristocrat (Sayers never let us forget it), is nevertheless not your usual aristocrat. How, then, does Sayers prove herself to be a snob? I repeat that Wimsey himself is not a snob; but this very fact is only one more trick whereby Sayers can convince us that Wimsey, and therefore certain others of the upper classes—like the flighty Hon. Frederick Arbuthnot, the real Bertie Wooster in Sayers (do British people really say "billy-ho" or "chappie"?)—are really OK kind of guys.

Wimsey can be a real card sometimes: he terrifies Harriet Vane by driving fast in a motor car; he shocks even the decadent young people in *Murder Must Advertise* by his antics at a wild party; he light-heartedly proposes to Harriet every April Fool's Day until she finally relents and accepts his hand. But Sayers gives herself away by little false notes and gaffes: in particular, her harping on the fact that Wimsey has all the money he could possibly want and that everything he owns costs a lot of money (he has a suitcase "of expensive-looking leather"; the Duke of Denver is "the wealthiest peer in England") reveals Sayers's fundamentally middle-class mentality. Snobbishness is really a middle-class failing; and it is a failing because it is so irredeemably vulgar.

Her portrayal of the "lower classes" confirms this notion: whereas Wimsey, Vane, and others speak like normal human beings, the working-class people in Sayers's novels can never make an utterance without countless grammatical mistakes—reduplicated plurals, double negatives, mispronunciation of difficult words, disagreement between subject and verb—and, of course, the ubiquitous dropped *h*. *These* people certainly never went to Oxford, like Wimsey and Harriet; or if they did it is only as servants and janitors. Whereas normal people are addressed by civilized names, the lower classes are addressed either by last names or by patronizing diminutives like "Annie." In two stories—"The Undignified Melodrama of the Bone of Contention" and "The Incredible Elopement of Lord Peter Wimsey"—the supernatural is hinted at, but in such a flippant way as to suggest a certain polite laughter at the ignorant and superstitious yokels who get taken in by what turns out to be mere jiggery-pokery. On the other side, Sayers writes herself almost into a frenzy when talking about the aristocracy. She cannot resist unearthing an archaic procedure whereby the House of Lords must try one of their own—the Duke of Denver—for murder (*Clouds of Witness*); and the mere recital of hoary and pompous titles—Lord High Steward, Clerk of the Crown in Chancery—acts like an intoxicant to Sayers.

But let us give Wimsey—and Sayers—their due. It is frequently Wimsey's sheer frivolity, especially when he archly catches someone in a lie or reveals a guilty secret, that becomes frustrating and even harrowing to his antagonists; and he is clever, there is no denying it. What is more, Wimsey becomes truly humanised not by the little tricks Sayers pulls in her early novels, but by his long courtship of Harriet Vane; and it is hardly to be questioned that Sayers's four novels of the Wimsey-Vane cycle are her most impressive achievement.

Apart from the initial implausibility of Wimsey falling in love with Harriet at first sight, while she is on trial for murder—the immediacy of his passion is never adequately accounted for—the whole of the romance is conducted without a dram of sticky sentimentality; instead, everything is

handled with the utmost delicacy, subtlety, sophistication, and even occasionally farcical humour. We are not alone in finding Wimsey's sentiments inexplicable at the start: Harriet too cannot understand them, and rejects his overtures firmly and sometimes peremptorily. But Wimsey wears away at her over the course of the four novels, and she finally capitulates at the end of *Gaudy Night.* I am not especially concerned with the question of how autobiographical Harriet Vane—detective writer, graduate of Oxford (not Sayers's Somerville, but the imaginary Shrewsbury College, made up for *Gaudy Night*), and not especially attractive by her own and others' admission—is meant to be. Anyone who thinks that Harriet is "explained" by these autobiographical traits, or that *Murder Must Advertise* is "explained" by the fact that Sayers worked for ten years in an advertising office, will also believe that *Moby-Dick* is "explained" by the fact that Melville was a sailor. There is some suggestion that Harriet's comment, in *Gaudy Night,* about her early novels ("The books were all right, as far as they went; as intellectual exercises, they were even brilliant. But there was something lacking about them") indicates Sayers's view of her own work; but the remark is too vague and general to be of use. In any case, Harriet is developed as a character as carefully—even lovingly—as Wimsey. If Sayers at any point deserves the critical acclaim she has received, it is for this finely modulated character portrayal.

At this point we must address a question that has exercised many of Sayers's critics, and that can hardly have been overlooked by the most unobservant of her readers: the staggering length of her later novels, particularly *Have His Carcase, Gaudy Night,* and *Busman's Honeymoon.* Is this length really necessary? On the whole, the answer can be a fairly confident "yes" for the first and third of these books, and a much more qualified "yes" for the second.

As pure detection *Have His Carcase* is Sayers's most elaborate mystery: everything is here, from a cipher painstakingly solved step by step, to a series of bafflingly interlocking alibis successively set up, destroyed, and re-established, to a solution that rests upon a very elementary but skilfully concealed medical fact. The pace is leisurely, to be sure, but not pallingly so. It is Sayers's finest detective story.

Gaudy Night has inspired extremely ambivalent reactions, even from Sayers's supporters; a typical response is Janet Hitchman's petulant complaint, "There is not even a corpse!" Of course there isn't; and the reason is to be found in a passing remark in *Busman's Honeymoon:* "Corpse and policemen—there they were, not to be got rid of, whatever one's feelings might be." It is important, in this novel about a crazed person leaving poison-pen notes and doing other disturbing but relatively non-violent things at a women's college at Oxford, that no outsiders be allowed to disrupt the

interlinked tensions between professors, students, and staff of the college; in its way the college must remain, metaphorically, a chamber as hermetically sealed as any of John Dickson Carr's. Even Wimsey is not a disturbing influence—he is a Balliol man, and therefore part of the inner circle of Oxford social life. The fact that the crimes must have been committed by an insider, whether it be the steel-hard dean of the college or a callow undergraduate, highlights the insular and hothouse atmosphere of the academy, where scholarly rivalry can become intensely and unnaturally personal. And only an academic could write—and understand—the following: "The fact that one had loved and sinned and suffered and escaped death was of far less ultimate moment than a single footnote in a dim academic journal establishing the priority of a manuscript or restoring a lost iota subscript."

All this accounts for the relatively sporadic moments of actual detection in *Gaudy Night;* but it does not get to the heart of its enormous length. To do this we must borrow the subtitle of *Busman's Honeymoon:* "A Love Story with Detective Interruptions." It is a subtitle far more apt for *Gaudy Night,* where Wimsey finally gains Harriet's hand; but more than that it shows that *Gaudy Night* is not a detective story in any meaningful sense of the term—or not only that. It is a novel, plain and simple; and we would no more wish to restrict it to a requisite length than we would a novel by any other writer. In fact, it might almost be said that the detective "interruptions" are more a distraction than anything else. I am obliged to note that, in a not very subtle way, this novel underscores Sayers's snobbishness more than any single work of hers: Oxford is at once the intellectual and social capital of England, and Sayers cannot allow any taint to violate its sanctified walls, even though she hints of it: in the end the crimes are revealed to be the work of a disgruntled servant. The learned dons and the students, all scions of the aristocracy, are vindicated.

Busman's Honeymoon is a much more successful integration of novelistic and detective elements, and in its rapid fluctuation from grotesque humour to tense melodrama it may be Sayers's single best work. Wimsey is a real human being for almost the first time—as when he and Harriet experience the first argument of their married life when they must decide whether to reveal a fact Harriet has learned in confidence, or at the end, when Wimsey suffers chilling guilt waiting for the execution of the man—a servant again, be it noted—he has brought to justice. Wimsey and Harriet nevertheless march off at the end in perfect wedded bliss; there was no especial reason why they could not have continued as a detective team, but Sayers never resurrected them in a novel.

Let us backtrack to the three non-Vane novels of this period, *The Five Red Herrings, Murder Must Advertise,* and *The Nine Tailors.* Each is shorter than the longest of the Wimsey-Vane novels, but each is more open than

the others to the charge of prolixity. The fault here is that Sayers can spend endless amounts of time recording idle conversations between characters in order to uncover some tiny bit of evidence. This would be all right in a writer more naturally gifted than Sayers; but the brutal fact is that her style is not intrinsically interesting. She has neither the pure comic genius of a Wodehouse nor the acerbic cynicism of an Evelyn Waugh, although she aspires to both. Certain passages in *Murder Must Advertise* are grotesquely overwritten in a sort of "arty" prose that only the critically naive will swallow as "deep" writing: this is exactly what Q. D. Leavis termed the "appearance of literariness." This novel yet again confirms Sayers's snobbishness: what poor fools most (lower-class) people are for being taken in by advertising, which is, as everyone knows, simply an artful form of lying! Wimsey infiltrates an advertising office in order to investigate a murder on the scene; and in spite of the fact that he finds it novel, engaging, and "dreamlike" to work for a living, he nonetheless offhandedly comes up with an advertising campaign that sweeps England. Ho, hum—Wimsey can do anything. He also distinguishes himself at the end in a cricket match, like an English Babe Ruth. As for *The Nine Tailors,* it is redeemed only by a conclusion almost horrifying in its suggestiveness; but the long wait is almost not worth the effort. Analogously, the conclusion of *The Five Red Herrings,* where Wimsey light-heartedly re-enacts the murder in order to trap the villain, gains a harrowing undercurrent as we realise that this is how the crime must actually have been committed.

Curiously, in light of her verbosity, Sayers is one of the few mystery writers to be consistently successful in the short story. This is because she chooses to treat problems that can be handled adequately at short-story length. The relative infrequency of murders in her stories is to be noted; instead, we have larceny, fraud, and other matters that do not involve any laborious laying of clues, elaborate character portrayal, shifting of suspicion among a large group of characters, or other devices requiring the space of a novel. Many of the Wimsey tales are satisfying little vignettes, and can take their part in the Wimsey-Vane saga; although, from this perspective, it seems highly implausible how, in "The Adventurous Exploit of the Cave of Ali Baba," Wimsey could have held himself incommunicado for two full years to break up a crime syndicate. Unfortunately, the final three Wimsey tales—"Striding Folly," "The Haunted Policeman," and "Talboys"—are sadly insubstantial; and the last one, written in 1942, seems to have no other function but to display the domestic harmony of Wimsey, Harriet, and their three sons. It is not a fitting end to the Wimsey-Vane saga.

We need waste no time on the Montague Egg stories, since Sayers obviously did not. They are all nearly identical in length, tone, and ephemerality; evidently we are to be amused whenever Egg, a travelling wine salesman,

unearths some fatuous little jingle from the *Salesman's Handbook* appropriate to the occasion. Egg is never fleshed out as a character, and does not succeed as parody: these tales quite literally have no point. Considerably more interesting are Sayers's non-series tales, where the absence of a recurring character seems to have freed her hand. These tales range from exquisite bits of comic deflation ("Scrawns") to grim *contes cruels* that could almost be considered horror stories ("Suspicion"). Like many mystery writers, Sayers cannot resist the lure of the supernatural; and though there is only one tale ("The Cyprian Cat") that can genuinely qualify as a weird tale, it is a riveting and unnerving one.

Whatever we may think of Sayers as fiction writer, we cannot deny her eminence as editor and critic. Her three *Omnibuses of Crime* (1928–34) are perhaps still the ablest anthologies of their kind ever compiled, and the sometimes lengthy introductions to them are full of interesting matter on the history and theory of the detective and horror tale. Sayers is the most well-read mystery writer in the field—something we would know not only from these introductions but from a hilarious passage in *Have His Carcase,* where Wimsey and Harriet analyse the case successively in the manner of Anthony Berkeley's Roger Sheringham, S. S. Van Dine's Philo Vance, Freeman Wills Crofts's Inspector French, and R. Austin Freeman's Dr. Thorndyke. And yet, Sayers flatly declares that the detective tale cannot "attain the loftiest level of literary achievement": does this not amount to a self-condemnation? Perhaps the reverse is the case: most detective stories are not Art, but *hers* will be; in most detective stories the "love element" is extraneous and badly managed, but *hers* will be handled ably. Still, on certain issues pertaining to the theory of detective fiction Sayers has made utterances of lasting value.

I now want to turn back to the matter of the explosion in Sayers criticism. It has taken all forms—from such works of joke scholarship as C. W. Scott-Giles's *The Wimsey Family* to biographies (by Janet Hitchman, James Barbazon, and Ralph E. Hone), book-length studies (by Mary Brian Durkin, Dawson Gaillard, Alzina Stone Dale, and Trevor H. Hall), collections of papers (notably *As Her Whimsy Took Her,* edited by Margaret P. Hannay), two bibliographies (one by Gilbert B. Colleen, another by Robert Harmon and Margaret Burger), doctoral dissertations, and articles in academic journals. The question is not so much whether Sayers deserves all this attention—God knows we need as much intelligent criticism of the mystery story as we can get—but rather: Why Sayers? Why not Margery Allingham or John Dickson Carr or Margaret Millar or several others one could name? The influence of Sayers on Allingham, Ngaio Marsh, and others is obvious enough; in terms of pure detection Allingham may have surpassed her mentor. Her Albert Campion is a more enigmatic figure than Wimsey, and

his personality develops even more radically than does Wimsey's; Campion's manservant, the ex-burglar Lugg, is a brilliant and hilarious parody of Bunter; and on the whole Allingham's are more substantial mystery novels than most of Sayers's. Sayers's plots are nowhere near as complicated or as adeptly executed as John Dickson Carr's; for all the vividness of Wimsey and Harriet Vane, she cannot draw character in as finely etched a manner as Allingham; her style does not have the music, tensity, or fluency of Allingham's or Millar's. And yet Sayers receives the attention and the others do not. I can only account for it by pointing again to her reputation outside the mystery field. There is evidence of Sayers's annoyance that her later works—plays, essays, translations—were not much read while her detective novels continued to enjoy popularity. But there is no reason to wonder at this: if John Bunyan had written a detective story, we should no doubt prefer to read that than *Pilgrim's Progress.*

JOHN DICKSON CARR: PUZZLEMEISTER

John Dickson Carr (1906–1977) rapidly took his place along with Agatha Christie as one of the leading—and one of the most prolific—writers of the "golden age" of the detective story. Although he was born in Uniontown, Pennsylvania, and attended Haverford College (where his first detective stories appeared in the student magazine, the *Haverfordian*), Carr spent the years 1933–48 in England and was believed by many readers like a British writer—an image he deliberately fostered by his use of English settings and even British spelling variants. In all, he wrote seventy-one novels, three or four novellas or short novels, seven collections of stories and radio plays (two posthumously published), two works of nonfiction, and dozens of articles, introductions and reviews (he was a longtime writer of the review column "The Jury Box" for *Ellery Queen's Mystery Magazine*). Although much of his work has fallen out of print, he remains an historically significant figure in the orthodox mystery fiction of his day.

And orthodox he was: he revelled in the fabrication of murder tales of bewildering complexity that nonetheless adhered strictly to the notion of "fair play": the idea that the author has laid out all the clues that would allow readers to solve the mystery on their own if they were able to interpret the clues properly. Carr focused in the "locked-room" mystery, a subgenre he perfected in a multitude of variations.

Carr enlivened his mysteries with a vibrant, almost rollicking prose style that carries the reader along in a tumult of action and intrigue; and, most distinctively, he was fond of featuring suggestions of the supernatural in his work, either as general background or as a potential solution of the cryptic mysteries he had fashioned. Of course, in all but one striking example the supernatural never actually comes into play, but its dark, brooding atmosphere leavens, and in some senses enhances, the boisterous humour of his characters and scenarios. As his most celebrated detective, Dr. Gideon Fell, states in one novel: "I have admitted to a weakness for the bizarre and the slightly fantastic. I have, in fact, worn it as a badge of pride" (*To Wake the Dead* 213).

Fell is, indeed, one of Carr's great inventions: a gargantuan individual who walks with two canes, he dominates both by his bulk and by his ingenuity the novels in which he appears. He made his debut in *Hag's Nook* (1933), a year before another immense detective, Nero Wolfe, appeared in Rex Stout's *Fer-de-Lance*. Unlike Wolfe, however, Fell is not content to remain an armchair detective, but becomes vigorously involved in the detection—usually in conjunction with his friend and occasional nemesis, Inspector David Hadley of Scotland Yard. An almost stereotypical description can be found in *The Man Who Could Not Shudder* (1940):

> Vast and beaming, wearing a box-pleated cape as big as a tent, he sat in the center of the gaudy swing with his hands folded over his crutch stick. His shovel hat almost touched the canopy overhead. His eyeglasses were set precariously on a pink nose; the black ribbon of these glasses blew wide with each vast puff of breath, which rumbled up from under his three chins, and agitated his bandit's mustache. But what you noticed most was the twinkle in his eye. A huge joy of life, a piratical swagger merely to be hearing and seeing and thinking, glowed from him like steam from a furnace. It was like meeting Father Christmas or Old King Cole. (110)

Fell was not Carr's first detective, of course: the Paris prefect of police Henri Bencolin had starred in his first few novels of the early 1930s; and a year after the creation of Fell, Carr introduced Sir Henry Merrivale, who appeared in dozens of novels. The introduction of Merrivale may have been a byproduct of Carr's astounding productivity: for much of the 1930s he wrote four novels a year, so that he had to publish two of them—most featuring Merrivale—under the transparent pseudonym Carter Dickson.

Those novels of the 1930s are worth considering in greater detail here, chiefly because they embody Carr's best detective work and garnered him the high reputation he deserved. In the 1940s his productivity eased a bit, in part because he was writing many radio plays for the BBC; and by the 1950s he had entered upon the task of writing historical mysteries—mystery novels set in some exciting period of history. These novels are not as compelling, as detective stories, as his earlier work, largely because the necessity of adhering to the historical record hinders the free play of imagination. Carr's orthodox mysteries of this period are themselves weaker than their predecessors, suggesting a decline in vigour and craftsmanship. But Carr continued writing entertaining novels into the 1970s, and the sum total of his output is at least as impressive as that of any of the detective writers of his time.

The Three Coffins (1935) is prototypical of Carr's mastery at bamboozling the reader. I am not referring to the celebrated "Locked Room Lecture," a chapter about two-thirds of the way through the novel that abruptly and boldly halts the action while Fell expatiates on the various methods by

which a murder can be committed in a locked room. It is of some interest to note that Fell happily admits that he is nothing but a fictional character ("we're in a detective story, and we don't fool the reader by pretending we're not" [160]); it is of somewhat greater interest to note Fell blandly acknowledging, indeed advocating, the improbability of the locked-room scenario—and, by extension, the great majority of Carr's criminal scenarios overall:

> "Now, it seems reasonable to point out that the word improbable is the very last which should ever be used to curse detective fiction in any case. A great part of our liking for detective fiction is *based* on a liking for improbability. . . . In short, you come to a point where the word improbable grows meaningless as a jeer. There can be no such thing as any probability until the end of the story. And then, if you wish the murder to be fastened on an unlikely person (as some of us old fogies do), you can hardly complain because he acted from motives less likely or necessarily less apparent than those of the person first suspected." (160–61)

It may well be that the hard-boiled writers—and also, perhaps, the writers of the psychological mystery story whom I treat in another section—criticised this very attitude of the "cosy" British mystery (although there is very little that is "cosy" in Carr's frenetic and at times grisly and grotesque shenanigans) when developing their own standards of "realism" or "probability"; but to all this Carr himself delivers a telling riposte:

> "When the cry of 'This-sort-of-thing-wouldn't-happen!' goes up, when you complain about half-faced fiends and hooded phantoms and blond hypnotic sirens, you are merely saying, 'I don't like this sort of story.' That's fair enough. If you do not like it, you are howlingly right to say so. But when you twist this matter of taste into a rule for judging the merit or even the probability of the story, you are merely saying, 'This series of events couldn't happen, because I shouldn't enjoy it if it did.'" (161)

What Carr is suggesting, I think, is that the puzzle-story of which he was such a master is really its own genre and should be judged as such, on its own terms. To the degree that Carr is implicitly denying any literary value to the puzzle-story aside from the ingenuity and clever execution of the puzzle itself, he is perhaps unwittingly delivering as condign a condemnation of the genre as any hostile opponent possibly could; but at the same time he is vaunting its virtues, however humble as they are, in ways that are largely impervious to rebuttal.

The actual mystery (or series of mysteries) in *The Three Coffins* fully justifies its rank as one of the pinnacles of Carr's output. We are introduced to a Dr. Charles Grimaud, who has had a strange encounter with one Pierre Frey, a self-described "illusionist" (11). Later, at Grimaud's house, shots are heard, and almost instantly Fell and others are on the scene. This (im-

plausible) timeliness is vital to the working out of the plot, because by this method Carr can establish the precise locked-room scenario he is portraying: there is no weapon in the room; there is no viable escape through the upper-story window, and in any case there is an unbroken expanse of snow on the ground below the window; the roof is also checked for footprints, but none are found. Fell even ascertains that Grimaud managed to burn some papers after he had been shot. Not long after, it is discovered that Frey himself was shot on the same night that Grimaud died.

Much of the cleverness of the plot's execution rests upon Fell's own baffling, even infuriating, utterances. Not far beyond the midpoint of the novel, Fell declares that some church bells "tell me the name of the murderer" (134). I am not sure that this utterance is ever satisfactorily explained. Not long thereafter, Fell declares that he knows the identity of the murderer(s), but not the method used. In the end, the murderer is declared to be . . . Grimaud. That is, Grimaud killed Frey (who was his brother), but before dying Frey shot Grimaud, who managed to get back into his house (disguised in a child's mask) and die in his locked study. The solution of the mystery is less significant than the sense of bafflement that preceded the lengthy explication by Fell.

The Mad Hatter Mystery (1933), one of Fell's earliest cases, is representative of the rollicking humour that enlivens some of Carr's best novels, while retaining a substratum of grimness bordering on terror. The novel opens with the charming utterance, "The whole case threatened for a time to become a nightmare of hats" (11): at the outset we do appear to be dealing only with a harmless prankster who steals hats from distinguished gentlemen in London—in particular, Sir William Bitton, who has had *two* hats stolen from him and whose own nephew, the newspaperman Philip Driscoll, has been making a name for himself by writing jocular articles about the situation.

Matters take a turn for the worse when, first of all, we learn that Britton has had an invaluable unpublished manuscript by Poe (what Fell refers to as "the first analytic detective story in the world" [113], antedating "The Murders in the Rue Morgue") stolen from him, and, still later, when Driscoll himself is found murdered at the Tower of London, with one of Britton's stolen hats on his head. Incredibly, it appears that he was shot with an archaic crossbow.

In the course of the novel's action—even more crazed than is usual with Carr, and during which an exasperated Inspector Hadley refers to Fell as a "fat lunatic" (198)—the portrayal of Driscoll, who at the outset seems like a frivolous fop in the mould of P. G. Wodehouse's Bertie Wooster, is carefully etched—chiefly by recollections from a variety of his relatives and acquaintances as they are interrogated by the police—and reveals a young man

who is desperate for notoriety (he himself is the hat thief, having begun his antics in order to write about them in the newspaper), and who carried on an affair with Laura Bitton, the young wife of his other uncle, Lester Bitton. In the end the murder is pinned to Robert Dalrye, a friend of Driscoll's who is engaged to Sir William's daughter, and who plausibly claims that he acted in self-defence. Hadley and Fell, not for the first time, take the law into their own hands and declare the case "unsolved."

Carr's most impressive and complex detective novel is *The Arabian Nights Murder* (1936), which I unhesitatingly declare to be the greatest pure detective story ever written—by which I mean that it excels in the core matter of presenting a mystery (in this case, a single murder) whose intricacy is unparalleled and whose solution is elaborated with the greatest possible artistry. The novel, unusually long for Carr, requires three police detectives— Detective-Inspector John Carruthers, Assistant-Commissioner Sir Herbert Armstrong, and Hadley, now a Superintendent—to solve; or, rather, the investigations of these three entirely capable officers allow Fell, listening in classic armchair detective fashion to their recitals in an all-night session, to pull the rabbit out of the hat and propound the full solution at the end.

The Arabian Nights Murder is at once Carr's most baffling mystery and one of his most amusing. At the very outset Carruthers, investigating the scene of the crime—the Wade Museum, a small museum devoted to curios and antiquities in London—is shown a Gallery of the Bazaars and is told, "That . . . was where somebody threw coal at the wall" (5). This is an instance of a much-used Carrian strategy of dragging an event out of its proper context and exhibiting it to the reader as an apparent example of mad or irrational behaviour. And whereas in *The Mad Hatter Mystery* we are for a time obsessed with stolen hats, we are here perplexed by the appearance of two different false whiskers, one black and one white, whose appearance and disappearance at various stages of the action contribute to the general atmosphere of lunacy pervading the entire case. The very fact that the dead man—initially unidentified but later determined to be an actor, Raymond Penderel—is found in an antique coach wearing the black whiskers and also holding a cookbook is meant to suggest that nearly all the characters, living or dead, are animated by either bizarre motives or no motives at all.

Carruthers's narrative is merely meant to lay out the general scenario— and, not coincidentally, to exhibit a series of baffling objects and events that subsequent investigators will successfully clarify. For example, a note found in the pocket of Gregory Mannering (a friend of Ronald Holmes, who in the absence of Geoffrey Wade is the temporary head of the museum) reading "There has got to be a corpse—a *real* corpse" (31) looks bad for him at the outset. Much later (in fact, toward the end of the report by Armstrong), it is noted that what Holmes and others, including Jerry Wade (son of Geoffrey),

were planning to do was to stage an elaborate hoax to scare Mannering, Miriam Wade's fiancé, including making a fool of himself. They had attempted to secure a real corpse from a medical school as part of the charade.

It is this charade that allows Carr to introduce the chief comic element in the novel, the figure of the bumbling, insufferably pedantic scholar William Illingworth. Having received a telegram from Geoffrey Wade urging him to come to the museum that evening for a meeting, he is assumed by the others to be the actor (Penderel) who had been hired to fill the role of an Asiatic scholar. It is for this reason that Jerry Wade affixes the white whiskers on him ("Who ever heard of an Asiatic scholar without whiskers?" [78]). Not knowing of the charade, Illingworth assumes that some actual criminality is under way—but amidst the clownish humour that this misunderstanding causes, Illingworth in fact sees one character place the actual corpse of Penderel in the coach. It is for this reason that he correctly believes that "I saw a crime committed" (66)—although he did not in fact see Penderel killed with a knife taken from one of the cases near the coach.

A further complication is of a more serious sort—for it transpires that Penderel, far from being an actor otherwise unassociated with the other characters, had in fact had a romantic relationship with Miriam, who had a child by him. Mannering had overheard a conversation to this effect between Miriam and Penderel in the basement of the museum; and because Miriam had taken the murder weapon down to the basement (purportedly to show Mannering what was in store for him—there was to be a fake attempt to kill him with the knife), Hadley arrests Mannering for the murder of Penderel. It was, under this reconstruction, Mannering who threw coal at the wall of the Gallery of the Bazaars in order to distract the attention of the night watchman while he took Penderel's body and stuffed it into the coach. The case against Mannering looks strong: in his flat, white gloves with blood and coal dust are found. But an unexpected obstacle appears: Geoffrey Wade appears and claims that he can bring forth an array of witnesses who will assert that Mannering was with them at a restaurant at the time when the murder must have been committed. It is plain that Wade is attempting to protect his future son-in-law by bribing witnesses. Hadley, infuriated as he is, seems stumped, and has come to Fell with the other detectives to see if anything can be done to convict Mannering.

Fell, listening to each officer recite his part of the investigation in turn, congratulates Hadley on "a brilliant piece of work" (188), but says there is a flaw "in one small and possibly trifling detail" (189)—the identity of the murderer. Warding off Hadley's explosive anger, Fell identifies the actual murderer as Jerry Wade, who was seeking to protect his sister. Mannering witnessed the murder and performed the subsequent actions as a deliberate means of shifting suspicion onto himself; and Geoffrey Wade steps in and,

with his lying witnesses, manages to weave a veil of protection over both his son-in-law and his own son.

The case in this sense ends unsatisfactorily with no one being arrested for the murder; but that is the least interesting aspect of *The Arabian Nights Murder*. In this novel Carr has created a genuine *Arabian Nights* atmosphere of breathtaking exoticism and inscrutable bafflement. If any feasible structure can be assigned to the novel, it might be a kind of peeling back of successive layers of an onion, each of which reveals more mysteries than the layer before. But this metaphor is inexact; it would be more accurate to say that each successive inspector solves his predecessor's mysteries, until Hadley seems to have come upon the only viable solution (as he declares at the outset of his discourse: "for a very outlandish circumstance there is normally only one possible explanation" [136])—his only error being the actual murderer. In a sense Fell is right that this detail is "trifling"—because, more than any other of Carr's detective stories, it is not the *who* but the *how* (and secondarily the *why*) that is of consequence here.

Carr then turns the entire genre of the detective story—and in particular his chosen subgenre of the "fair play" detective story, whether it involves a locked room or not—on its head in *The Burning Court* (1937). It is difficult to overstress the brilliance of this novel: it is simultaneously Carr's most ingenious and most chilling in its suggestions of the supernatural. By presenting the scenario at the outset as a straightforward murder story—simple or complex as the case may be—where the supernatural overtones (chiefly the suspicion that the fetching Marie Stevens may be a witch) are merely a red herring, Carr lulls the reader into a false sense of security, especially when a fully satisfactory and rational solution to the case is offered, only to be foiled by the epilogue, where Marie is revealed to be an actual witch with supernatural powers.

The crime at the focus of the novel is the death of the elderly Miles Despard, who apparently died of gastro-enteritis. But his housekeeper saw, through a window, a woman in old-fashioned dress in Despard's room on the night of his death—and she apparently disappeared through a door that had been bricked up 200 years before. Coincidentally, Edward Stevens, Marie's husband and a book editor, is reading the manuscript of a book by one Gaudon Cross that contains a chapter on Marie D'Aubray, who was guillotined in 1861 for witchcraft; her photograph looks uncannily like Marie, whose maiden name was in fact D'Aubray. Was she a relative? Cross also states that slow doses of arsenic result in death that could be attributed to gastro-enteritis. Stevens also learns of an older Marie D'Aubray, marquise de Brinvilliers, a poisoner who was beheaded and burned in 1676. As the capstone to the pseudo-supernatural suggestion, a motive for the killing of Despard emerges when it is learned that one of his ancestors had caught

Madame de Brinvilliers and caused her to be executed. (The court in seventeenth-century France that tried poisoning cases was called *La Chambre Ardente,* lending the novel its title.)

Although Marie is herself agitated when Edward confronts her about the 1861 figure (she momentarily believes he is referring to herself—and he also suspects that she may have stolen the photograph of Marie D'Aubray that accompanied Cross's manuscript), we are nonetheless led to believe that, at worst, Marie is perhaps psychologically disturbed and, perhaps because of her ancestry, believes herself a witch. Other details fancifully suggest the supernatural, with full awareness that the reader will dismiss them as error or trickery, as when it is stated of the woman in Despard's room: "the woman's neck might not have been completely fastened on" (248).

The detective element is supplied by Captain Brennan, of the Philadelphia police, who comes to investigate the death of Despard after receiving an anonymous note stating that Despard was poisoned. His initial investigations lead to an increasingly strong case against Marie: other members of the Despard family, Edith and Lucy (who were in fact at a fancy-dress ball that night), have ironclad alibis; Brennan learns that Marie once asked Despard's nurse where one could buy arsenic; a bracelet that is exactly like one owned by Marie was once owned by both the 1676 and 1861 Marie D'Aubrays.

But the case then begins to crumble before Brennan's eyes. First, the photograph of the 1861 figure turns up—it had fallen out of Edward's briefcase, and was not stolen by Marie. Then Gaudon Cross makes an entrance, armed with the dramatic announcement that Marie Stevens had been adopted by a French-Canadian branch of the D'Aubray family because she looked like the 1861 figure. This is a tad implausible, but Cross goes on to say that Marie had been raised with a belief in witchcraft, and this largely accounts for her suspicious actions throughout the case. The murder is finally pinned on the nurse, and the seeming disappearance of the woman in fancy dress is accounted for by the use of a mirror.

But anomalies remain. Chief of them is the fact that the nurse strenuously denies her guilt, in a manner that an actual criminal (in a detective story, at any rate) rarely does:

> "I didn't kill him. I did not. I never thought of it. I didn't want any money. All I wanted was Mark [Despard's nephew]. He didn't run away because he did anything like that. He ran away because of that —— that's his wife. You can't prove I killed the old man. You can't find the body, and you can't prove it. I don't care what you do to me. You can beat me till I die, but you won't get anything out of me. You know that. I can stand pain like an Indian. You'll never—"

She broke off, choking. She added, with sudden rather terrifying misery: "Doesn't anyone believe me?" (351)

Passages like this set the stage for the epilogue, told from Marie's point of view, where the reader gradually comes to the appalling realisation that she is in fact a witch and the reincarnation of both previous Marie D'Aubrays.

What *The Burning Court* does is to play tricks with genre, leading the reader to suspect a natural explanation to the death of Despard while setting up a supernatural explanation that in fact more satisfactorily accounts for the events than the other does. It is no small point that Carr's previous books—beginning with the brooding atmosphere of the early Bencolin novels and moving on through such works as *Hag's Nook*—have been laying the groundwork by incorporating the quasi-supernatural as a critical component of the overheated atmosphere of the scenario. Carr was, therefore, in a unique position to perform this act of genre-flipping; and he accomplishes it with ingenuity and aplomb.

Carr's more orthodox detective novels following *The Burning Court* are perhaps not quite as scintillatingly brilliant as some of its predecessors, but they continue working the terrain he seized with those novels. Some of them feature a frenetic action more reminiscent of the thrillers of Edgar Wallace than the staid "cosies" of Agatha Christie. *To Wake the Dead* (1938) begins rather alarmingly with a man, Christopher Kent, down to almost his last dollar, trying to cadge a breakfast at a swank London hotel by pretending he is registered in room 707 (a number he had chosen because it was on a card that he found on the ground outside the hotel). The room in question, it turns out, has a do-not-disturb sign on which has been written in pen, "Dead Woman." Sure enough, there is a dead woman inside. This striking opening sets the stage for an unusually tumultuous narrative involving a complex time schedule where a few minutes makes all the difference between an ironclad alibi and a potentially weak one, and where the several murders that occur (seemingly by strangulation) are pinned on a man with a paralysed left arm. It is all good fun, but the novel is a bit more frivolous than Carr's usual fare.

The Crooked Hinge (1938) has earned justifiable fame as something of a pinnacle of ingenuity in Carr's output, and the elements of terror and quasi-supernaturalism that infiltrate the work from beginning to end lend it an atmospheric effectiveness surpassing that of even some of his more celebrated novels. The premise of the novel is the attempt by John Farnleigh to reclaim a baronetcy to which he would seemingly be entitled—if, indeed, he was the real John Farnleigh. Another man soon shows up claiming that *he* is the real John Farnleigh. This latter man, who has been going by the name Patrick Gore, had sailed to the United States on the *Titanic* at the age of fifteen, and there is a suggestion that he switched identities with another

boy on the boat. The course of the narrative strongly compels the reader's sympathies to rest with the first John Farnleigh, so it is startling when this man dies early in the novel: he is found dead in a garden pool, his throat cut. This happens just before an old tutor, Kennett Murray, is about to examine a set of old fingerprints that should definitively prove which one of the men is the real Farnleigh. Was the dead man murdered, or did he commit suicide? The former hypothesis is rendered implausible because no one seemed to be near him at the time of his death, and the latter is also unlikely because no murder weapon is found near him.

Gideon Fell, who is quickly brought in to investigate, makes the intriguing observation at the outset that this case is "an almost purely psychological puzzle" (82)—by which he means that, in the general absence of material clues, the psychologies of the two claimants to the baronetcy are the focus of the case. The comment may be a bit disingenuous, for the crux of the case is how the man died—whether by accident, suicide, or murder. Fell also determines fairly early on that the man going by the name John Farnleigh is in fact an impostor, and that Patrick Gore is the real Farnleigh.

The novel for a time focuses on the existence of an automaton, in the shape of a woman, built during the reign of Charles II. At one point the automaton, in an attic room, comes crashing down—conveniently just after the time when Fell has declared he is on the verge of solving the case (150). Fell does not, however, think the automaton was pushed in order to kill him, but in order to destroy the machinery itself. Further terror is created when Betty, a maid, tells the harrowing tale of being locked into the room with the automaton, whereupon it put its arms around her and looked up at her from eyes in the knees. The suggestion is that this automaton was somehow used to commit the murder, although this proves to be a red herring.

Fell then constructs an extraordinarily precise and complete case against Molly, Lady Farnleigh (wife of the dead man)—but purely as a means of smoking out the real murderer. Fell maintains that Molly knew that the man posing as Farnleigh was an impostor who had switched places with the real John Farnleigh on the *Titanic*. But the real Farnleigh, as a boy, had gotten her interested in Satanism; the impostor knew of her interest but had kept it quiet to protect his wife's reputation. If the real Farnleigh ever appeared, the impostor would have no reason to maintain his silence on the matter, and so he had to be killed. This dim echo of *The Burning Court* effectively transforms Molly from a loyal wife who refuses to believe the aspersions against her husband into an evil quasi-witch who was partly responsible for the death of a woman, Victoria Daly, whom she had plied with hallucinogenic drugs (aconite and belladonna) used in the witch-cult.

As I say, this reconstruction of events is deliberately false, for it compels the butler, Knowles, to identify the real murderer—Patrick Gore. Gore

(the real John Farnleigh) had been attacked on the *Titanic* by the impostor, but the ship's striking of the iceberg had caused the hinges of a metal door to collapse, crushing his legs. Gore in fact has no legs, and he walked on his arms to the impostor at the garden pool and killed him with a knife. In the end, Gore and Molly flee, and the final chapter is Gore's lengthy recital of his sole guilt in the crime.

Implausible as this scenario sounds, it is powerfully effective when unveiled in the gradual and painstaking manner that Carr manages. It cannot be said, of course, that *The Crooked Hinge* broaches any significant historical or philosophical issues, but its psychological portrayal of all the principal characters is unusually sharp and penetrating, and the resolution of the case is satisfying in a way that some of Carr's other rabbit-out-of-the-hat scenarios fail to be. The fake terror of Molly's witchcraft delusions is balanced by the very real terror of the destruction of Gore's legs on the *Titanic* and his long years of waiting to gain revenge on his assailant.

In *The Case of the Constant Suicides* (1941) Carr makes deliberate attempts to be funny—and, as so frequently happens in such cases, the novel proves to be considerably less funny than several others where the humour arises more or less naturally from the interplay of hyperbolic characters and contrived action. Here we are asked to be entertained by the initial hostility and eventual romance of two historians, Alan Campbell and Kathryn I. Campbell, who have come to the Castle of Shira in Scotland for a family conference after the death of the patriarch, Angus Campbell. Carr's habitually patronising treatment of women—even, as here, a learned historical scholar—creates frequent situations where the reader is more inclined to wince than laugh. In the end, the case revolves around the use of dry ice as a poison (when melted, it releases carbonic acid gas); and it is no surprise that Alan and Kathryn (distant cousins) are married as the novel concludes.

The Man Who Could Not Shudder (1940) must hold some sort of record for surprising plot twists, especially at the end. Here we are taken to a house called Longwood, a Jacobean manor-house near Southend-on-Sea, where, in 1920, a butler apparently died by swinging on a chandelier until it fell on him, and where, in the course of a "ghost party" held by the house's current owner, Martin Clarke, a woman states that an antique pistol "came off the wall by itself, and hung in the air, and shot my husband" (91). Once again, the ins and outs of the convoluted plot, involving an unusual number of houseguests, all of whom come under suspicion at one time or another, are too byzantine to recount; suffice it to say that at one point Fell upbraids the first-person narrator, Bob Morrison, by saying that he is unwittingly creating mysteries: "By words. By the wrong implications. By your manner of stating the facts, or what you believe to be the facts" (251)—a perfectly accurate description of Carr's own narrative methodology.

In the end, the murder is attributed to Andy Hunter, the architect who had renovated the house some years earlier, and the means by which he managed it was an electromagnet that could make the pistol—set on a hair-trigger—jump from the wall and fire. But in a final twist, Fell—who, in perhaps his greatest act of self-justifying criminality, actually sets fire to the house—blandly notes that Morrison himself had unwittingly caused the pistol to fire by stepping on a board in the billiard-room.

I don't know that *The Man Who Could Not Shudder* is any more ingenious than any of Carr's other novels, but the compactness of its writing, and the unusually precise manner in which all the loose ends—both in the death that had occurred twenty years earlier and the present-day murder—are knitted together engenders a particularly satisfying reaction in the reader. It is almost as if Carr had set a test for himself: How can I make it seem as if a pistol had pulled itself away from a wall where it was hanging and shoot of its own accord? Carr manages the trick without unduly straining the reader's credulity.

The Sir Henry Merrivale novels are in every sense what one might call "Fell lite." As Carr attempts to inject a greater degree of humour—bordering at times on buffoonery—in these works, the baroque complexity of the plots generally decreases, and there is a marked reduction—amounting to a virtual absence—of the quasi-supernaturalism that so enlivened both the Bencolin and the Fell novels. Merrivale himself, although a large man, appears not to be quite as gargantuan as Fell—at any rate, he does not require two canes to move about—and, in a bit of a surprise, we learn that he is head of the Military Intelligence Department of the War Office. Although this position is of relevance in several early mysteries, one wonders how Merrivale can carry on as a private detective while burdened with this presumably onerous position.

The Red Widow Murders (1935) makes a fleeting attempt to suggest the supernatural in its opening scenario. A man, Ralph Bender, takes up the challenge to stay in a previously sealed-up room of a house where several people have died mysteriously. He calls out every fifteen minutes, including at 11:45, but is found dead at midnight. A physician declares that he has been dead for an hour. In spite of all this, there is very little suggestion that the room is "haunted" (it is instead depicted as a kind of poison trap, operated by some unknown means), and still less of a suggestion that the ghost of Bender cried out after his death: clearly some jiggery-pokery (as Carr would say) is involved. The case seems to involve an unusually contrived means of murder—Bender might have been killed by a dart laced with curare, the dart then being retracted out a window by means of a silk thread—but the true solution proves a tad simpler than that.

The Peacock Feather Murders (1937), by no means the longest of Carr's

mysteries, is the one Merrivale novel that rivals—indeed, perhaps surpasses—the Fell novels in complexity of plot. The challenge that Carr has set for himself—and the reader—is to create a locked-room mystery where the murderer seems to have disappeared. It is important for this purpose that a policeman be stationed outside the attic room where the murder occurs: a Sergeant Pollard is watching the closed door of the room where two gunshots are heard; the moment these shots are fired, Pollard enters the room and finds the dead man, one Vance Keating. Keating has been shot, apparently at close range, in the back of the head (there are powder burns there), and also in the spine; but although the weapon itself, a .45 revolver, is found in the room, the murderer is of course not present. It is quickly ascertained that the murderer could not have left through a window (even though it is open), nor are there any trap-doors in the room. Ultimately, the case is solved when Merrivale determines that the murderer, a friend of Keating's named Ronald Gardner, had shot Keating in the back of the head with a blank cartridge the day before, as part of a planned "murder game" that the two were to be involved in the next day; this causes the powder burns at the back of Keating's head, creating the impression that the shot in the head—actually fired by Gardner from a building across the street—had been fired at close range. Gardner then throws the revolver into the room through the window, and its landing on the floor causes it to go off, shooting Keating in the spine. As if this were not implausible enough, the fact that Keating had screamed *before* being hit by the first bullet is explained by his seeing Gardner aiming the revolver as reflected in his cigarette case.

Carr makes his boldest and most aggressive challenge to the reader in *The Reader Is Warned* (1939). The novel is peppered with footnotes steering the reader away from false reconstructions of various aspects of the case, as if the author—like Fell in *The Three Coffins*—is perfectly prepared to admit that this is all a literary game. But the novel nonetheless is a success, if only for its cleverness. Here the quasi-supernatural is brought in by the apparently uncanny ability of a German man, Herman Pennik, to read the minds of various guests who have come to the house of Sam and Mina Constable. One of his predictions is that Sam is to die imminently; he in fact does so. Pennik is so bold as to admit to Inspector Masters that he killed Sam—by something he calls Teleforce. Merrivale, who shows up on the scene, tells Masters ominously: "this business is queerer than you think" (70). Halfway through the novel, Merrivale already tells Masters that he thinks he knows how Pennik committed his mind-reading fraud (95), but of course he does not reveal it at the time. Pennik continues his arrogant boldness by predicting that Mina—who was furiously seeking to expose Pennik as a fraud—would die one evening when she and Dr. John Sanders (the narrative voice of the novel) are alone in the house. She does so.

There is, regrettably, more than a suggestion of racism in the solution—at least, in the naturalistic solution of Pennik's mind-reading powers. It is bluntly stated that he is "an East African mulatto"—that is, the son of a German father and a other who was "a Matabele savage. His grandfather was a Bantu fetish-man, or witch-doctor; and he was brought up in a Matabele hut until he was eight years old" (170). It is true that this statement is placed in the mouth of the actual murderer of Mina Constable (Mina herself had accidentally caused Sam's death by dropping an electric heater into the bathtub while he was taking a bath); but Merrivale expresses himself in somewhat similar but less offensive terms later on (190). In addition, Merrivale flimsily accounts for Pennik's seeming mind-reading powers by pointing to his "stunning penetration, an ability to read thoughts in the sense of reading people and judging (by their features, like the Muscle-Readers) exactly where their thoughts are likely to go" (189).

But the real problem with this novel, as with much of Carr's work as a whole, is that the intense focus on bamboozling the reader as to the *how* of the various crimes results in relatively weak character portrayal that renders the actual motive of the central murder—in this case, that of Hilary Keen, who was seeking to get rid of her hated young stepmother, Cynthia Keen—unconvincing. Carr has placed himself in a box: if he recounts more detailedly the hatred of Hilary for Cynthia, that would tip off the reader as to the identity of the murderer, if not the means by which it was committed; so he is obliged to allude to this issue in only the most fleeting and tangential of ways, and the result is that the reader derives little sense of the powerful emotions that could drive a person to commit such a crime in the first place.

Carr repeats his challenge to the reader in *The Nine Wrong Answers* (1952), where again a series of nine footnotes steers the reader away from the "wrong answers" to the case. Of course, there is little likelihood that any reader could guess the right answer, especially in a narrative as breathtaking as this one—a narrative that begins when an ex-RAF pilot, Bill Dawson, overhears a conversation in a New York lawyer's office whereby a man named Lawrence Hurst will inherit a huge fortune if he goes back to England and looks in on a hated uncle, Gaylord Hurst, once a week until his death. Dawson quickly agrees when Lawrence Hurst offers to have Dawson take his place for a period of six months. Gaylord had, in Lawrence's words, "devoted his life to frightening a kid" (42)—i.e., himself, and he says he cannot face his uncle now. When Lawrence appears to die in a bar from drinking a drink intended for Dawson, the latter carries through with the plan—as a means of avenging Lawrence.

The novel focuses on the figure of Gaylord, who exhibits his bland amorality by proposing that he will make one legitimate attempt to kill Dawson (whom he takes to be Lawrence) over the next six months; if Dawson sur-

vives, he will inherit Gaylord's entire fortune. Only then does Gaylord reveal that he knows Dawson's true identity. He now offers an approximately similar challenge to Dawson: he can keep the $10,000 that Lawrence had given him; otherwise he will report Dawson to the police. First, Gaylord tries to set his evil butler, Hatto, on Dawson; but when the latter beats up Hatto, the enraged Gaylord says his attempt on Dawson will occur in the next twenty-four hours. When Dawson, that evening, breaks into Gaylord's house, he finds him dead of cyanide poisoning. He then believes that Gaylord had planned to "kill" him by having him convicted of his own death. This would be a most ingenious manoeuvre, but Carr in a footnote proclaims that Gaylord did not kill himself in order to frame Dawson. This proves to be true—in the sense that the person that Dawson thought to be Gaylord was in fact Lawrence Hurst, who had been masquerading as him until he (Lawrence) killed Gaylord.

It is all great fun, and Carr succeeds for once in characterisation by his portrayal of the ruthless and vicious Gaylord (who, even though he is at this point played by Lawrence Hurst, is presumably an accurate reflection of the actual Gaylord who had terrorised Lawrence when he was a child) and his equally vicious manservant, Hatto. Otherwise, the novel is properly seen as a thriller filled with narrow escapes from death by Dawson and his girlfriend, Marjorie Blair, whom he had conveniently met on the plane to England.

The laborious plot synopses that have filled this chapter—many of which, in all frankness, have only focused on relatively limited aspects of the overall works—point to the labyrinthine complexity of the average Carr novel. He has clearly made this his specialty—and, indeed, it can unhesitatingly be stated that no one in the entire realm of mystery or detective or crime fiction has equalled him in this regard. And we must frankly admit that that is indeed an achievement of sorts—the equivalent of producing a thousand-piece jigsaw puzzle.

The fact that Carr's work is almost entirely vacuous on an aesthetic level—we learn virtually nothing about human nature from his many dozen novels or stories, and it cannot even be said that there is anything approaching "realism" in his work, since from the outset he repudiated realism, whether topographical or psychological, in his relentless focus on the puzzle element—is not, or not necessarily, a mark against him. It is a criticism that could be levelled at the great majority of detective stories ever written, from Poe and Conan Doyle to the present day. What can be said for Carr is that he provides more than his share of wholesome entertainment—entertainment, in other words, that does not pander to the lowest and most vulgar tastes of ill-educated readers whose thirst for tinsel romance, ludicrous action-adventure scenarios, and deliberately chosen controversies fill the bestseller

lists with the Danielle Steels, the James Pattersons, and the Dan Browns of the world.

In my estimation, the level of enjoyment in reading Carr is significantly higher than that provided by the flaccid prose and repetitive plots of Agatha Christie, the languid snobbery of Dorothy L. Sayers, the literarily distinguished diction but laborious plot development of Margery Allingham, and the otherwise capable work of Philip MacDonald, Ngaio Marsh, and any number of other practitioners of the "cosy" mystery who could be named. It may seem odd to refer to Carr as a member of the "cosy" mystery school, but his work must be placed there, if only because of its date of composition and its extreme divergence from the work of the hard-boiled school, the psychological mysteries of Margaret Millar, the grim crime novels of Patricia Highsmith, or any other subgenre that could be cited. Carr had no illusions that he was another Dostoevsky; and on his humble level he succeeds admirably in achieving what he set out to do.

MARGERY ALLINGHAM:
MURDER, GANGS, AND SPIES

British writer Margery Allingham (1904–1966) wrote more than twenty detective novels along with a number of novellas and short stories, but she appears never to have received the celebrity or acclaim of such of her coevals and rivals as Agatha Christie and Dorothy L. Sayers, either among readers or among critics. In a sense, her own work embodies many of the characteristics of her mild-mannered, self-effacing, and seemingly foolish detective, Albert Campion. Allingham's writing is anything but foolish; but then, Campion is anything but a fool, in spite of the author's increasingly tiresome attempts to depict him as (outwardly) a kind of Bertie Wooster figure. Indeed, there is some suggestion that this portrayal is meant as a gentle satire on Sayers's Lord Peter Wimsey, who does indeed exhibit Wooster-like traits from time to time; to say nothing of Campion's sidekick, the ex-convict Magersfontein Lugg, as exquisite a parody of the staid Bunter (himself a combined parody/homage of Jeeves) as could be imagined.

Allingham's greatest creation, indeed, is Campion. We never learn very much about this ambiguous figure: much of his personal history is left tantalisingly unexplained. Campion is not his real name; he has a murky past that may actually include criminal activity, but at the same time he is a scion of one of the noblest families in England; he did some unnamed government work during World War II, but its nature is never elucidated. Most noticeably, he exudes an aura of vague inanity that deceives many of his antagonists. But right from the start we know—and Allingham intends us to know—that Campion's "idiocy" is only a guise. I think the degree to which Campion gradually sheds his air of vacuity over his long career is exaggerated by some critics: even in the late novels we are soberly informed by Allingham (quite disingenuously by now) of his blank expressions and sense of confusion. The joke has become tiresome.

After stumbling badly with her first detective novel, *The White Cottage Mystery* (1928), a poor and insubstantial work, Allingham went on to write some of the most literarily distinguished mysteries of her time. Her dense, richly textured style—far different from the languour of Dorothy L. Sayers or the hyperbole of John Dickson Carr—and razor-sharp characterisation

give her work a literary substance that the subtlety and ingenious execution of her plots could not by themselves have done.

Allingham's earlier novels tend to be her best, in part because several of them present distinctive fusions of the pure detective tale and the crime or gangster story. *The Crime at Black Dudley* (1929) introduces the pattern. Black Dudley is a lavish house in Suffolk where, in typical fashion, a diverse array of characters gather for the party; but this is the only conventional element about this novel. The surface "crime" occurs fairly early: the host, Colonel Gordon Combe, is found dead, apparently of a heart attack, although it is quickly ascertained that Combe died from a stab wound in the back. This had apparently occurred in the course of a game in which a dagger was passed around in the dark; one character states that the dagger had blood on it.

But this is only the beginning of what proves to be a thriller of sorts involving kidnapping, arson, and organised crime. Campion's presence at the party is initially unexplained, as no one can be found who actually invited him. The matter comes out later, when it is discovered that a member of the household, Benjamin Dawlish, is actually the crime boss Eberhard von Faber. Faber and his cohorts imprison the others, demanding that they turn over some papers he is looking for. It would appear that Combe was himself part of—and perhaps head of—the criminal gang, but he was planning to double-cross Faber by giving plans for a robbery to a rival gang, using Campion as an intermediary. (Campion had earlier admitted that he was "more or less" [104] a crook.)

The actual murder mystery comes to the fore in the midst of all this action through the revelation that Faber and his gang in all likelihood did not kill Combe, for they were as surprised to learn of his death as anyone. The novel—told largely through the perspective of George Abbershaw, a physician—features a succession of spectacular events at the end. Abbershaw had himself unwittingly secured the papers that Faber was after and had burned them; so it appears that the party guests are in a bit of a pickle, given that Faber threatens to burn the house down, with the guests inside, if the papers are not handed over. The house is in fact set on fire, but Faber and his gang are nevertheless captured—because they become entangled in a passing fox-hunt. What a triumph of English normalcy over foreign criminality! The party guests escape the burning house, and it is Abbershaw—not Campion—who ascertains that Combe was killed by his nephew, who had found out about his uncle's criminal activities. But by this point this matter is largely an afterthought.

Mystery Mile (1930) is in a sense a follow-up to *The Crime at Black Dudley,* as it focuses around the Simister gang, an American criminal organisation mentioned in passing in the earlier novel. Campion, who has

saved the life of an American judge, Crowdy Lobbett, on board a ship going to England (Crowdy had been the focus of previous attempts on his life), rents a manor-house at Mystery Mile—a virtual island off the English coast—to house him for a time. There are a number of suspicious characters lurking in the area, ranging from an itinerant palmist, Anthony Datchett, to one A. Fergusson Barber, an art appraiser. Allingham lets on that Barber was on the ship that carried Lobbett to England, but initially suspicion focuses more intensely on the dubious Datchett.

Things appear to take a turn for the worse when Lobbett enters a hedge maze—and disappears. A cryptic message comes to the manor-house, carried by a dog: "Am safe if blue suitcase is not lost" (94). But this suitcase appears to contain nothing but children's books. It is around this time that we are introduced to the imposing figure of Magersfontein Lugg:

> There was a heavy step in the passage, and the next moment the largest and most lugubrious individual Marlowe had ever seen appeared on the threshold. He was a hillock of a man, with a big pallid face which reminded one irresistibly of a bull terrier. He was practically bald, but by far the most outstanding thing about him was the all-pervading impression of melancholy which he conveyed. He was somewhat unconventionally clothed in what looked remarkably like a convict's tunic, apparently worn as a house-coat over an ordinary suit. (108)

Lugg's speech is as pungent as his appearance. And this novel also introduces Stanislaus Oates, a detective inspector who teams up with Campion on many subsequent cases.

A bit later, Lobbett's clothes are found, with blood on the *outside* of them. Matters become even more serious when a local woman, Biddy Paget, goes missing; Campion believes she was kidnapped by the postmaster at the behest of the gang. After a ferocious fight, Campion and others rescue Biddy. But she reports the startling news that the Simister gang did not in fact kidnap Lobbett, since it was trying to pressure her to reveal Lobbett's whereabouts. It is at this point that Campion admits that he himself spirited Lobbett away for his own protection. But there remains the matter of the children's books in the blue suitcase. Campion at last ascertains that a book about Ali Baba is a hint that Barber is Simister. There is a tense and surprisingly violent confrontation between Barber and Campion, during which Barber shoots Campion a number of times but himself drowns in a salt marsh. Campion of course survives.

The incidents in these two novels may seem to suggest that Allingham is writing the British equivalent of hard-boiled crime stories; but this would be far off the mark. In the first place, her language is nothing but refined British elegance; indeed, on the level of prose she is probably the best mystery writer of her time, and certainly leagues ahead of the pedestrian Ag-

atha Christie. Even the episodes of violence are narrated with a fluidity that, while in no way diminishing their dramatic tensity, renders them anything but extreme or exploitative.

Look to the Lady (1931; US title *The Gyrth Chalice Mystery*) is another clever fusion of the British "cosy" mystery with the gangster story. Here, Campion summons Val Gyrth, the impoverished son of a baronet who owns a castle called The Tower, in Suffolk. He tells Val about a band of wealthy men who pay criminals to steal valuable *objets d'art* from museums and private collections so that the men can secure them. They now want to steal the Gyrth Chalice, a fabulously old and valuable cup in the possession of the Gyrth family, but will leave the Chalice alone if the person chosen to steal it is killed. This is, admittedly, a highly artificial premise, but it leads to interesting results.

Campion and Val go to The Towers, where it transpires that his aunt Diana—who is a kind of guardian of the Chalice—has invited a bunch of artists and mystics to the place. This seems to be inviting trouble, and very quickly Diana is found dead on a path in the nearby woods. She was, however, not murdered, but apparently scared to death. As one character states: "She saw something dreadful, Val. She died of fright" (79). Are the woods haunted? They are, but—as Val's sister Penny declares—"not by a ghost, but by something much worse than that" (88).

Three days after Diana's death, the Chalice then goes missing. But Campion finds it soon thereafter in a suitcase packed by Penny; she had wished to put it in a safe deposit box. But an American professor, Gardner Cairey, staying nearby affirms that the Chalice in question is only 150 years old; can the real Chalice be in a secret room where every male Gyrth heir is taken at the age of twenty-five? The quasi-supernatural element of the novel is enhanced when Lugg sees what appears to be a strange animal ("A great thin thing with little short legs and 'orns on its head" [172]). This would seem to be some kind of hallucination, but then a photograph of the entity appears to confirm its existence. This minor mystery is quickly resolved when it is learned that the figure is Mrs Munsey, a suspected witch who dresses up in weird garb to frighten people so that her son can poach in the woods. But she denies scaring Diana to death, and goes on to claim that the head of the criminal gang that is after the Chalice is one "Daisy"—who is, surprisingly enough, none other than Mrs. Daisy Shannon, an irritating and noisy neighbour.

Events now occur thick and fast. The fake Chalice is stolen, but then comes back to the house by mail. Campion allows himself to be captured by the gang, led by Daisy Shannon, but escapes with the help of Professor Cairey. A band of gypsies in the woods battles with Daisy and her gang, but she escapes by car. Campion follows her on her own horse. She ascends

to the roof of The Towers and lowers herself by rope to the window of the secret room; but then she sees something that terrifies her and falls to her death. (Campion, who had himself gone up to the roof, endures a moral dilemma by considering whether he should cut the rope; but he declines to do so.) It is later discovered that the real Chalice is guarded by an immense skeleton in armour; and there is a faint suggestion that the skeleton may have spoken to Daisy, augmenting her fear and causing her death.

The supernatural trappings of *Look to the Lady* are, in the end, unconvincing, but they add a distinctive flavour to the novel—as they do to many of the novels of John Dickson Carr, who generally handles this element better. The complex nature of the case, and the multitude of piquant and distinctive characters put on stage, make this one of Allingham's most engaging novels.

Police at the Funeral (1931) is one of Allingham's first "pure" detective stories, without any infusion of gangster or espionage elements. The plot focuses on a seriously dysfunctional family ("there's no vent to the suppressed hatreds, petty jealousies, desires and impulses of any living soul under that roof" [43], as one family member states) in Cambridge, consisting of sundry brothers, sisters, cousins, and so on. The matriarch of the family is Great-Aunt Caroline, who appears to know something of Campion's "real" identity (she at one point calls him "Rudolph" [66]) and who otherwise maintains a tyrannical control over the household. In the end, the murders are pinned on a quasi-uncle, Andrew Seeley, who had been found dead in the river Granta. It transpires that he had cleverly arranged for other family members to die even after he had staged his own death (he had contrived to tie himself up on a bridge over the river and shoot himself). Some of the deaths he had arranged are quite hideous—one man had died by smoking a pipe filled with powdered cyanide—but otherwise this novel contains perhaps a few too many implausible twists to be convincing.

Sweet Danger (1933) is significant on numerous levels, not least of which is its introduction of Amanda Fitton, a fetching young woman who will eventually marry Campion. The byzantine complexity of the plot—concerning the discovery of documents relating to the ownership of land in a tiny principality in Europe that has an important port—need not concern us. It is one of several novels where Campion proves to be surprisingly active—as far as possible from the armchair detective model of Rex Stout's Nero Wolfe. Here again a criminal gang is involved, in the form of a mastermind named Savanake, who at one point lures Campion to London and apparently puts him on a boat to South America to get him out of the way; but Campion manages to elude his clutches and return to the village of Pontisbright (once again in Suffolk), where the main action occurs.

Aside from such engaging features as Campion dressed at one point

as a woman and a local physician who practises witchcraft, *Sweet Danger* focuses in the end on a dramatic conflict between Campion and Savanake, as they battle for possession of an iron box while fighting each other near a water mill. In the midst of the fisticuffs, Amanda herself is shot (not fatally, of course), and Savanake ends up falling through some rotten floorboards in the mill and dying. The fact that Campion had attempted to save him is meant to testify to his moral uprightness and disinclination to see anyone, even a hardened criminal, die needlessly. At the end of the novel, Campion and Amanda agree to marry in six years.

Death of a Ghost (1934) is of interest in featuring a particularly odious character who in the end proves to be the villain. Allingham exhibits considerable skill in the portrayal of such characters, and this instance proves no different. The "ghost" in this novel is the deceased painter John Lafcadio, who nonetheless hovers around the entire scenario and affects the actions of all the characters. There is Belle Lafcadio, the painter's widow and the protector of his legacy; there is Tom Dacre, a young painter who was Lafcadio's protégé, and who is spectacularly killed when the lights momentarily go out during an exhibition of Lafcadio's paintings; and there is Max Fustian (whose very name prejudices us), Lafcadio's biographer, an arrogant, pompous individual who magnanimously confesses to the murder, apparently as a means of protecting Linda Lafcadio, the painter's granddaughter. Campion himself believes at the outset that Linda had committed the deed, and both he and the police are convinced that Fustian's confession is false.

And yet, Campion in the end is convinced that Fustian himself is the murderer, both of Tom Dacre and of Claire Potter, the wife of an elderly artist living on Lafcadio's estate; the trick is in proving it. Historically, this is a relatively early novel in detective fiction in which the identity of the murderer is not in doubt. Campion deliberately engages directly with Fustian, who attempts to get him drunk on a special and particularly potent vintage of wine and then push him into the path of an oncoming train in the Underground. This dramatic scene—in which Campion's impressions while drunk are conveyed in stream-of-consciousness fashion (he is ultimately saved by a plainclothes policeman who had been following him)—occupies much of the latter part of the novel. Fustian is arrested for the attempted murder of Campion, but Campion still despairs of assembling evidence to prove Fustian's guilt in the other murders. But the matter becomes academic when Fustian's mind snaps. "He was my dearest enemy," Campion concludes, "but I wouldn't have wished that for him" (202).

A similarly odious character appears in *Black Plumes* (1940). Here we are concerned with a succession of suspicious, perhaps malicious, incidents at a gallery owned by Meyrick Ivory, who is away in China. Suspicion falls on Henry Lucar, who wishes to marry Meyrick's sister Frances, perhaps for

her money. A relative by marriage, Robert Madrigal, who is running the gallery in Meyrick's absence, is found dead. His wife, Phillida, says oddly, "Thank God" (25), when she learns the news. Could she be the murderer? Perhaps not. Not only does Lucar vanish for a time, drawing suspicion on himself, but a new character emerges on the scene—the explorer "Dolly" Godolphin, who maintains that he was secretly married to Phillida before her marriage to Madrigal. Godolphin makes a convincing case for why a young painter, David Field, should be the murderer; but the narrative has portrayed Field as a sympathetic character, so our suspicions must rest elsewhere.

The issue revolves around the absence of the murder weapon, a knife of some sort. Lucar, returning, maintains that he knows far more about the murder than he has told the police—but he is found dead almost immediately after this revelation. In the end, Godolphin proves to be the culprit: not only did he kill Madrigal (not so much for marrying his wife as for deserting him during an expedition), but he also killed Lucar, who had known all this and was blackmailing Madrigal. The murder weapon is revealed to be a sword hidden in Godolphin's cane. The depiction of the bombastic, self-important Godolphin is masterful, if only because his identification as the murderer nonetheless proves to be a surprise.

Allingham's most innovative novel, perhaps, is *Traitor's Purse* (1941). Written during the early stages of World War II, it exhibits a kind of James-Bond-before-James-Bond plot and atmosphere and may comprise Allingham's ultimate utilisation of the espionage motif. But the most distinctive feature of the novel is, once again, Campion himself—for we find him at the outset waking up in a hospital bed, stricken with amnesia.

Once again, the artificiality of this plot device may strike us as contrived, but its execution is singularly deft. Campion manages to get some clothes and escape the hospital, where he believes he had been confined by the police—on the suspicion of murder. When he stumbles upon Amanda, he takes her for his wife, but she corrects him: "You know you were going to marry me next month?" (30). They have, it seems, been unofficially engaged for a full eight years—but now, to Campion's extreme dismay, she wants to call it off, although perhaps only temporarily.

Campion receives a cryptic letter from Stanislaus Oates—or, rather, a letter he finds cryptic, since it appears to tell of some vital mission he is supposed to perform, but he cannot recall what it is. Later he stumbles upon a shop where Lugg is hiding out; but Lugg knows little of Campion's mission. After a long series of complications, Campion gains some insight on what he is to do. It involves a shadowy group called the Masters, who have hired a criminal gang to circulate vast amounts of counterfeit currency throughout England, seemingly under government auspices, to "Persons of Incomes

Below Tax Level" (198), with the result that the British economy would be brought to its knees. How exactly is Campion to stop a fleet of 300 trucks from heading out all over England to distribute the currency? He does so by hurling some kind of explosive egg into the cavern where the fleet is parked, so that a fire breaks out. And who is the mastermind behind the scheme? It proves to be one Lee Aubrey—very conveniently for Campion, for it appears that Amanda had postponed or even cancelled her wedding plans with Campion because she had fallen in love with Aubrey. Now that he is out of the way, Campion can declare at the end: "It's time we got married" (208).

The breathless pace of *Traitor's Purse* is matched by its unflinching and highly suspenseful depiction of the amnesiac Campion struggling to regain a memory of the mission that he knows is vital to save his country. Although narrated in the third person, the novel firmly views all events through Campion's eyes, and the fusion of emotional trauma generated by Amanda's equivocation about marriage and the size and complexity of the espionage plot make for unparalleled dramatic tension. It is one of several novels by Allingham in which the actual "crime"—the murder of an elderly man, Anscombe, who had worked for the Junior Lord of the Treasury—is a relatively insignificant aspect of the whole affair.

Allingham's later novels are quite uneven. *More Work for the Undertaker* (1949) is an incredibly slow and meandering murder mystery involving the Palinode family, whose mutual hatreds recall those of the Faradays in *Police at the Funeral*. Its only distinctive features are its portrayal of an ageing Campion—now depicted as "a tall man in the forties, over thin, with hair once fair and now bleached almost white" (8)—and the piquancy of yet another gang's plans to smuggle criminals out of the country in coffins.

In *Hide My Eyes* (1958; US title *Tether's End*) Campion is now in his "early fifties" (7). What is striking about this novel is, once again, the fact that no effort is made to conceal the identity of the murderer; instead, frantic and frustrated efforts to prove his guilt occupy our attention. The murderer—Gerry Hawker—is involved with a curio museum where a number of murders or disappearances have taken place. He is endowed with the classic attributes of a sociopath: "I've never been faintly fond of anything or of anybody in my life" (82). He is ruthless in his crimes, and his killing of an elderly lawyer, Matthew Phillipson, is quick and merciless. When he is finally cornered in the curio museum, he momentarily thinks of killing himself; but in the end, when a fire breaks out in the place, he both rescues Polly Tassie (the owner of the museum, and the one person he appears to have some feeling for) and then turns himself in. Campion has relatively little to do with the solution of the case.

Allingham's final novel, *The Mind Readers* (1965), is a curious specimen that attempts, not entirely successfully, to mingle detection with sci-

ence fiction. The latter element comes to the fore in a device—colloquially called the "iggy tube"—that appears to facilitate telepathy between two individuals. We are evidently to take this object—and the reality of telepathy—at face value. Indeed, at one point Campion and a policeman, Charlie Luke, try the device—and it appears to work. Much of the novel focuses on two teenage boys, Sam Ferris and Edward Longfox, who appear to be telepathically linked in some way, and whose powers are augmented by the iggy tube. There is at least one murder and several attempted murders (including one against Campion), and in the end Edward goes on television, where he announces that the discovery of the tube came by means of a transistor (consisting of a minute quantity of an imaginary element called nipponianum) made in Japan. It is a bizarre end to Allingham's literary career.

Much more could be said about Allingham. Her comic detective novel *The Case of the Late Pig* (1937) is a delightful jeu d'esprit. Allingham was a master of the novella, and several of her books—such as *Deadly Duo* (1949) and *No Love Lost* (1954)—consist of a pair of novellas that, in their richness and density, are as satisfying as her novels. She also is unusual among detective novelists in excelling in the short story, and such volumes as *The Allingham Case-Book* (1969) and *The Allingham Minibus* (1973) contain much good work.

It is tiresome to have to use the hackneyed word "distinguished" in regard to Allingham, but no other word quite conveys the supreme competence she exhibited in the very narrow range of her work. Her novels are strangely similar in manner and style, and there is relatively little development over the course of her career; but what she chose to do, she did supremely well.

PHILIP MACDONALD: EXPANDING THE "COSY" MYSTERY

British writer Philip MacDonald (1900–1980) is a good example of the classic British mystery at the height of its popularity in the 1930s and 1940s. Although his first detective novel, *The Rasp,* dates to 1924, he only hit his stride in the late 1920s and early 1930s: between the years 1928 and 1933 he published no fewer than sixteen mystery novels (three under the pseudonym "Martin Porlock"), as well as two mainstream novels. (His first two novels, dating to 1920 and 1923. were mainstream works written in collaboration with his brother, Ronald MacDonald.) After 1933, MacDonald devoted at least as much of his career to screenwriting as to detective writing (he wrote or assisted in the screenplays to *Rebecca, Strangers in the Night,* and other celebrated films), and wrote only six mystery novels from 1938 to 1959; a mystery short story collection, *Death and Chicanery,* appeared in 1962.

Most of MacDonald's novels feature Anthony Gethryn, who for a time seemed to enjoy a popularity rivalling that of Hercule Poirot or Gideon Fell, but who—like most of MacDonald's works in general—has faded into near-oblivion. Our introduction to him, in the opening pages of *The Rasp,* shows him to be a man of implausibly wide talents:

> Anthony Ruthven Gethryn was something of an oddity. A man of ac-
> tion who dreamed while he acted; a dreamer who acted while he dreamed.
> The son of a hunting country gentleman of the old type, who was yet one
> of the most brilliant mathematicians of his day, and of a Spanish lady of
> impoverished and exiled family who had, before her marriage with Sir
> William Gethryn, been in turn governess, dancer, mannequin, actress,
> and portrait painter, it was perhaps to be expected that he should be no
> ordinary child. And he was not. (10)

MacDonald goes on to say that Gethryn excelled both academically and athletically at Oxford, and afterward painted two pictures, "wrote a novel which was lauded by the critics" (11), became a colonel in the Army (he was injured in World War I), later wrote another novel and painted more pictures—and then, by the convenient death of an uncle, became a man of leisure.

Gethryn stumbles into the role of amateur detective when the editor of

a newspaper, the *Owl*, asks him to investigate the murder of John Hoode, a Cabinet minister, in his own home. As with many amateur detectives, he has a conveniently close relationship with the police—in this case, Superintendent Boyd of the C.I.D.—which allows him ready access to the crime scene and other matters that would ordinarily be barred to private citizens.

The interesting thing about *The Rasp* is that it is a *self-conscious* detective story—a story that knows it is already part of a tradition that is perhaps on the verge of becoming trite and hackneyed. This was, remember, only four years after Agatha Christie's first novel, *The Mysterious Affair at Styles* (1920), ushered in the modern age of detective fiction, and before any books by John Dickson Carr, Margery Allingham, and many other writers had appeared; Dorothy L. Sayers had published only her first novel. One comment among many is sufficient to prove the point. In regard to the murder victim, Gethryn remarks dryly: "Ever read detective stories, Boyd? They're always killed in their studies" (20).

The Rasp was an immediate success and put MacDonald on the map, but it is a flawed work at best. Although cleverly executed, its solution depends on information withheld from the reader—a fatal flaw in the kind of "fair play" detective story MacDonald is manifestly attempting to write. The novel proceeds in routine fashion by shifting suspicion from one character to the next—first to A. B. T. Deacon, Hoode's secretary, whose fingerprints are actually found on the murder weapon, a rasp; then to Jimmy Masterson, Hoode's former secretary, who, ailing and perhaps not in his right mind, actually confesses to the murder, although Gethryn quickly ascertains that he could not have committed it; then finally to the actual murderer, Arthur Digby-Coates, a fierce political and personal rival of Hoode. But it is here that MacDonald conceals vital information—the fact that Hoode had bested Digby-Coates in a number of academic and other honors; the fact that they were vying for the attentions of a dancer named Vanda; and the fact that Digby-Coates was the owner of several different newspapers that had run harsh articles on Hoode.

What is more, the manner of committing the murder is so artificial, and so dependent on an implausibly precise time-line, as to collapse of its own absurdity. First, Digby-Coates manages to get Deacon's fingerprints on the handle of another tool, then transfers it to the rasp; he ridiculously arranges his toupée, trousers, and shoes in an armchair in his room so that, from the back, it looks as if he is sitting there; he then climbs out of his second-story window to the window of the study on the first floor at the exact time when all manner of other guests and servants are *not* passing up and down the corridor outside the study, allowing him to perform the nefarious deed.

But *The Rasp* does feature some elements of novelty that make it stand apart from the standard "cosy" mystery. The hideous mutilation of the dead

man's head, as effected by the rasp, is described in minute terms that bring the horror of the deed to life:

> It [the body] sprawled upon the hearth-rug, legs towards the window in the opposite wall. The red-tiled edge of the open grate forced up the neck. The almost hairless head was dreadfully battered; crossed and re-crossed by five or six gaping gashes, each nearly half an inch wide and an inch or so deep. Of the scalp little remained but islands and peninsulas of skin and bone streaked with the dark brown of dried blood, among it ribands of gray film where the brain had oozed from the wounds. (23)

The almost obscene explicitness of this description makes one realise the vileness of the act of murder, in contrast to those many "cosy" mysteries where the crime is merely an academic starting-point for displays of erudition and cleverness by the detective.

In subsequent novels MacDonald is perennially confronted with the quandary of how to make Gethryn a plausible participant in the investigation of a case. In *The Link* (1930) he had conveniently been to lunch with Sir Charles Greville and Lady Sheila Greville the day before Sir Charles is murdered. Gethryn attempts some further justification of his own: "I'm blessed, or cursed, whichever way you look at it, with an aura which seems to breed crimes, generally of violence. . . . What I mean . . . is that wherever I go—and always in the most unlikely places—I tumble into the middle of some unsavoury wrong-doing" (72–73). An excellent reason for not inviting Gethryn to one's home, it would seem! And yet, he continually shows up at opportune moments, or is related by ties of blood or friendship to the victims of crime or the suspects.

MacDonald performs a tour de force of sorts in *The Maze* (1932; US title *Persons Unknown*), subtitled "An Exercise in Detection." The exercise is performed in classic armchair-detective fashion by Gethryn, who does nothing but read the transcript of an inquest (occupying the first three parts of the novel), then writes a long letter (as he did in *The Rasp*) outlining his solution. In a letter to Gethryn that opens the novel, Assistant Commissioner Sir Egbert Lucas tells Gethryn that the victim in question, Maxwell Brunton, "met his death, abiding by all the canons of the best 'mystery fiction' in his study" (12). Brunton presided over a household that conveniently had an array of suspects—his wife, Enid; his son, Adrian; his secretary, Sydney Harrison; and so on. The novel was published two years after Sayers and Robert Eustace utilised a nearly identical documentary style in *The Documents in the Case* (1930).

Gethryn's solution to the case—that the crime was committed by a scullery maid, Violet Burrage—may be somewhat unorthodox in violating the informal rule that servants should not be the culprits in the murder of

their employers. But MacDonald renders the solution plausible by empha-
sising—unusually, given the date of the novel's writing—the extraordinary
lengths to which Brunton's philandering went. We learn through the course
of the testimony of various parties that Brunton's wife had confronted him
about a liaison with a woman, and that this woman (whoever it was) was by
no means the first such partner. As Enid expresses it agonisingly:

> It [a quarrel] was about a woman. I had learnt, on reliable informa-
> tion, that my husband had been enjoying a liaison with this woman. I
> told him that I knew. I reminded him of promises he had made before. I
> asked him to put an end to his intimacy with this woman. He was very
> angry. Angrier, I think, than I had ever seen him before. He accused me
> of having had him spied upon, and I admitted the accusation. He threat-
> ened—he threatened— (74)

But there is more. Brunton had also had affairs with the mother of one of
his houseguests (who had then killed herself) and also with a houseguest
and friend of his wife, Mary Lamont. In one sense these various philander-
ings are meant to spread the net of suspicion to the various occupants of
the house, but they also play a role in the final solution; for it turns out that
Violet Burrage was also one of Brunton's mistresses. Alas! MacDonald (or
Gethryn) is not much of a feminist, for Gethryn declares that Violet Burrage
was "one of those unhappy young women with an abnormally unpleasant
exterior, an abnormally uninteresting personality, a subnormal education so
rudimentary that her mind can find no solace for her bodily troubles, and an
abnormal sex impulse" (234). Crazed by Brunton's dalliance with the much
more attractive Mary Lamont, she kills him and tries to throw suspicion on
her rival!

The Choice (1931; US title *The Polferry Riddle*) is similar to *The Maze*
in that the setting—a house located in a remote part of England—artificial-
ly sets up a scenario where only the occupants of the house could have com-
mitted the crime, in this case the murder of one Eve Hale-Storford; and in-
evitably, there are an abundance of suspects: Eve's sister, Miriam Rossiter;
a college friend, Susan Kerr; George Anstruther, a cousin of Eve's husband,
Dr. Richard Hale-Storford; Dorothy Graye, the housekeeper; and Dr. Hale-
Storford himself, who had been married to Eve for only six months. On top
of that, two friends of Hale-Storford, Percy Banner and Ralph Trenchard,
conveniently show up on the night of the murder and provide him with a
seemingly unbreakable alibi.

Our attention, however, is at once directed to both the manner of death—
Eve's throat is cut, but the weapon cannot be found—and with the alarming
number of people who are subsequently killed (Anstruther, Miriam) or who
are threatened with death (Susan). And yet, Gethryn—who investigates the

case in conjunction with Superintendent Arnold Pike—concludes startling-
ly, in regard to the several "accidents" that Susan experiences: "All I was
doing was to show you, in effect, that in all probability—in so much prob-
ability that we must, at least at this stage, take it as certainty—the murderer
of Eve Hale-Storford did *not* cause the *accidents*" (383–84). This remark, as
we shall see, is in fact highly misleading.

Initially suspicion falls upon Hale-Storford—not for killing his wife,
but for taking revenge on Anstruther and Miriam in the belief that one or
the other of them killed her. This hypothesis turns out to be true; but we
are still left with the puzzle of Eve's death. When Susan Kerr is kidnapped,
the culprit proves to be Ralph Trenchard: he had spirited Susan away in the
belief that *she* had killed all the parties in question; but as he talked to her,
he realised that he had made a "ghastly mistake" (430).

At this point, Gethryn and Pike undertake the classic charade of re-
enacting the crime, effecting several different reconstructions of that night's
events that results in the conclusion that Eve in fact committed suicide with
a safety-razor that then conveniently slipped from her hand and fell down
into a crack in the floorboards.

The twists and turns of *The Choice* come at a sufficiently fast pace
to conceal the overall implausibility of the entire scenario. As in Agatha
Christie's mysteries, the idea that *so many people* associated with the initial
event (the death of Eve Hale-Storford) could be killed in a matter of days
is so grotesquely unlikely as to be laughable; but MacDonald's narrative
complexity serves to blind us to this plain fact. Whether the final revelation
of Eve's suicide is a satisfying conclusion is debatable: her character was
insufficiently drawn at the outset to render this conclusion plausible, and
the real interest in the matter is not her psychological motivations but the
unwittingly clever means by which she managed to conceal the fact of her
own suicide.

In *The Nursemaid Who Disappeared* (1938; US title *Warrant for X*)
Gethryn has to share detective duties with Sheldon Garrett, an American
playwright in London who becomes unwillingly drawn into the mystery
by the fact that he overhears two women in a tea shop apparently plotting
some criminal act, possibly involving the kidnapping of a child. Much of
the novel is told from his viewpoint, and MacDonald arranges matters so
that just enough evidence is provided to move the plot along. For example,
although Garrett attempts to follow the ladies to their home, he loses them
in the Underground; but going back to the tea shop, he finds that one of them
has dropped a glove. He takes this glove—which happens to have a bus tick-
et and what appears to be a grocery list—to Gethryn, who performs more
feats of armchair detection by ascertaining that what looks like "L Lamb.
1 Ll. Str." is not a food item but the name and address of a person—a Miss

Lamb who lives on a street beginning with *Ll*. This person is conveniently found, and she tells of a friend, Janet Murch, who is in the employ of Major General Sir Charles Ballister, who has three children. Is Janet planning to kidnap one of them?

The twists and turns in this novel are even more byzantine than in most of the other Gethryn books. The key to the breathless course of events is that, just when various avenues of inquiry seem to be blocked or to have come to nothing, an additional piece of evidence arrives that allows the investigation to continue. For example, at one point a portfolio with unknown contents is sought; it is housed in a railway cloakroom. The police hope to follow the individual who calls for it, but the criminal (a man named Evans) does not go himself, but sends a boy to pick it up for him, and the boy cleverly gives the police the slip. But (implausibly) the police had made a list of the portfolio's contents before it was handed over! A single item on this list—a series of numbers—allows Gethryn to determine that it indicates the arrival of a ship in two days' time. This further allows him to conjecture that Ballister's children are not in fact the targets of the kidnapping, but rather the children of one of two wealthy couples arriving on the ship.

The Nursemaid Who Disappeared contains all manner of murders (three by my count), a suicide, several attempts on the life of Sheldon Garrett and his British girlfriend, Avis Bellingham, the kidnapping of a young girl, and some concluding fisticuffs on the part of Gethryn, Garrett, and Superintendent Pike. It's all great fun—but again, the utter implausibility of the events is concealed from us by the frenetic pace of the narrative. MacDonald shrewdly draws the reader in from the beginning by setting up the initial scenario in the tea shop—a scenario that any of us would wish to pursue if it had befallen us. Who doesn't wish to be the hero in foiling an attempted kidnapping of a child, even if the matter is best left to the police rather than to private citizens or to amateur detectives like Gethryn?

Some of MacDonald's most interesting novels are those that do not involve Gethryn, and they accordingly break the mould of the "cosy" mystery in ways that render his work considerably more interesting than it would otherwise be. *Rynox* (1930; US title *The Rynox Murder Mystery*) is one such case, and it also flexes its muscle as an ingeniously structured mystery story. It begins with an "Epilogue" and concludes with a "Prologue." The epilogue concerns the anomalous *return* of a large sum of money—in cash—to an insurance company, with the notice: *"THIS IS THE BALANCE. THANK YOU VERY MUCH!"* (326). The body of the text concerns the apparent murder of F. X. Benedik, the director of Rynox Unlimited, an investing company. Benedik is found dead of a gunshot wound one evening, and considerable evidence points to a Mr. Marsh, who seems a most unpleasant individual and who made no secret of purchasing a gun earlier that day. Correspon-

dence from Marsh to Rynox indicates that he believes himself to have been the inventor of a synthetic rubber process that Rynox was investing in; so it becomes clear that Marsh is seeking revenge on Rynox and its director. The fact that his hat was found in Benedik's room is also incriminating. And yet, three weeks pass and Marsh has not been arrested, nor even located. Whatever the case, a large sum of money has to be paid to Benedik's heirs in accordance with the insurance policy that Benedik had taken out.

The solution to the mystery is as contrived as the entire framework of the novel—but ingeniously so. The crux of the matter rests upon the fact that *Benedik is Marsh*. Benedik has been diagnosed with incurable cancer, but his death is not imminent; in the meantime, his company needs a temporary influx of cash. He cannot take his own life, because in that event the insurance company will not pay the nearly £300,000 of the policy, so Benedik has to arrange his death such that it looks like murder. He does so, but then (in a long letter that forms the prologue) instructs his son to return the money to the insurance company, as the temporary infusion of cash has solved the company's difficulties.

That letter also tells of the clever way in which Benedik arranged his own death, part of which involves tying a bit of string to a tree and to a gun, and so on and so forth. Part of the letter actually written in three columns, outlining the time of every planned event in the fabricated murder, along with "remarks" by Benedik. The likelihood that such a deception could have been carried out in the manner outlined is so remote as to take us into the realm of fantasy; but the readers of mysteries of this sort are not concerned with realism, only with ingenuity. And *Rynox* certainly provides enough of that.

A very different type of work is *Mystery at Friar's Pardon* (1931; US title *Escape*), written under the Martin Porlock pseudonym. This is nothing less than a thriller in the manner of Edgar Wallace, and a most engaging one. It is entirely focused on Peter Craven, who tells the breathless story in the jaunty, "masculine" manner of Rudyard Kipling ("I have always been fond of horses, women, dogs, whisky, and Peter Craven" [207]). Once again, the story is implausible in the extreme, but it is one that any reader thirsting for adventure would give much to have been involved in.

Down and out in London, Craven, starving and desperate for money, makes his way into a prosperous-looking house, consumes much food and drink, and promptly falls asleep. Waking up, he finds himself in the presence of a young woman—she appears frightened, but oddly enough not of him. Instead, she leads him to a library, where there is a dead man—her stepfather, Armitage, who has been murdered. An ordinary person would no doubt have thought that the stepdaughter—who doesn't reveal her name, Frances, until well along in the narrative—was the culprit; but of course this

would not allow for the thrilling series of events to follow, so we put that possibility out of our minds at once.

Craven, ever the chivalrous hero, puts the body into a taxi, pretending that both he and it are drunk, and deposits it in a telephone booth far from the house. Imagine his consternation, then, when he returns to the house and finds the body is there again! Someone—presumably the actual murderer—must have witnessed the whole thing and brought the body back. Frances informs Craven that Edgar Marriott, a friend of her stepfather's, had a key to the house and also knew that the servants would be away all weekend. Could Marriott be the killer? But when Frances and Craven leave the house to buy him some suitable clothes, they return to find the police—and Marriott—at the house. At this point, they flee in a succession of stolen cars. It is only when they are in the temporary safety of an inn in a small town that Frances admits to Craven:

> "There's something *wrong* with me! I think, perhaps, I might say there *was* something wrong with me. When I was a child I used to have fits of rage—I don't mean 'bad temper,' I mean *rage.* I usen't to know what I was doing or even what I'd done. . . . And what's more—much more—is that . . . in the morning of yesterday, I had a violent row with—with my stepfather." (264–65)

Well, this is a pretty kettle of fish! But by this time we have gained so much sympathy for Frances's plight that the prospect that she herself is the murder remains nil.

The couple make their way to the house of Armitage's younger brother, Ned, who proves to be absent. They go back to the house of a man, Allwright, whose daughter they had saved from an attack by a dog, and who therefore—although he has heard of a couple just like them who are on the run—expresses sympathy for their plight. If there is any detective in the case, it is Allwright, although at the outset he seems nothing more than a nosy neighbour with a penchant for armchair detection. He concludes that the murderer planned the crime in order to implicate Frances, probably to secure Armitage's great fortune. Could the criminal be Armitage's older brother, Lionel? But he appears to be in Australia.

At one point Allwright appears to betray the couple, as Craven, hiding out in a hut on Ned's property, sees Frances and Allwright in a police car. But Allwright later convinces Craven that he is still on his side. Disguising him, he takes Craven to meet Ned's manservant, whom they pressure into revealing that Ned is in fact the murderer. Ned conveniently kills himself, and Frances and Craven inevitably marry. Allwright, for his part, proves to be a police superintendent recovering from his injuries.

There is not the slightest depth or literary interest in *Mystery at Friar's*

Pardon, but as a fast-paced, action-packed thriller it is undeniably successful. Both the rugged Peter Craven and the more complex Frances—frightened but full of perhaps justified rage at her stepfather—are well realised characters. But the relentless focus of the novel on them diminishes our awareness of any of the subsidiary players, to the degree that MacDonald's attempt to shift suspicion from one character to the next is unsuccessful; we are not, fundamentally, concerned with *who* killed Armitage so long as it proves not to have been Frances.

A much later book, *Guest in the House* (1955), shows how far MacDonald had come since his early days as a perhaps too prolific writer of mystery/suspense tales. Set in the imaginary town of Arthuria, in southern California—where MacDonald himself had settled since 1931—it concerns Ivor St. George, an Englishwoman who "accidentally" comes to the house of his wartime friend Jeffrey Gould. In fact, St. George is hard up for cash and needs a roof over his head; in his own mind, he plans to stay for several months, relying on Jeffrey's gratitude for saving his life in the war. His presence is markedly irksome to Jeffrey's wife, Mary, but she has other problems: her first husband, Victor Voss, is importuning her for money, although we are initially kept in ignorance on what secret he has over her that would force her to cough up the dough. We learn the true state of affairs in short order: the divorce decree granted Victor the right to gain possession of their daughter, Sandy, for increasingly long periods of time.

MacDonald skilfully portrays the odiousness of Victor Voss in deft strokes: caring little for his own daughter, he is only seeking money to launch various unlikely schemes that will no doubt come to nothing; but his envy for Jeffrey Gould, a moderately successful film and television director, is palpable. In effect, he resents the happiness that his ex-wife has managed to establish with her new husband.

Matters take a turn for the worse when, although Jeffrey expends great effort to raise $20,000 to buy Victor off permanently, Victor rejects the offer because he has managed to woo the celebrated actress Rhoda Tanqueray, and they now wish to marry—and claim Sandy. Private detectives are constantly watching the house to make sure that Jeffrey and Mary don't take Sandy out of state.

It is at this point that St. George, initially portrayed merely as a sponger off of Jeffrey, takes on the role of saviour. He instructs Mary to drop Sandy off with friends (thereby leading the detectives to stake out that house instead of Mary's own); then he encounters Victor, gets him drunk, and leaves him on his boat. St. George comes back later that evening, ties Victor up, and demands that he sign a paper relinquishing rights to Sandy permanently, or else he will set fire to the boat. Victor signs.

With the possible exception of this final episode, no actual crime has

been committed in *Guest in the House*. Victor's own pressuring of Mary and Jeffrey for money could qualify as blackmail, but in fact he is within his rights to threaten to take Sandy away; the real culprit is the divorce decree that Mary unwisely agreed to. But the true merits of the novel do not rest in the incidents, but in the crisply realised characters, each of whom is portrayed vividly with the minimum of descriptive prose. St. George emerges as a man of quiet efficiency and ruthlessness—presumably the qualities that had served him well in the war.

At least three of MacDonald's novels involve mass murderers or serial killers, and they demonstrate both the strengths and the weaknesses of the "cosy" mystery in dealing with a kind of mystery not generally amenable to treatment in the orthodox manner. This is because the frequency of the murders—they usually happen in rapid succession over a period of days or weeks—makes it impossible to establish the elaborate game of shifting suspicion from one character to the next: in most cases, the crimes appear to have been caused randomly, and therefore the victim's close associates are by design not implicated.

The first such novel is *Murder Gone Mad* (1931). It opens tragically with the death of a teenage boy, Lionel Colby, who was returning home to his house in a placid-seeming suburb, Holmdale. Soon thereafter the police receive a short message from the apparent murderer, signed "The Butcher." In quick succession two young women are killed. Arnold Pike, investigating, wants Gethryn's help, but the latter declines; as one character notes:

> it's not in his line, and you know it. This isn't a job for a man so much as a job for an organization. When you can't find a motive—in fact, when there *isn't* a motive, you're dealing with some form or other of lust-killing; and to pick a lust-killer—who may be, on the surface, a most ordinary, respectable citizen—out of a crowd of six thousand citizens isn't a job which can be done by deduction. It's got to be done by massed police work, cleverly directed. (205)

This is a fairly cogent rationale for what proves to be a competent police procedural mystery, but the novel has other flaws that vitiate its overall effectiveness. In the first place, as the murders mount, MacDonald makes feeble attempts to implicate various individuals peripheral to one or the other victim—Percy Godly, the boyfriend of one of the early victims; a Dr Reade, whose female assistant first disappears and then is found dead; and so on. None of these suspects is at all a plausible culprit for *all* or even several of the murders.

But the overriding problem with *Murder Gone Mad* is MacDonald's failure to realise the deep psychological malady that a serial killer must have in order to commit such crimes. He seems to imagine a killer who

engages in the crimes for the fun of it, or for the mere purpose of taunting the police. "The Butcher" continues to send letters to the police, each of them increasingly brazen: first he offers to provide advance warning for his exploits; then he states that he will kill a person the very next day (and does so); and so on. When the murders are finally pinned, interestingly, to a woman—Ursula Finch, editor of a local paper, the *Clarion*—not the slightest motivation for her crimes is supplied, aside from the implication that she happens to like killing people. Finch had been a minor figure in the novel, writing articles that criticised the police's failure to apprehend the criminal; but what could have led her to commit these repeated killings is never probed in the slightest degree.

MacDonald rectifies this deficiency to some degree in *X vs. Rex* (1933; US title *Mystery of the Dead Police*), written under the "Martin Porlock" pseudonym. Here the victims are all policemen, so one would infer that the perpetrator (labelled X by the police and the press) is someone who feels he/she has been wronged by the police or by law enforcement in general. Moreover, MacDonald provides some insight into the killer's motivations by periodically printing extracts from his/her diary. One of the early entries in this diary suggests that the murders are related to something involving a woman named Elsie. Could the policeman have taken Elsie away from the murderer? After several more policemen are killed—one by the murderer disguised as a policeman—the authorities become alarmed, believing that the credibility of the entire police force, and of legal and political authority in general, is at stake.

The narrative focuses on Nicholas Revel, a man-about-town whose very name suggests that he is engaging in this detection largely as a lark. He works in conjunction with Sir Christopher Vayle, a young man whom he saved from being implicated in one of the early murders. Revel engages in the ingenious plan of writing a letter as if by the murderer and planting it in the newspapers, as a way of snuffing out the real killer. He also plants another story in which a policeman named Ernest Biggleswade claims that he is unafraid of the killer and on two occasions has nearly captured him. A photo of Biggleswade—in fact, of Vayle—is published, again as a way of luring the killer to take a potshot at him. The killer does in fact make the attempt; it is unsuccessful, and he flees, pursued by Revel. They engage in suitable fisticuffs in a hotel room before Revel shoots him with his own gun. The culprit's identity—although at this point it hardly matters—is one John Summerlees, whose "girl-wife" Elsie had been seduced by a policeman.

In *X v. Rex* MacDonald succeeds a bit better in portraying the murderer as a crazed—or at least a seriously disturbed—individual. Right from the start his work is compared to that of the most notorious of British serial killers: "Like a Jack the Ripper job" (48). The killer's diary entries attempt

to portray him as intemperate, irrational, and perhaps insane. Consider the following, when the killer hears a friend saying that X has been captured:

> But that fat, red-faced fool with his silly lies got my goat. It's such impertinence for one thing to go about saying that they've got X. X is me, isn't he? And they haven't got me, and never will!
>
> By god, I'll show him! I'll show the whole lot of 'em! I had meant to leave another fortnight, but, by God, I won't have this sort of thing! I'll show 'em!
>
> Now what shall I do? Wait while I think. . . . Listen, I'm thinking! You know, if I wasn't so damned angry I should have to laugh. I'll put you away, book, for half an hour while I lie on the bed and think. (155)

This is, in all honesty, a trifle crude and clumsy, but at least MacDonald is coming to realise that crimes of this sort aren't committed just for the fun of it.

MacDonald's final, most celebrated, and on the whole best novel, *The List of Adrian Messenger* (1959), concludes his forays into the serial killer subgenre. The novel effectively links many of the better features of Mac-Donald's earlier novels—the dissection of successive pieces of evidence, the systematic pursuit of leads by the police, the involvement of private individuals in the case, and so on. Gethryn, who seems not to have aged a whit in spite of the fact that he had first appeared in a novel published thirty-five years earlier, assists George Firth of Scotland Yard in the investigation. Firth had been given a list of ten men by Messenger, who had merely wanted Firth to "ask about them" (16). Messenger went on to make a cryptic remark: "It's so big, and so—so *preposterous,* I daren't tell anyone yet" (17). He emphasises that it is not political, sparing us the unappealing possibility that he has "uncovered some sort of Communist or Fascist or What-Have-You conspiracy" (17). Messenger boards a plane the next day; it crashes into the ocean, and a witness—a Frenchman named Raoul St Denis, who then becomes involved in the case—conveniently overhears Messenger muttering some incoherent and incomprehensible words before dying.

It is quickly ascertained that at least seven of the men on the list are dead. One man, identified on the list as "J. Slattery," appears to be alive, at which point Gethryn utters the cynical remark, "Living like flies, aren't they!" (39). This person, Jonathan Slattery, is shown the list, but he recognises no one. Only much latter is it revealed that Slattery had a cousin, Joe Slattery, who had died recently. At this point, no one on the list can be definitively ascertained to be alive.

Messenger was a member of the Bruttenholm family—a name that we are helpfully informed is pronounced *Broom.* Our minds immediately go back to one of Messenger's dying utterances: "only one . . . broom left" (22). Is the killer somehow trying to secure the immense Bruttenholm fortune?

But in that case, how could all—or any—of the ten men on the list, all of whom have different surnames, be related to the family? Note that at this point the Bruttenholm/Broom connexion is known to the (astute) reader but not to Gethryn: St Denis, unfamiliar with the eccentricities of British pronunciation, had believed that Messenger had said something about a "brush."

Like *X vs. Rex, The List of Adrian Messenger* provides scattered glimpses of the murderer. Indeed, at one point Firth actually makes passing acquaintance with him. He appears to be an American or Canadian. Once this point is established, the reader becomes attuned to the appearance of Americans or Canadians throughout the novel—and, indeed, in virtually every instance the figure in question proves to be the murderer. His dual purpose—apparently securing the Bruttenholm fortune by inheritance and eliminating the men on the list—becomes clear when a widow of one of the men states that all the men had participated in a secret mission in Burma during World War II, in which they had been betrayed by a Canadian sergeant; and that Canadian's real name is George Brougham, clearly a relative of the Bruttenholms.

The capture of Brougham is effected ingeniously. After he has caused the death of the elderly Marquis of Gleneyre, leaving only the teenage Viscount Saltmarshe and Brougham himself in line for the marquisate, Gethryn spreads the story that the Viscount has left for an extended visit to an estate in California. Sure enough, Brougham goes there, and in a failed attempt to kill the boy he is forced to flee pursuit by Gethryn and others. He apparently drives his jeep over a guardrail to his death; but we are startled to learn that, in fact, Gethryn and others had boobytrapped the jeep so that it exploded.

As with many of MacDonald's other novels, *The List of Adrian Messenger* presents a scenario that is indeed "preposterous," although not in the sense that its title character intended; but again, the pace of the narrative—not quite so frenetic as *Mystery at Friar's Pardon* or *the Nursemaid Who Disappeared*—blinds us to this defect. The fleeting images of Brougham throughout the text effectively create a sense of his utter ruthlessness and single-minded focus on his ultimate goal, while subsidiary characters such as Jocelyn Messenger, Adrian's sister—who conveniently marries Raoul St. Denis at the end—are vividly realised. Although the reader's attention is, for at least half the novel, focused on the list—as the police undertake an increasingly desperate search for any one of the ten men who might actually be alive—it becomes virtually a red herring in the overall scenario.

Philip MacDonald enlivened the "cosy" British mystery with all manner of innovations—the serial killer novel, a rudimentary stab at the police procedural, the thriller, and so on—while remaining true to the form in its

focus on an infallible detective, a reliable group of suspects each of whom could (implausibly) have a plausible motive for killing, and a narrative style that largely focuses on detection rather than character portrayal or broader social and cultural issues. In so doing he displayed both the virtues and the limitations of the "cosy" mystery while also, even if unwittingly, providing halting glimpses of how the form could be superseded. His work fulfils its humble goals of ingenuity and entertainment, and his brisk, lively prose renders his work enjoyable even to present-day readers. If there is little of depth or substance in his novels, that is a criticism that could apply equally to his better-known contemporaries.

II. THE HARD-BOILED SCHOOL

DASHIELL HAMMETT: SAM SPADE AND OTHERS

Dashiell Hammett (1894–1961) is the first writer of what came to be called the hard-boiled detective story to attain widespread celebrity. And yet, he is a most unlikely figure to have become a literary icon. Born on a farm in southern Maryland, he left school at the age of thirteen and eventually took up work for the Pinkerton National Detective Agency (1915–22)— work that provided invaluable background and source material for the tales he began writing very soon after he left the agency. Beginning in 1922 he wrote a brace of short stories, novelettes, and novellas in the pages of *Black Mask* and other detective pulp magazines, then produced five novels in quick succession, published between 1929 and 1934, of which *The Maltese Falcon* (1930) is far and away the most notable. Although his literary career petered out after this time, his work left an indelible imprint on the detective story; and it is not too much to say that virtually every subsequent writer of hard-boiled fiction owes more than a little to him.

I do not gain a sense from Hammett's early short stories that he had any particular axe to grind against the "cosy" mystery story. In part this was because that subgenre had scarcely established itself when he began writing: Agatha Christie's first novel was published in 1920, Dorothy L. Sayers's in 1923, and John Dickson Carr's as late as 1930, whereas Hammett's first tales began appearing in *Black Mask* in late 1922. Even the relatively late document "Suggestions to Detective Story Writers" (1930) is chiefly devoted to recommending precision in the matter of various types of firearms and certain mundane details regarding policemen, Federal agents, sheriffs, and so forth. Only a single comment—"Even detectives who drop their final g's should not be made to say 'anythin'"—an oddity that calls for vocal acrobatics" (*CS* 911)—can be taken as a snide remark (in this case, directed clearly against Sayers's Lord Peter Wimsey), while one other comment—"'Youse' is the plural of 'you'" (*CS* 911)—is the slightest possible nod to Hammett's own use of the *sermo vulgaris* in contrast to the standard, or even highbrow, English of Christie, Sayers, and others.

Indeed, the core of some of Hammett's early short stories feature a mystery element not entirely dissimilar to that of his more orthodox col-

leagues. Mistaken identity is at the heart of "Arson Plus" (*Black Mask,* 1 October 1923) and "Zigzags of Treachery" (*Black Mask,* 1 March 1924). The young woman Audrey Gatewood who, as it turns out, contrives her own fake kidnapping in "Crooked Souls" (*Black Mask,* 15 October 1923) would not be entirely out of place in a "cosy": daughter of a wealthy and ruthless businessman, she seeks the $50,000 ransom money as a means of getting away from her father and starting a new life. "The Golden Horse-shoe" (*Black Mask,* November 1924) also focuses on an elaborate case of mistaken identity—or, rather, of an Englishman, Norman Ashcroft, who killed himself in a hotel room, whereupon another man adopts his identity. As in the classic "cosy" mystery, this revelation occurs toward the end of a virtual short novel that otherwise has the hapless private detective trudging from San Francisco to Tijuana to Seattle and back again in search of the elusive solution to the case.

"Women, Politics and Murder" (*Black Mask,* September 1924) displays a surprisingly orthodox examination of eyewitness testimony that would not be at all out of place in mysteries of a very different sort—perhaps not exactly the "cosies," but more along the lines of a Perry Mason mystery. (It should be noted that Erle Stanley Gardner himself was a prolific contributor to *Black Mask* before he began writing the Perry Mason mysteries in the early 1930s.) The analysis reveals surprisingly that, since both of the women who are suspects in a murder were on the sidewalk at the time the victim was killed and both saw no one but the policeman, the policeman himself is the culprit.

But it would be misleading to overstate the resemblance, either in plot or in overall ambiance, between the Hammett hard-boiled mystery and the "cosy" mystery. The fundamental distinction between the rather frivolous and usually well-bred amateur detective of the Poirot or Miss Marple sort, who always happens to be conveniently on the scene when a murder (and it is almost always a murder) takes place, and the tough, professional "private investigator" who is explicitly called in—and always for a fee—by a specific client to investigate a specific crime (usually *not* murder, although plenty of violence or killing—sometimes by the investigator himself—occurs) is evident on every page. The crimes in question are either of a lesser sort than murder or are not crimes at all: kidnapping, arson, the fleeing of a spouse or child from a household for unspecified reasons, and so on.

The investigator in the great majority of Hammett's short stories, the nameless, virtually faceless Continental Op—an employee of the San Francisco office of the Continental Detective Agency—is an interesting mix. The first-person narration of all the stories sets the tone for the subsequent work of Chandler, Macdonald, and other hard-boiled writers, but the Continental Op is at pains to emphasise his bland, even unappealing exterior. In

"Arson Plus" he flatly declares himself "a busy, middle-aged detective" (*CS* 12)—a comment explicitly made to explain his lack of appeal to (and his own lack of interest in) an attractive woman character in the story. In "The Girl with the Silver Eyes" (*Black Mask,* June 1924) a woman with the seductive name of Elvira addresses him tartly: "Little fat detective whose name I don't know . . ." (*CS* 187). But at the same time he is keen on underscoring his own toughness in a tough world:

> You hear now and then of detectives who have not become callous, who have not lost what you might call the human touch. I always feel sorry for them, and wonder why they don't chuck their jobs and find another line of work that wouldn't be so hard on their emotions. A sleuth who doesn't grow a tough shell is in for a gay life—day in and day out poking his nose into one kind of woe or another. ("The Golden Horseshoe"; *CS* 238–39)

This may not be quite as poetical as Chandler's celebrated comments about "mean streets," but it gets the same point across.

And yet, the Continental Op does not always reveal himself to be entirely immune to feminine charms. In "The Girl with the Silver Eyes" the character of Elvira is resurrected from the earlier "The House on Tuck Street" (*Black Mask,* 15 April 1924), where she was involved in a killing but escaped. Now she becomes entangled in another sordid series of crimes— murder, forging bad checks, and the like. As the Continental Op laboriously subdues her and carts her off to jail, she makes one last attempt to seduce him—not entirely as a calculated ploy to escape from paying the penalty for her crimes, but to preserve a shred of her pride. But the Continental Op doesn't bite:

> Her lids had come down half over the silver-grey eyes, her head had tilted back so far that a little pulse showed throbbing in her white throat; her lips were motionless over slightly parted teeth, as the last word had left them. My fingers went deep into the soft white flesh of her shoulders. Her head went further back, her eyes closed, one hand came up to my shoulder.
> "You're beautiful as all hell!" I shouted crazily into her face, and flung her against the door. (*CS* 188)

And it is perhaps not entirely uncharacteristic that, in "The Gutting of Couffignal" (*Black Mask,* December 1924), the Continental Op cannot bring himself actually to shoot a woman—in this case a Russian princess— who is urging another man to kill him. The Continental Op disables the man and, as the princess boldly walks out of the room, daring the Op to shoot her, he at last does so—but only in the calf. "I had never shot a woman before. I felt queer about it" (*CS* 482).

It is, however, rare that a Hammett short story features much explicit

sex or even the suggestion of sex. (We will find that the novels are signifi-
cantly different in this regard.) Whether this has to do with strictures against
overuse of sex in *Black Mask* and other detective pulps or with Hammett's
own progression as a writer is unclear. One exception in the stories is "The
Scorched Face" (*Black Mask,* May 1925), where sex—or at least pornog-
raphy—is the core of the plot. The case starts out as one involving either
kidnapping or merely the sudden and unexplained departure of two young
women, aged eighteen and twenty, from the house of a prosperous business-
man in San Francisco; it eventually focuses on a house of dubious repute
on Telegraph Hill filled with people of all sorts, some naked. After some
gunplay, a "queer little dead man" (*CS* 387) is identified as one Hador, the
leader of a mystical sex cult who has been blackmailing the young women.
The Continental Op goes to considerable effort—including persuading a
colleague to claim that he, and not the Op, shot Hador and that one of the
women was never there, lest her involvement in the cult be revealed—to
destroy evidence relating to the cult, including the burning of hundreds of
compromising photographs. It is one of the relatively rare instances where
the Op ventures into illegality—in this case chiefly, if not exclusively, to
protect the reputations of any number of women.

The Op establishes the ethos of the prototypical hard-boiled detective
by acknowledging that he is a grunt working in a tough profession with little
in terms of monetary gain to show for it; but in one instance he takes pride
in his lowly status by resisting a bribe—on the rationale that he doesn't
know any other line of work and actually enjoys what he does:

> "Now I pass up that twenty-five or thirty thousand of honest gain
> because I like being a detective, like the work. And liking work makes
> you want to do it as well as you can. Otherwise there'd be no sense in it.
> That's the fix I am in. I don't know anything else, don't enjoy anything
> else, don't want to know or enjoy anything else. You can't weigh that
> against any sum of money. Money is good stuff. I haven't anything against
> it. But in the past eighteen years I've been getting my fun out of chasing
> crooks and tackling puzzles, my satisfaction out of catching crooks and
> solving riddles. It's the only kind of sport I know anything about, and I
> can't imagine a pleasanter future than twenty-some years more of it. I'm
> not going to blow that up!" ("The Gutting of Couffignal"; *CS* 478–79)

That fondness for "chasing crooks and tackling puzzles" may actually ren-
der him not all that distant from the amateur detective of the "cosies," but
one suspects that the latter would reverse the formulation.

The Continental Op's relations with the police are not nearly as ad-
versarial as those of Chandler's Philip Marlowe or even of Macdonald's
Lew Archer, and on any number of occasions he works with them—and,
indeed, with other members of his own agency. Indeed, in one striking in-

stance—"$106,000 Blood Money" (*Black Mask,* May 1927)—a fellow op is himself the culprit. The story is a sequel to "The Big Knock-over" (*Black Mask,* February 1927), where a criminal mastermind named Papadopoulos escapes justice at the end. There is now a $106,000 reward for his arrest. The Continental Op thinks he has tracked him down to a house in Sausalito and brings in a colleague, Jack Counihan, to seize him. In the end the Op determines that Counihan is himself part of Papadopoulos's gang and has tried to double-cross him. Counihan tries to shoot the Op but is killed by another man, who is in turn killed by another operative. The effect of the story—putting aside the extensive gunplay—is analogous to the identification of the "amateur detective" in a "cosy"—or at least some colleague of the detective—as the criminal.

A late story, "Two Sharp Knives" (*Collier's,* 13 January 1934), features something of the same idea. A man, Lester Furman, wanted for murder is arrested in a small town but then dies in jail, apparently by suicide. But small bruises are found on Furman's head, leading the police chief to suspect that Furman was murdered. The upshot is that one of the chief's own men killed Furman with the idea of marrying his widow and securing control of her inheritance. But the story is sketchy and contrived, and resolved too easily.

If the characters with whom the Hammett detective (and Hammett explicitly states in his 1930 essay that he is still writing "detective stories" [*CS* 910]) are generally kidnappers, fortune hunters, stick-up men, and all manner of low- or high-level gangsters, it may only reflect the kind of characters Hammett himself encountered as a Pinkerton and therefore those whom he felt comfortable writing about. There is no overt suggestion of an immense class distinction between the wealthy upper crust (who would naturally be the victims of kidnapping, extortion, and the like) and the lowlife who seek to prey upon them; nor is there much of the hostility toward the former that animates much of Chandler's work.

One inevitable consequence, however, of the prevalence of professional criminals—and their professional antagonists in law enforcement, whether private or official—is an increasingly high level of overt violence in Hammett's short stories. It is this that probably most clearly distinguishes his work, novels and stories alike, from the British "cosy" tradition. In the latter, the murders usually take place off stage, since the crux of the "whodunit" is concealment of the identity of the murderer until the amateur detective assembles the evidence to expose him or her. In Hammett, especially in those stories that feature a substantial number of hoodlums or gangsters, death and injury are visible for all to see.

The tendency may begin with "The House on Tuck Street," which not only features the Continental Op being tied up, freeing himself, and killing

a man, but also a Chinese man killing an elderly couple whom he had tried to double-cross. There are shootouts aplenty in "The Girl with the Silver Eyes"; and although the Op tactfully notes that "I didn't want to kill him, but I wanted to put him out of the way quick" (*CS* 179), he in the end does kill a man. It would be inconceivable for a Poirot or Lord Peter Wimsey to shoot a man even in the heat of a gun-battle—although we have seen Wimsey, Gideon Fell, and others quietly allow a murderer to kill himself to save face.

"Nightmare Town" (*Argosy All-Story Weekly,* 27 December 1924) features an almost grotesque level of violence, given that we are facing an entire town built on crime and corruption—bootlegging, insurance fraud, and the like. As one character blandly puts it: "Everybody is trying to slit everybody else's throat" (*CS* 303). This is not a Continental Op story, but a third-person narrative featuring one Steve Threefall, who happens to be in the town of Izzard by accident and manages to get out of it with a nice young woman named Nora. But before that happens he has to run a grim gauntlet:

> Steve dropped on a knee beside him, but he knew nothing could be done—knew Brackett had died while still on his feet. For a moment, as he crouched there over the dead man, something akin to panic swept Steve Threefall's mind clean of reason. Was there never to be an end to this piling of mystery upon mystery, of violence upon violence? He had the sensation of being caught in a monstrous net—a net without beginning or end, and whose meshes were slimy with blood. Nausea—spiritual and physical—gripped him, held him impotent. (*CS* 295)

The next paragraph—the laconic "Then a shot crashed"—indicates that the struggle is not over.

By the time we come to "The Gutting of Couffignal," the level of violence seems tantamount to that in contemporary action films. The story takes place on an island off the coast of southern California, where the Continental Op is brought in for the seemingly mundane purpose of guarding presents at an exclusive wedding. But explosions and gunfire at night suggest that a bank has been broken into—and the Op discovers that a criminal gang is using machine guns and hand grenades (!) to break into the bank. And this is the story, let us recall, where the Op exhibits a certain squeamishness in shooting a female criminal in something approximating cold blood, even though he would be legally justified in doing so to prevent her escape.

The violence continues in "The Big Knock-over," where an informer tells the Continental Op that the Seaman's National Bank is going to be robbed—and is killed moments later. The next morning, both that bank and the Golden Gate Trust Company are broken into with explosives by a mob

involving an incredible one hundred and fifty criminals. Some days later, a house in Fillmore Street is found to have fourteen dead crooks—either poisoned or shot. Some men who had gone to the house and then left are later found in another house—dead. One man has even written a note on the wall in his own blood. One develops the impression that Hammett's *Black Mask* readers demanded increasingly higher doses of violence to stimulate their jaded senses; but some of it is so over-the-top as to enter the realm of fantasy and militate against the gritty realism that was, in some sense, the very *raison d'être* of the hard-boiled crime story as distinguished from the acknowledged artificiality of the "cosy" mystery.

"The Gutting of Couffignal" involves some foreign players—a Russian general and princess and a parolee from Italy—that sets the stage for one of the oddest of the Continental Op stories, "This King Business" (*Mystery Stories,* January 1928). Here we find the Op in the Balkans, where a young American, Lionel Grantham, wants to secure $3 million to wage a revolution that would make him king—and, in fact, he makes a reasonably sound case for such a thing. A bloodless revolution occurs and Grantham is crowned Lionel I. There are some further adventures, but one gains the faint sense that this story is something of a parody.

Aside from overt gunplay, the chief means by which the Hammett hard-boiled story differs from the "cosy" mystery is its workingman's prose. Given that Hammett was something of a self-taught writer, it would be difficult to pinpoint any specific literary influences that led him to adopt the austere, clipped prose that dominates his work. It is customary to call it Hemingwayesque, but Hammett was older than Hemingway and the latter's first book only dates to 1923, after Hammett had already begun writing; whether Hammett read Sherwood Anderson (*Winesburg, Ohio,* 1919) and other writers who pioneered this style is not clear. Since it is apparent that Hammett wrote about the lowlife characters he had encountered as a Pinkerton, it is unsurprising that, from the very beginning of his career, we find him using a pungent slang that would have induced apoplexy in Christie or Sayers but that has now become almost hackneyed: "If Clane tries to blow town, grab him and have him thrown in the can" ("Slippery Fingers"; *CS* 28). And yet, it would be inaccurate to say that Hammett's style is entirely shorn of prose-poetry, as this incredible description of a man in a bar attests:

> Across the table a man stood glaring at me—legs apart, fists on hips. He was a big man, and ugly. A tall, raw-boned man with wide shoulders, out of which a long, skinny yellow neck rose to support a little round head. His eyes were black shoe-buttons stuck close together at the top of a little mashed nose. His mouth looked as if it had been torn in his face, and it was stretched in a snarl now, baring a double row of crooked brown teeth. ("The Golden Horseshoe"; *CS* 244)

This passage would not be out of place in Chandler's work. But on the whole it might be said that Hammett's Attic prose was something of a fortuitous accident—harmonizing perfectly with the kind of tough-guy scenario he habitually featured but not calling attention to itself as an explicit contrast to or repudiation of the tony British prose of Sayers, Allingham, and even their followers.

With the passing of years, it becomes evident that Hammett was increasingly dissatisfied with the short story or even the novella as a vehicle of expression. Several later works feature more plot than even a substantial novella could handle and shows Hammett yearning for a broader canvas. Perhaps the first such indication is "Dead Yellow Women" (*Black Mask*, November 1925), which opens when a woman, Lillian Shan, daughter of a man who made money dubiously in China, comes home to find a strange man in her house. She and her maid are tied up, and the maid subsequently dies, along with another servant; two other servants vanish. In the end we are introduced to another man, Chang Li Chiang, who claims to be smuggling guns to battle the Japanese. But the story is scattershot and unfocused, and the plot is manifestly too complex even for a story that runs to 55 pages in the Library of America edition.

Much the same could be said for "The Assistant Murderer" (*Black Mask*, February 1926), a non-Continental Op story involving Alexander Rush, a fantastically ugly private investigator in Baltimore. This story fills nearly 40 pages and involves murder, several attempted murders, a man who has both a wife and a mistress (and a child by her), blackmail, and so on and so forth—not to mention a character with the incredible name of Scuttle Zeipp. The story reads like a synopsis rather than an actual narrative.

In fact, Hammett's first two novels also suffer from an excess of plot, especially the second. Both are Continental Op novels. The first, *Red Harvest* (1929), appeared as a series of four novelettes in *Black Mask* between November 1927 and February 1928 before it was published in book form by Knopf. Blanche Knopf, not surprisingly, objected to the high level of violence in the serialised version, and Hammett did tone this aspect of the novel down a bit—but only a bit.

We are at the outset concerned with the murder of a newspaper owner, Donald Willson, in the town of Personville. Hammett initially makes sporadic attempts to portray the crime in terms of an orthodox murder mystery: Willson's wife is at first suspected because she was out of the house during the time the murder was committed (he died on the street) and returned home with blood on her shoe; some thugs hired by Willson's father, Elihu Willson, a mining company owner whose workers are on strike, are also suspected. But the murder is cleared up less than a third of the way through the novel, as Hammett pulls the culprit—a bank teller named Robert Al-

bury who confesses to the crime—out of a hat.

Hammett's manifest focus, as in the story "Nightmare Town," is the financial and moral corruption of an entire town. Elihu Willson proclaims loftily to the Continental Op, "I want Personville emptied of its crooks and grafters" (*CN* 38), but he seems as much involved in the corruption as anyone else. The Op proposes to Willson that he and his agency will clean up the town for $10,000. But a crooked police chief, Noonan, warns the Op at one point: "I think you're pretty good, but I'm damned if I think you're good enough to crack this camp. It's too tight" (*CN* 61).

It would be profitless to pursue the variegated twists and turns of the plot, but both the Op and others make it quite clear not only that violence is endemic to Personville but that the killing is unlikely to stop. About two-thirds through the novel, the Op has already tallied up sixteen people who have been killed (*CN* 135). More troublingly, the Op himself seems to have gained a fondness for killing. Referring to Elihu Willson, he states:

> "I could have gone to him this afternoon and showed him that I had them ruined. He'd have listened to reason. He'd have come over to my side, have given me the support I needed to swing the play legally. I could have done that. But it's easier to have them killed off, easier and surer, and, now that I'm feeling this way, more satisfying. I don't know how I'm going to come out with the Agency. The Old Man will boil me in oil if he ever finds out what I've been doing. It's this damned town. Poisonville is right. It's poisoned me." (*CN* 137)

At a later date, the Op himself is suspected of murder and a warrant is put out for his arrest. With the Op in tow, a bootlegger named Reno Starkey uses guns and bombs to subdue some thugs. At the end the Op confronts Elihu and states that all his enemies are dead; but he must demand that the mayor or governor suspend the entire police department and bring in the National Guard to clean up the town. But Hammett cannot resist a final twist that pulls several more rabbits out of the hat, showing a man who was thought to be killed to be still alive and identifying the murderer of a woman, Dinah Brand, who had been working with the Op to clean up the town.

The Dain Curse (1929) is, if anything, even more violent than *Red Harvest,* and its byzantine plot renders it something of a pseudo-realistic fantasy of death and carnage, with some quasi-supernatural episodes to boot. This novel was also serialised in *Black Mask* (November 1928–February 1929) before being published by Knopf. Here the excess of plot fractures the novel approximately a third of the way through, where the initial mystery appears to have been solved, only to gear up again for further entanglements. The theft of diamonds from a chemist, Edgar Leggett, opens the way to an investigation of Leggett's sordid past. For it turns out that Leggett is in fact

a Frenchman named Mayenne who married one Lily Dain, who bore him a child, Gabrielle; but Leggett really loved Lily's sister Alice. Leggett apparently killed Lily, was convicted and sent to a French prison, but escaped to the United States; Alice and Gabrielle joined him later, and Leggett later married Alice.

Leggett himself dies, apparently by suicide, but the Op accuses Alice of killing both her sister and Leggett; she initially says that Gabrielle killed Lily by accident with a pistol at the age of five, then later admits that she had trained Gabrielle to use the gun to kill Lily. In a subsequent tussle with the police, Alice herself is killed. The case now seems over, but later the Op receives a message: "The Leggett matter is active again" (*CN* 249). And so the novel must re-energise itself, this time focusing on Gabrielle.

In a scenario somewhat reminiscent of "The Scorched Face," we learn that Gabrielle has fallen under the influence of a cult called the Temple of the Holy Grail, operated by a married couple, Joseph and Aaronia Haldorn. The Op and Gabrielle's boyfriend, Eric Collinson, had already rescued Gabrielle from their clutches once, but she finds her way to the place again; and when the Op and Collinson go there to confront her, they come upon a startling sight:

> Gabrielle Leggett came around a corner just ahead of us. She was barefooted. Her only clothing was a yellow silk nightgown that was splashed with dark stains. In both hands, held out in front of her as she walked, she carried a large dagger, almost a sword. It was red and wet. Her hands and bare arms were red and wet. There was a dab of blood on one of her cheeks. Her eyes were clear, bright, and calm. Her small forehead was smooth, her mouth and chin firmly set. (*CN* 261)

It would seem that she has killed one Dr. Riese, who is involved with the Temple; but as the focus of the reader's sympathy (if there is one), Gabrielle cannot be a murderer, and so it is no surprise that the Op ascertains in due course of time that Riese was killed by Minne Hershey, a maid recently hired by Leggett and who also is an underling of the Haldorns.

There is much, much more to *The Dain Curse* than all this—Eric Collinson, who has hastily married Gabrielle, is himself killed (but, of course, Gabrielle is not his murderer); the actual murderer, one Harvey Whidden, is himself bumped off—and there is even one bizarre pseudo-supernatural episode in the Temple where the Op comes upon some kind of spectre:

> Not more than three feet away, there in the black room, a pale bright thing like a body, but not like flesh, stood writhing before me.
>
> It was tall, yet not so tall as it seemed, because it didn't stand on the floor, but hovered with its feet a foot or more above the floor. Its feet—it had feet, but I don't know what their shape was. They had no shape, just

as the thing's legs and torso, arms and hands, head and face, had no shape, no fixed form. They writhed, swelling and contracting, stretching and shrinking, not greatly, but without pause. (*CN* 269)

There is considerably more to the vision than this; but it is so obviously either a hallucination or (in the manner of the "weird menace" pulps of the day) a piece of trickery that it is difficult to take it seriously; and indeed, it is revealed as a charade at the end.

If there is any aesthetic value to *The Dain Curse,* it is the Op's stern but sympathetic lecture to Gabrielle that she is not somehow "cursed" because she is a Dain. Here Hammett addresses vital issues regarding childhood trauma, notions of familial "degeneracy," and so on. Much of this discussion is psychologically sound and rhetorically effective:

> "Take my word for it, you're sane. Or don't take my word for it. Look. You got a hell of a start in life. You got into bad hands at the very beginning. Your step-mother was plain poison, and did her best to ruin you, and in the end succeeded in convincing you that you were smeared with a very special family curse. . . .
>
> "If you aren't normal, it's because you're tougher, saner, cooler than normal. Stop thinking about your Dain blood and think about the Mayenne blood in you. Where do you suppose you got your toughness, except from him? . . . Physically, you take after your father, and if you've got any physical marks of degeneracy—whatever that means—you got them from him." (*CN* 342–43)

But this passage is so overwhelmed by baroque levels of violence and implausible plot twists that it is virtually buried. And Hammett cannot resist pulling one final rabbit out of the hat, whereby a writer named Owen Fitzstephan acquainted with both the Op and Leggett is somehow identified as the mastermind behind all the novel's events, as the Op explains in a laborious manner in the penultimate chapter.

Given Hammett's difficulties in the novel form, as exemplified in *Red Harvest* and *The Dain Curse,* it is more than surprising that he could have produced such a masterwork as *The Maltese Falcon* (1930). It is not too much to say that this work remains the exemplary hard-boiled detective novel, surpassing all the novels of Chandler, Macdonald, Ellroy, and others. Like his two previous novels, it too was serialised in *Black Mask* (September 1929–January 1930) and published in book form soon thereafter.

We must make considerable effort to forget the imperishable 1941 film—perhaps also the first and most notable exemplar of film noir—for the book differs from it in several significant regards, even though the film faithfully conveys the essence of the novel's plot as well as several of its more notable lines ("You're good. You're very good" [*CN* 419]). In the first

place, Sam Spade is a considerably more sinister figure than in Humphrey Bogart's portrayal. The opening paragraph is striking:

> Samuel Spade's jaw was long and bony, his chin a jutting v under the more flexible v of his mouth. His nostrils curved back to make another, smaller, v. His yellow grey eyes were horizontal. The v *motif* was picked up again by thickish brows rising outward from twin creases above a hooked nose, and his pale brown hair grew down—from high flat temples—in a point on his forehead. He looked rather pleasantly like a blond satan. (*CN* 391)

Secondly, it becomes abundantly clear that Spade is something of a ladies' man: there is no doubt not only that he has been carrying on an affair with the wife of his partner, Miles Archer, but also that he regularly sleeps with his secretary, Effie Perrine; he also sleeps with the seductive client, Brigid O'Shaughnessy, who initiates the Maltese Falcon case. Chapter 9 ends: "Spade's arms went around her, holding her to him, muscles bulging his blue sleeves, a hand cradling her head, its fingers half lost among red hair, a hand moving groping fingers over her slim back. His eyes burned yellowly" (*CN* 467). Chapter 10 opens: "Beginning day had reduced night to a thin smokiness when Spade sat up. At his side Brigid O'Shaugnessy's soft breathing had the regularity of utter sleep" (*CN* 468). So it comes as no surprise that, at a critical moment later on in the novel, Spade makes her strip naked in a bathroom to make sure she is not carrying a missing $1000 bill (*CN* 565).

What Hammett has learned from his two previous false starts in the novel form is that violence must be curtailed—that, in this case, less can be more. It is true that three or four people meet their deaths in the course of the novel, but each of these deaths is critical to the progression of the plot, and they appear with sufficient intervals of suspense and intrigue that they convey true impact rather than merely shock value. Archer himself is found dead early on in the novel, as he was trailing one Floyd Thursby; soon thereafter Thursby himself is killed. But attention quickly shifts to the location of the statuette of the Maltese Falcon, as Joel Cairo (who is manifestly portrayed as both Jewish and gay [*CN* 425]) offers Spade $5000 for its recovery. The emergence of the "fat man" (*CN* 500), Casper Gutman, enlivens the action, as he elucidates in a long monologue (*CN* 489f.) exactly what the Maltese Falcon is. The only other person who is killed onstage is Captain Jacobi, who memorably stumbles into Spade's office carrying the Falcon and dies on the spot.

The solution of the actual murders—O'Shaugnessy killed Archer (as Spade deduces from the fact that Archer had been killed at close range and without a struggle), and Thursby and Jacobi were killed by Wilmer Cook,

Gutman's bodyguard—is an almost incidental detail in the case, which remains focused on the possession and disposition of the Falcon. In a striking scene, all the principals—Spade, Gutman, O'Shaugnessy, Cairo, and Cook—gather in an apartment to see what to do with the Falcon and how to deal with the crimes that have occurred. Spade blandly offers to "sacrifice" Cook to the police as the murderer of Thursby and Jacobi, and Gutman offhandedly agrees. The incredible cynicism of this episode (lessened, perhaps, by the fact that Spade knows that Cook actually did commit the murders in question) is difficult to equal in the entire range of hard-boiled detective fiction. Not one of the characters appears anything less than corrupt and self-serving.

The final cynical twist—the revelation that the Falcon being sought so long and hard by so many is a fake—is only the capstone of a novel that blandly portrays an array of greedy, crooked, and deceitful individuals all seeking to betray one another if the opportunity presents itself. It is this bleak vision of humanity, far more than the twists and turns of the plot, that gives *The Maltese Falcon* its high place in literature. It is not clear that even Spade remains unscathed. He keeps $1000 (out of the $10,000 that Gutman had given him for securing the bird, and which he demanded back at gunpoint) as his legitimate fee for his work on the case; and, as both Gutman and Cairo cheerfully make plans to return to Constantinople to find the real Falcon, Spade blandly tells the police that Cook's murders were done at their instigation. The novel ends by the news that Cook has killed Gutman, enraged by his double-crossing him.

Whether because of the immense success of the film or not, the figure of Sam Spade has become the prototype of the hard-boiled detective. It is difficult to name a fictional detective of any sort who has appeared in such a small number of literary works—for, aside from *The Maltese Falcon,* Spade figures in only three insignificant short stories written a year or two after the novel. These stories suffer from the same problems that afflict a number of Hammett's other short stories. In "A Man Called Spade" (*American Magazine,* July 1932) the case—which is solved in what seems a matter of minutes after Spade and the police investigate a murder—hangs on Spade's breaking of an alibi of the chief suspect (the murdered man's brother). In "They Can Only Hang You Once" (*Collier's,* November 19, 1932), not one but two murders are pinned on an old and seemingly infirm man—the latter murder committed while Spade is actually on the scene. But the story is far too rushed in its execution and the plot is far too complex for treatment in a relatively short story. "Too Many Have Lived" (*American Magazine,* October 1932) is probably the most successful of these stories, focusing on Spade's hunt for a man who has gone missing and soon turns up dead. But here again, Spade solves the crime in lightning-quick fashion.

In the one novel and three stories that feature him, Spade is by no means an entirely admirable figure, and subsequent hard-boiled detectives did not follow him either in his sexual proclivities or in his readiness to skirt the law for his own benefit; but Hammett was perhaps suggesting that, in a case like that of the Maltese Falcon, only such a figure could emerge victorious amidst such a cadre of knaves and scoundrels.

The lessons Hammett learned in writing *The Maltese Falcon* were quickly squandered in his final two novels, *The Glass Key* (1930) and *The Thin Man* (1934). Amusingly enough, *The Glass Key*—serialised in *Black Mask* (March–June 1930) before appearing in book form late that year—essentially reverts to the formal detective story, albeit with some fleeting and not particularly interesting political asides. The focus is on the murder of Taylor Henry, the son of a senator. The detective, if he can be called that, is one Ned Beaumont, a gambler who, somewhat irritatingly, is referred to by his full name on every single occasion when Hammett cites him. Although scattered suspicion is directed toward Paul Madvig, who is running Senator Henry's re-election campaign, nothing much is made of this nor of the political overtones of the murder. At one point a reporter is killed in a house occupied by a number of the central characters, in what might almost pass as a parody of the standard "cosy" mystery scenario of a murder committed with a convenient number of suspects ready to hand. In the end we are evidently to be surprised at the jack-in-the-box revelation that the senator killed his own son and that Madvig was trying to cover for him.

The Thin Man is a bit better, although whether it should be called a hard-boiled detective novel—and whether Hammett even intended it as such—is very much in question. This was the only one of his novels not serialised in *Black Mask;* an abridged version appeared in *Redbook* (December 1933), but only after Hammett had already finished the full novel. Its charming protagonists, Nick Charles and his wife Nora, have been immortalised in the 1934 film version; the novel is told in the first person by Nick. Nick was formerly a private investigator working in San Francisco for the Trans-American Detective Agency, but is now (1933) retired, enjoying life in New York. When Dorothy Wynant comes to him asking him to find her missing father, the inventor Clyde Wynant—and, more pertinently, when Clyde's secretary, Julia Wolf, is found murdered the next day—Nick is persuaded to come out of retirement.

The details of the well-executed plot need not concern us: in the end the murder both Wolf and Clyde Wynant, who has been dead for months, is pinned on Wynant's lawyer, Herbert Macaulay. What is of greater interest is the substantially lighter tone of this novel as compared with its predecessors. Consider this passage in which Nick and Nora banter with an ex-convict, Studsy Burke:

We sat at a table in a corner and Studsy told the waiter exactly which bottle of wine to bring. Then he examined me carefully and nodded. "Marriage done you good." He scratched his chin. "It's a long time I don't see you."

"A long time," I agreed.

"He sent me up the river," he told Nora.

She clucked sympathetically, "Was he a good detective?"

Studsy wrinkled what forehead he had. "Folks say, but I don't know. The once he caught me was a accident. I led with my right." (*CN* 842)

As a light-hearted, engaging mystery with lively characters and sufficient plot twists to keep the reader guessing, *The Thin Man* is difficult to beat; but it raises no weighty moral or psychological issues and in the end is little more than a puzzle story of the sort that Christie, Carr, and others wrote in their dozens.

Hammett wrote no further adventures of Nick and Nora—he had nothing to do either with the original *Thin Man* film or with its five successors—nor, indeed, wrote any further detective fiction over the remaining twenty-seven years of his life. He devoted his energies to left-wing causes and, because he had actually joined the Communist Party in 1937, was eventually (1953) brought before the House Un-American Activities Committee; although not charged with any crimes, his reputation was ruined and he spent the last eight years of his life in poverty and an alcoholic stupor.

But the merits of any number of his short stories and novellas— "Crooked Souls," "Zigzags of Treachery," "The Golden Horseshoe," "Dead Yellow Women"—as well as of *The Maltese Falcon* are sufficient to give him a place in the history of the detective story and of literary history as a whole. He was by no means the only writer for *Black Mask* in its early years, but his work was singled out as the *fons et origo* of the hard-boiled detective story, and in that sense he all but single-handedly gave birth to that subgenre just as Edgar Allan Poe had invented the detective story out of whole cloth eight decades before. His spare, clipped, tough-guy prose was exactly what was needed to establish this subgenre as distinct from the orthodox puzzle story—chiefly the work, at the outset, of British writers whose prose was of a very different order. Subsequent writers, especially Chandler, made more deliberate attempts to distinguish themselves from what they regarded as an effete tradition of the "cosy" mystery; but it was perhaps Hammett's bland disregard of that tradition that renders his work the more dramatically different from what the Agatha Christies of the world were offering.

RAYMOND CHANDLER:
MEAN STREETS

Raymond Chandler (1888–1959) has come to be regarded as a kind of highbrow version of Dashiell Hammett, his richly textured, prose-poetic style held up as a welcome contrast to the austerity of his predecessor's prose. Like Hammett, Chandler focused on novellas early in his career: his first, "Blackmailers Don't Shoot," appeared in *Black Mask* in December 1933, conveniently at the very time when Hammett's career was coming to an end; he switched to novels in the later 1930s, publishing eight novels over a widely scattered period from 1939 to 1959. His corpus of work, therefore, is almost identical in quantity to Hammett's.

And as with Hammett, a glance at his biography makes it seem intrinsically unlikely that he would have become a writer at all, let alone a hardboiled crime writer. Born in Chicago, he was abandoned by his alcoholic father and taken by his mother to Ireland, then England, where he attended Dulwich College and wrote a few poems, essays, and reviews. Returning to the United States in 1912, he eventually settled in Los Angeles, making that burgeoning megalopolis the focus of his crime writing just as Hammett vivified San Francisco. But writing seemed far from Chandler's mind as he served briefly in the Canadian Army during World War I and then worked as an accountant for an oil syndicate. It was only when he was fired from that job in 1932 that he took up writing as a career. But Chandler never wrote frequently or quickly enough to make a good living as a pulp writer—where quantity was the key to even moderate success, given the low rates of payment—and even his now highly regarded novels were, at first, both critical and financial failures. It was only when *The Big Sleep* and *Farewell, My Lovely* sold millions of copies in paperback during the 1940s that Chandler gained some modicum of financial success—success that was augmented by his sporadic work as a screenwriter in Hollywood during the 1940s and 1950s.

Chandler was more articulate than Hammett in enunciating the theory and practice of hard-boiled detective fiction—or, at any rate, he seized on an opportunity given him for the purpose. His essay "The Simple Art of Murder" (*Atlantic Monthly,* December 1944) stands as both a manifesto for

the hard-boiled detective story and a (largely after-the-fact) justification for the kind of fiction he himself was writing. It is a consciously cynical, at times flippant, and in general world-weary document (one is almost tempted to call it hard-boiled); it is also a bit vague and more than a little self-serving. Chandler begins by lamenting the sheer quantity of "detective stories" now being published. At the moment he is not necessarily referring only to "cosy" mysteries or strict puzzle stories (what he later on calls "problems in logic and detection" [6]); indeed, he admits that "in my less stilted moments I too write detective stories" (3). But it becomes gradually clear that the puzzle story really is the target of his attacks—something we can gauge not only by the parodic titles he supplies (*The Triple Petunia Murder Case, Inspector Pinchbottle to the Rescue* [3]), but by a long diatribe on the logical lapses of what was then held up as one of the towering examples of the form, A. A. Milne's *The Red House Mystery* (1922). Attacks on E. C. Bentley's *Trent's Last Case* (1913), Freeman Wills Crofts, and Agatha Christie follow; even Sir Arthur Conan Doyle is not spared ("Sherlock Holmes after all is mostly an attitude and a few dozen lines of unforgettable dialogue" [5]).

There follows a pungent and, in truth, unanswerable condemnation of the puzzle story as traditionally practiced: "There is a very simple statement to be made about all these stories: they do not really come off intellectually as problems, and they do not come off artistically as fiction. They are too contrived, and too little aware of what goes on in the world. They try to be honest, but honesty is an art" (12). This is a body-blow because, in Chandler's estimation, even the most exalted puzzle stories fail through logical flaws (in addition to, as Chandler goes on to note, a portrayal of the police as habitual dunces so that the amateur detective can shine by comparison), thereby undercutting the one element these stories could claim as their *raison d'être*. And the point about failing "as fiction" is elaborated in a later passage dealing with Dorothy L. Sayers's comment that "It [the detective story] does not, and by hypothesis never can, attain the loftiest level of literary achievement." Fundamentally agreeing with this utterance despite some reservations as to what the phrase "the loftiest level of literary achievement" actually means, Chandler goes on to say:

> her kind of detective story was an arid formula which could not even satisfy its own implications. It was second-grade literature because it was not about the things that could make first-grade literature. If it started out to be about real people . . . they must very soon do unreal things in order to form the artificial pattern required by the plot. When they did unreal things, they ceased to be real themselves. They became puppets and cardboard lovers and papier-mâché villains and detectives of exquisite and impossible gentility. (14)

There follows a paean to Dashiell Hammett, although Chandler is careful to state both that Hammett was "one of a group—the only one who achieved critical recognition—who wrote or tried to write realistic mystery fiction" (15) and that he emerged as part of the Modernist movement of the period, as his mentions of Hemingway, Sherwood Anderson, and others suggest.

It would be unfair to maintain that Chandler is caricaturing the puzzle story as a literary failure even on its own terms and vaunting the hard-boiled story (he actually uses the term in reference to Hammett: "He was spare, frugal, hard-boiled" [17]) as uniformly successful merely because it deals with "mean streets" (18) and the similarly mean characters who fill them. He is aware that hard-boiled prose can itself become stylised ("The realistic style . . . is easy to fake; brutality is not strength, flipness is not wit, edge-of-the-chair writing can be as boring as flat writing" [18]), and he justifies the emphasis on "low" or "common" characters by stating that that is where crime, especially murder, is usually found ("Hammett gave murder back to the kind of people that commit it for reasons, not just to provide a corpse; and with the means at hand, not hand-wrought dueling pistols, curare and tropical fish" [16]).

It is in the context of the cruel, corrupt world that Chandler believed was a true reflection of the current sociopolitical scene that his most famous utterance on the subject occurs. Noting that "it is not a fragrant world, but it is the world you live in" (20), he states:

> In everything that can be called art there is a quality of redemption. It may be pure tragedy, if it is high tragedy, and it may be pity and irony, and it may be the raucous laughter of the strong man. But down these mean streets a man must go who is not himself mean, who is neither tarnished nor afraid. The detective in this kind of story must be such a man. He must be a complete man and a common man and yet an unusual man. He must be, to use a rather weathered phrase, a man of honor—by instinct, by inevitability, without thought of it, and certainly without saying it. . . .
>
> He is a relatively poor man, or he would not be a detective at all. He is a common man or he could not go among common people. He has a sense of character, or he would not know his job. . . . He talks as the man of his age talks—that is, with rude wit, a lively sense of the grotesque, a disgust for sham, and a contempt for pettiness. (20–21)

The question becomes whether Chandler's novels and tales of Philip Marlowe actually follow through on this lofty program.

In all frankness, no one is likely to grant Chandler his deservedly high place in American literature solely on the basis of his short stories. In fact, these tales are—with the exception of some late stories that he wrote largely after his novel-writing career was over—all novellas: the shortest of them

is 46 pages in a recent edition of his *Collected Stories.* The first of them, "Blackmailers Don't Shoot," is widely acknowledged even by Chandler's advocates as marred by confused narration, too many characters, few of whom are developed to any degree of flesh-and-blood reality, aesthetically unnecessary violence, and the suggestion of prolixity. In a pungent irony, given his ridiculing of how the puzzle mystery conveniently "provide[s] a corpse," nearly all the central figures in the story get killed with little thought to their lives or deaths; if anything, their demise provides the blackmailer of the title, the small-time actress Rhonda Farr, an opportunity to express an utter lack of remorse: "Two crooks, a double-crossing policeman, make three of them. I should lose my sleep over that trash!" Then, in a fleeting moment of compassion directed at a gangster she happens to have liked: "Of course, I'm sorry about Landrey" (35).

The high level of violence and killing continues in Chandler's second story, "Smart-Aleck Kill" (*Black Mask,* July 1934), which also focuses on blackmail. But in a nod to the puzzle story, where the careful interpretation of clues is at the heart of the case, the private investigator Johnny Dalmas ascertains that a dead man could not have committed suicide because the gun was placed in his right hand whereas the man was left-handed. In the end, as in some of Hammett's stories, a jack-in-the-box ending is supplied when the murder is pinned on a city councilman—who is then promptly blown away.

Chandler's third story, "Finger Man" (*Black Mask,* October 1934), is of significance chiefly because it introduces us to Philip Marlowe. In contrast to the widely held belief that the name of Chandler's most charismatic private investigator is a fusion of Sir Philip Sidney and Christopher Marlowe, Chandler's biographer Tom Hiney maintains that the name derives from Marlowe House at Dulwich College (99). Whatever the case, Chandler follows Hammett's lead in having Marlowe narrate all his stories in the first person: it is not clear whether Chandler used this device to advance the heroic status of the private investigator as later articulated in "The Simple Art of Murder." The problem is that we learn about Marlowe's life and character only what he cares to tell us—which, at the outset, isn't much. Aside from the fact that, as his biographer notes, Marlowe was a "loner and an alcoholic" (Hiney 102)—much as Chandler himself was, for all that he remained married for thirty years to a woman, Cissy Pascal, who was twenty years his elder—it takes the reader a very long time to gain even a partial conception of exactly who Philip Marlowe is.

What we do learn from "Finger Man" is that Marlowe is in a pretty dangerous line of work and seems to relish it: he is knocked out, shot at, and kidnapped, escaping only by the grotesque expedient of throwing his kidnapper's pet cat in his face. In the end, although he has the option of

pocketing the sum of $20,000, he keeps only $200 of it for his troubles.

At the outset, Chandler was far from certain that he had discovered his answer to Hammett's Sam Spade, for it took him some time to resurrect Marlowe in a story. Meanwhile, he concocted the novelty of a Latino detective (a police officer), Sam Delaguerra, for "Spanish Blood" (*Black Mask,* November 1935), and other detectives—or no detective at all—in other tales of the period. Marlowe does return in "Goldfish" (*Black Mask,* June 1936)—but, amusingly enough, the case turns on a technical knowledge of goldfish (a man's dying cry, "The Moors, Hattie!—the Moors!" [*CS* 516], is found to refer to the fact that some missing pearls are to be found in a specific type of goldfish, the Japanese Moor), not so very different from the use of "curare and tropical fish" that Chandler would later ridicule in the puzzle story.

Even the characteristic Chandleresque prose—notably the vibrant use of similes that made him perhaps the master of that device in the entirety of Anglophone literature—was surprisingly long in manifesting itself. Chandler's early novellas are not markedly different from Hammett's in this regard, being far more spare than what one would have been led to expect if one were familiar only with his novels. Consider this passage from "Nevada Gas" (*Black Mask,* June 1935):

> At the back of the house was what had been a chicken house. A piece of rusted junk in a squashed garage was all that remained of the family sedan. The back door was nailed up like the windows. De Ruse stood silent in the rain, wondering why the front door was open. Then he remembered that there had been another flood a few months before, not such a bad one. There might have been enough water to break open the door on the side towards the mountains. (*CS* 256)

The first story that, to my mind, reveals distinctively Chandleresque prose is "Trouble Is My Business" (*Dime Detective Magazine,* August 1939), published at about the same time as his first novel. It is here that Chandler demonstrates not only his mastery of the cynical, world-weary tone that has become almost *de rigueur* in hard-boiled fiction but also of a crisp, almost electric prose that saves the cynicism from being nihilistically self-defeating by its vivification of both characters and landscape. Its opening paragraph is pungent:

> Anna Halsey was about two hundred and forty pounds of middle-aged putty-faced woman in a black tailor-made suit. Her eyes were shiny black shoe buttons, her cheeks were as soft as suet and about the same color. She was sitting behind a black glass desk that looked like Napoleon's tomb and she was smoking a cigarette in a black holder that was not quite as long as a rolled umbrella. She said: "I need a man." (*CS* 991)

The progression of Chandler's prose can perhaps be gauged by his attitude toward Hemingway, the exemplar of the austere style. As he was beginning his detective writing in 1932, he considered Hemingway "the greatest living American novelist" (Hiney 74); but less than fifteen years later, as he was well into his career as a novelist, his opinion had shifted, as he wrote to Blanche Knopf (27 March 1946):

> Even Hemingway has let me down . . . his eternal preoccupation with what goes on between the sheets becomes rather nauseating in the end. One reaches a time in life when limericks written on the walls of comfort stations are not just obscene, they are horribly dull. This man has only one subject, and he makes that ridiculous. I suppose the man's epitaph, if he had the choosing of it, would be: Here Lies A Man Who Was Bloody Good In Bed. Too Bad He's Alone Here. But the point is I begin to doubt whether he ever was. You don't have to work so hard at things you are really good at—or do you? (Hiney 123–24)

It is true that this comment seems solely addressed to Hemingway's subject matter, but I suspect a certain disenchantment with Hemingway's bare-bones prose as well, given that by this time Chandler had moved in a very different direction.

Chandler's high place in literature rests almost entirely on his novels—and perhaps only on three or four of these. But that is enough. Indeed, *The Big Sleep* (1939) might have been sufficient to give anyone a toehold in the American literary canon. It is here that, for practically the first time, we get some background on Philip Marlowe. We learn almost at the outset that he once worked for the District Attorney's office but was, unsurprisingly, fired for "insubordination" (8). Also from the outset, the stark differences in wealth and class between Marlowe and his client—General Guy Sternwood, who is having trouble controlling his two wayward daughters—is evident, leading Marlowe to say at a later point: "To hell with the rich. They made me sick" (44).

The rather byzantine plot of this novel needs no rehearsing, given the familiarity of the reasonably faithful 1946 film. What that film, like the film of *The Maltese Falcon,* fails to convey fully is the strong sexual undercurrent of the novel. From the beginning, both of Sternwood's daughters, Vivian and Carmen, make plays for Marlowe, even though Vivian is married (one aspect of the case involves finding her missing husband, Rusty Regan). In a striking scene, Marlowe goes to the house of a rare book dealer, A. G. Geiger, and finds him dead; Carmen is also there: "She was wearing a pair of long jade earrings. They were nice earrings and had probably cost a couple of hundred dollars. She wasn't wearing anything else" (24–25). Later, Vivian shows Marlowe a nude photograph of Carmen in Geiger's house and claims that a blackmailer is asking for $5000 for it. Still later,

Marlowe engages in some lovemaking with Vivian ("I kissed her tightly and quickly. Then a long slow clinging kiss. Her lips opened under mine. Her body began to shake in my arms" [102]) but stops short of actual sex. And a critical scene toward the end involves Carmen aiming five shots at Marlowe (he had wisely loaded the gun with blanks) because he had rejected her sexual advances; the incident allows Marlowe to determine that Carmen had killed Rusty in exactly the same way and for exactly the same reason. In this sense Marlowe may be conforming to the sexual morals of the private eye as spelled out in "The Simple Art of Murder": "he is neither a eunuch nor a satyr; I think he might seduce a duchess and I am quite sure he would not spoil a virgin" (20). There is even a surprising gay element in the novel: Geiger had been sexually involved with a young man with the ambiguous name of Carol Lundgren.

The high level of violence in the novel is also worth noting. There are a grand total of six deaths, including one dramatic scene where the black-mailer, Joe Brody, is shot when he opens the door to his apartment while Marlowe is sitting inside. Marlowe tracks down the killer, who turns out to be Carol Lundgren. Marlowe himself knocks off one Lash Canino, a hitman who no doubt deserved his demise.

But a study of the individual elements or characters in *The Big Sleep* cannot capture its compelling narrative drive—fueled, indeed, by the sexual tension generated by Marlowe's relations with Vivian and Carmen, and also generated by the deaths that occur with dismal regularity throughout the work, but ultimately dominated by a bleak vision of the futility of human accomplishment. High or low, rich or poor, gangster or upstanding citizen, you end up in the same place, as Marlowe reflects bitterly in a concluding paragraph that explains and justifies the title:

> What did it matter where you lay once you were dead? In a dirty sump or in a marble tower on top of a high hill? You were dead, you were sleeping the big sleep, you were not bothered by things like that. Oil and water were the same as wind and air to you. You just slept the big sleep, not caring about the nastiness of how you died or where you fell. Me, I was part of the nastiness now. Far more a part of it than Rusty Regan was. But the old man didn't have to be. He could lie quiet in his canopied bed, with his bloodless hands folded on the sheet, waiting. His heart was a brief, uncertain murmur. His thoughts were as gray as ashes. And in a little while he too, like Rusty Regan, would be sleeping the big sleep. (154–55)

It is not surprising that the novel was initially panned because it was too depressing—as if a case like this could be cheerful! Chandler complained to Alfred Knopf: "[The critics] seemed more occupied with the depravity and unpleasantness of the book than with anything else. In fact the notice

from the New York Times, which a clipping agency sent me as a come-on, deflated me pretty thoroughly. I do not want to write 'depraved books'" (Hiney 107–8). It is, however, not clear that Chandler ever surpassed *The Big Sleep* in any of his subsequent novels. It, along with *The Maltese Falcon,* would alone be sufficient to guarantee the hard-boiled detective novel a noteworthy place in American literature.

Farewell, My Lovely (1940) is nearly as good, but is crippled by a serious plot flaw that becomes evident only at the end. Once again, a fantastically complex plot featuring a multitude of vividly realised characters conceals the core of the story and its nearly fatal problem. After we peel away all the side issues, what we are left with is the murder of one Lindsay Marriott by a wealthy woman, Mrs Lewin Lockridge Grayle (a "blonde to make a bishop kick a hole in a stained glass window" [218]). This murder occurred when Marlowe accompanied Marriott on what he believed to be the payment of ransom for a stolen necklace; but if Mrs Grayle killed Marriott, why didn't she go on and kill Marlowe also? Instead, he was merely knocked out. Perhaps we can assume that Mrs Grayle believed he was dead, but Chandler never makes this clear even at the end, when Marlowe identifies her as the murderer. Indeed, it is at this point that we learn that Mrs Grayle had herself hired Marriott to kill Marlowe because he was investigating the whereabouts of a woman named Velma, the wife of a gangster, Moose Molloy (Mrs Grayle proves to be Velma). Marlowe maintains that Mrs Grayle killed Marriott when the latter botched the job of killing Marlowe—which only emphasises her inexplicable failure to kill Marlowe herself.

Putting this aside, we have in *Farewell, My Lovely* a vibrant, action-packed, and extraordinarily convoluted plot featuring gangsters, members of high society, a charlatan psychic, and a corrupt police force. Perhaps the most interesting element is the emphasis on wealth or class distinctions in an area as politically, socially, and culturally diverse as the Los Angeles metropolitan area. Marlowe's first sight of the Grayle residence elicits this cynical reflection: "The house itself was not much. It was smaller than Buckingham Palace, rather gray for California, and probably had fewer windows than the Chrysler Building" (237). But, as if to underscore how wealth does not bring happiness, Marlowe is enticed to make love to the lovely Mrs Grayle; but as her husband unexpectedly enters the room, he merely says, "I beg your pardon, I'm sure" (245) and walks out. The fake psychic, Jules Amthor, also plays a role in this depiction of the shallowness and fundamental worthlessness of the upper crust: Marlowe ascertains that Marriott was providing the names of wealthy women to Amthor as a means of securing damaging information on them and blackmailing them.

Marlowe, aside from being coshed by Mrs Grayle at the outset, is also beat up by a Native American sidekick of Amthor and, for good measure,

pummelled by two rogue cops on the Bay City police force. It has been conjectured that Marlowe's tense relations with the police throughout the stories and novels in which he appears is a reflection of the endemic corruption in the Los Angeles police department (see Hiney 65). Whatever the case, it is clear that the police do not appreciate Marlowe's involvement in a criminal investigation, especially a murder case. In the end Marlowe actually makes peace with the two officers who beat him up and uses one of them to help crack the case.

The High Window (1942) has more of the trappings of the conventional puzzle story than Chandler's other novels, although that is not to say that it is in any sense analogous to the British "cosy" mystery. But we are here dealing with not just one but two counterfeit coins (the original being of great value), and the admittedly implausible discovery of a photograph that purports to show the murderer pushing a man out of a window—exactly the sort of convenient clue that Chandler by implication ridiculed in the puzzle story. And the novel is further hampered by a multiplicity of characters, few of whom are portrayed fully or empathetically.

What merits there are in the novel reside in its trenchant prose, as Chandler has more and more come to master the hard-boiled idiom—infused with his own brand of prose-poetry—that distinguishes his work both from puzzlemeisters like Christie and Carr but also from the more austere Hammett. Consider this description of the seedy town of Bunker Hill:

> In and around the old houses there are flyblown restaurants and Italian fruitstands and cheap apartment houses and little candy stores where you can buy even nastier things than their candy. And there are ratty hotels where nobody except people named Smith and Jones can sign the register and where the night clerk is half watchdog and half pander.
>
> Out of the apartment houses come women who should be young but have faces like stale beer; men with pulled-down hats and quick eyes that look the street over behind the cupped hand that shields the match flame; worn intellectuals with cigarette coughs and no money in the bank; fly cops with granite faces and unwavering eyes; cokies and coke peddlers; people who look like nothing in particular and know it, and once in a while even men that actually go to work. But they come out early, when the wide cracked sidewalks are empty and still have dew on them. (396)

And how can we ever forget the description of a woman who "had eyes like strange sins" (437)?

If any character stands out—or would stand out if she were on stage a bit more—it is Merle Davis, the put-upon secretary of Mrs Elizabeth Bright Murdock, who had initially hired Marlowe to retrieve (or at least ascertain the whereabouts of) a rare coin that she believes her daughter-in-law stole. In the end Marlowe determines that Mrs Murdock's seemingly inexplicable

hold on the weak-willed and nearly hysterical Merle rests on having convinced her that she had pushed her first husband out of the "high window" in their house; but those telltale photographs tell a different tale, identifying Mrs Murdock herself as the murderer. Marlowe magnanimously takes Merle under his wing and drives her back to her parents' house in Wichita.

The Lady in the Lake (1943) completes the quartet of novels that Chandler wrote in relatively rapid succession during the early years of World War II. Here too there are more than a few resemblances to the puzzle story, notably in what proves to be a case of mistaken identity: the "lady in the lake" whose body triggers a criminal investigation is first identified as Muriel Chess but later as Crystal Kingsley, whom Muriel had killed and whose identity she had then assumed. Marlowe, brought in by Crystal's husband Derace to find Crystal, who has been missing for a month, once again has to deal with the corrupt Bay City police department; one cop in particular, Al Degarmo, takes pleasure in roughing up Marlowe during an investigation:

> "Then there's nothing in it," I said.
> He looked at his cigarette. "Nothing in what?"
> "Nothing in the idea that Almore murdered his wife, and had enough pull to get it fixed."
> Degarmo came to his feet and walked over to lean down on me. "Say that again," he said softly.
> I said it again.
> He hit me across the face with his open hand. It jerked my head around hard. My face felt hot and large.
> "Say it again," he said softly.
> I said it again. His hand swept and knocked my head to one side again.
> "Say it again."
> "Nope. Third time lucky. You might miss." I put a hand up and rubbed my cheek.
> He stood leaning down, his lips drawn back over his teeth, a hard animal glare in his very blue eyes.
> "Any time you talk like that to a cop," he said, "you know what you got coming. Try it on again and it won't be the flat of a hand I'll use on you." (619–20)

But as in *Farewell, My Lovely,* Degarmo later teams up with Marlowe to try to crack the case, thinking that that would get him back into the good graces of the department. The plan, however, does not work: Marlowe, after he has identified Muriel Chess as the murderer of Crystal, follows up by fingering Degarmo as the murderer of Muriel (his former wife). Degarmo bolts out of the cabin where Marlowe had made the revelation and is gunned down by sentinels when he tries to get across a dam.

After completing *The Lady in the Lake,* Chandler found himself bored

with the task of writing novels and accepted an offer to cowrite the screen-play to *Double Indemnity* (1944), based on the James M. Cain novel. That screenplay and a solo job on the film *The Blue Dahlia* (1946) each earned Chandler an Academy Award nomination. In a later chapter I discuss the catastrophic error that Chandler and his cowriter Czenzi Ormonde made in altering the basic plot of Highsmith's *Strangers on a Train* for the 1951 film version, although Chandler had such difficulties working with Alfred Hitch-cock (who made a public show of throwing out two drafts of the screenplay) that it is not clear to whom the discredit should be attributed. Chandler did manage to write another novel, *The Little Sister* (1949), much of which was written while he was in Hollywood and which is set there; and, although it sold better in hardcover than several of Chandler's previous novels, it is not regarded as an aesthetic success.

What *is* a success, although not an unalloyed one, is *The Long Good-bye* (1953), which ranks with *The Big Sleep* as the pinnacle of Chandler's work in the novel and in the hard-boiled idiom as a whole. Throughout the course of his novelistic work, Chandler had been portraying Marlowe in bleaker and bleaker tones, until the ultimate in cynicism is reached in a self-description toward the beginning of the novel:

> "I'm a licensed private investigator and have been for quite a while. I'm a lone wolf, unmarried, getting middle-aged, and not rich. I've been in jail more than once and I don't do divorce business. I like liquor and women and chess and a few other things. The cops don't like me too well, but I know a couple I get along with. I'm a native son, born in Santa Rosa, both parents dead, no brothers or sisters, and when I get knocked off in a dark alley sometime, if it happens, as it could to anyone in my business, and to plenty of people in any business or no business at all these days, nobody will feel that the bottom has dropped out of his or her life." (74)

His cynicism about himself is matched by his cynicism about the law:

> "Let the law enforcement people do their own dirty work. Let the lawyers work it out. They write the laws for other lawyers to dissect in front of other lawyers called judges so that other judges can say the first judges were wrong and the Supreme Court can say the second lot were wrong. Sure there's such a thing as law. We're up to our necks in it. About all it does is make business for lawyers. How long do you think the big-shot mobsters would last if the lawyers didn't show them how to operate?" (259)

An entirely irrelevant episode that is designed to show "a day in the life of a P.I." concludes with the following reflection:

> Not exactly a typical day but not totally untypical either. What makes a man stay with it nobody knows. You don't get rich, you don't often have

much fun. Sometimes you get beaten up or shot at or tossed into the jail-house. Once in a long while you get dead. Every other month you decide to give it up and find some sensible occupation while you can still walk without shaking your head. Then the door buzzer rings and you open the inner door to the waiting room and there stands a new face with a new problem, a new load of grief, and a small piece of money. (129)

There are other structural problems to the novel. What begins with an incident where Marlowe rescues an acquaintance, Terry Lennox, whose ex-wife, Sylvia, has abandoned him after she finds him drunk at a dance club (Marlowe understandably has sympathy with drunks, given Chandler's own crippling alcohol addiction), appears to veer in a different direction when Marlowe is hired by a literary agent, Howard Spencer, to investigate why a bestselling author, Roger Wade, is drinking heavily and is unable to finish his novel-in-progress. In the interim, Sylvia Lennox is found dead and Marlowe himself is roughed up by the police and briefly arrested on suspicion of murder. The connexion between these two cases is quite long in coming, but is at last provided by Linda Loring, who is Sylvia's sister and also acquainted with Wade.

Eventually, the two cases become inextricably fused: Marlowe discov-ers that Wade had an affair with Sylvia, who was killed in a guest house on his property; Eileen Wade, Roger's current wife, was formerly married to Terry Lennox, then operating under a different name; and so on. Well before the conclusion of the novel, Marlowe identifies Eileen as the murderer of both Sylvia and Roger Wade; she then kills herself after writing out a con-fession. Chandler then pulls a final rabbit out of his hat: a Mexican, Cisco Maioranos, purporting to be a day clerk at a hotel in Tijuana where Terry Lennox supposedly killed himself (or was murdered), proves to be Lennox himself, who staged his own suicide.

Chandler's prose in *The Long Goodbye* has never been more vibrant and gripping; and the complex plot, with its multitude of characters, is han-dled with such skill that every twist and turn is simultaneously surprising and a logical result of the nature of the protagonists and their relations with one another. Every figure, however minor, is rendered vividly and dramati-cally, from the wealthy Roger Wade to the gangster Mendy Menendez to the assistant district attorney, Bernie Ohls, who had appeared in several previ-ous novels as Marlowe's sometime colleague and sometime adversary. The longest of Chandler's novels, *The Long Goodbye* is close to his best.

Chandler wrote two further novels, *Playback* (1958), based on an un-produced screenplay, and the unfinished *Poodle Springs* (1959), but they add little to his reputation. That reputation will no doubt be based on the five novels discussed here—and, really, only the two best ones, *The Big Sleep* and *The Long Goodbye*—along with a selection of his short stories and

novellas. Without making any notable structural changes in the hard-boiled story as established by Hammett, Chandler did infuse it with a scintillating prose that elevates it incalculably above the average run of stories in the pulp magazines or in the cruder (but more popular) novelists of the period (notably Mickey Spillane, with his unspeakable illiteracy and contemptible penchant for raw sex and violence). And if the overarching cynicism of Marlowe itself comes close to becoming a shtick at times, it remains a genuine reflection of the enduring class distinctions and explosive violence endemic to the American society of that era.

ROSS MACDONALD: FAMILY AFFAIRS

The life of Kenneth Millar (1915–1983), who published most of his work under the pseudonym Ross Macdonald, was in many ways just as interesting as his writings. Born in Los Gatos, California, of Canadian parents, he was taken to Canada as a child and educated there. It was at the Kitchener-Waterloo Intercollegiate Institute that he met his future wife, Margaret Sturm; they married in 1938. Their first and only child, Linda, was born in 1939. The couple moved to California in the 1940s, where they remained for the rest of their lives. But their daughter proved to be a source of deep anguish to them. In 1956, she was involved in two separate car accidents that resulted in the death of a boy; as a juvenile, she received probation. Then, in 1959, she disappeared for some weeks, wandering away from the campus of the University of California at Davis; with an irony that was not lost on him, Millar was forced to hire a private detective to find her. Linda then seemed to establish some stability in her life, marrying and giving birth to a child; but she died in her sleep in 1970, and her parents never fully recovered from the emotional blow. In the late 1970s Macdonald contracted Alzheimer's and died a few years later just as he was belatedly receiving recognition for his writing.

For much of their lives, Ross Macdonald and Margaret Millar waged a mostly friendly rivalry in mystery writing—he focusing on the hard-boiled crime novel while she, as we will see, wrote intense and disturbing psychological mysteries. Although at the outset Margaret surpassed Ross in both popularity and critical esteem, he eventually overtook her in both regards. *The Goodbye Look* (1969) was his first bestseller, and he was immensely gratified when a close literary colleague, Eudora Welty, wrote a long and favourable review of his next novel, *The Underground Man* (1970).

In some ways Macdonald never quite lived up to the high reputation he attained after decades of writing. His first novel, *The Dark Tunnel,* was published in 1944; but he hit his stride only with the first of eighteen novels featuring the private investigator Lew Archer, *The Moving Target* (1949). It seems that Macdonald laboured under the weight of high expectations: many critics regarded him as the natural successor to Hammett and Chan-

dler in hard-boiled writing, and in 1969 William Goldman uttered the pronouncement that "the Archer books [are] the finest series of detective novels ever written by an American" (cited in Nolan 11). Whether Macdonald truly deserves this high praise remains to be seen. To be sure, he approached his work with admirable seriousness, seeking to probe deeply into his characters and embellishing them with prose of occasional vividness and pungency; but, although the sheer volume of his work far surpasses that of Hammett and Chandler combined, it would be a mistake to rank him above either. In my judgment, his wife, Margaret Millar, remains a superior writer in matters of character portrayal and elegance and fluidity of prose.

If there is any significant difference between Macdonald and his predecessors, it is a substantial increase in focus and intensity on a complex network of familial conflicts—chiefly relating to a catastrophic absence of love and empathy between parents and children—that both triggers Lew Archer's involvement in a case and that leads to grisly and multiple murders. Accordingly, Archer is at times forced into the uncomfortable role of psychologist or father confessor as well as investigator.

It would be a truism to say that this tendency—exemplified in the repeated scenario of a parent seeking Archer's assistance to track down a missing child (usually a young woman)—was inspired by Macdonald's own troubles with his daughter; but some inklings of it occurred as early as the 1940s, well before his daughter had fallen on hard times. The stories in *The Name Is Archer* (1955)—Macdonald's first story collection, consisting generally of novelettes that had appeared in *Manhunt* and other detective magazines—are indicative. It appears to contain the very first Archer story, "Find the Woman" (1946), where we find that Archer has "just got out of the army" (2). The focus here, ultimately, is Millicent Dreen, a publicist who hires Archer to find her missing twenty-two-year-old daughter Una Sands but who proves to be the villain of the case, as she in fact set up a (very implausible) scenario whereby Una's husband, Jack Rossiter, killed Una because of her infidelities, thereby clearing the way for Millicent to get Rossiter for herself. The two prominent features in this story—the suggestion of quasi-incest and the fact that the very person who summons Archer to investigate proves to be the culprit, even if at second hand—are repeated throughout the Archer novels.

Other stories in *The Name Is Archer* are of no particular distinction, for they simply contain too much plot to be properly expounded even in the space of a novelette or novella—a problem that afflicts some of his novels as well. In one of them, "Gone Girl" (1953), Archer piquantly calls himself "a garbage collector in the moral field" (43). "The Bearded Lady" (1948) turns on an Oedipal situation whereby a painter's fiancée thinks he is in love with her stepmother (in fact, the painter did have a brief affair with his

fiancée's mother). In "Guilt-Edged Blonde" (1954), a man takes money from his brother so that the latter can make love to his stepdaughter. "Wild Goose Chase" (1954) focuses on a tangled web of marital infidelities. A man, Glenway Case, is on trial for the murder of his wife, Ruth. Archer is convinced (correctly, as it happens) that Case did not commit the crime; but what he did do was to inform the wife of his lawyer, Rod Harvey, that Harvey was having an affair with Ruth, leading Harvey's wife to kill Ruth. Case is acquitted, but he fails to profit from his misdeeds, conveniently dying while driving a Ferrari he had purchased from the proceeds of his wife's millions.

In *The Moving Target* we learn a little bit more about Archer, notably that he was divorced from a woman named Sue (15–16). All this is not very interesting nor very surprising. Somewhat more interesting are Archer's reflections on his prior career and on why he became a private detective:

> "I'll take it from the beginning. When I went into police work in 1935, I believed that evil was a quality some people were born with, like a harelip. A cop's job was to find those people and put them away. But evil isn't so simple. Everybody has it in him, and whether it comes out in his actions depends on a number of things. Environment, opportunity, economic pressure, a piece of bad luck, a wrong friend. The trouble is a cop has to go on judging people by rule of thumb, and acting on the judgment."
> "Do you judge people?"
> "Everybody I meet. The graduates of the police schools make a big thing of scientific detection, and that has its place. But most of my work is watching people, and judging them." (76)

This is an accurate if somewhat mundane exposition of how Archer functions: we will find instances where he does use "scientific detection" in the manner of the know-it-all amateur detectives of the puzzle mystery, but in general it is his psychological acuity—and, perhaps more relevantly, his swift action based upon it—that cracks the cases in which he is involved.

The Moving Target was, upon publication, regarded as a competent pastiche of the Hammett-Chandler hard-boiled novel, with a few signs of originality. This is a fairly accurate assessment: it features Archer getting bruised and bloodied on several occasions, at one point coming close to being killed in a fight; and some routine sparks fly when Archer tangles with the police in the course of a murder investigation. And we are presented with a scenario whereby the very person who hired Archer proves to be the murderer, although someone else was involved in kidnapping the victim.

The Way Some People Die (1951) features a notable disquisition by Archer on his involvement with drug addicts: "'I've known weed- and opium-smokers, coke-sniffers, hemp-chewers, laudanum drinkers, plain and fancy drunks. Guys and girls who lived on canned heat and rubbing alcohol. There

are even people in the world who can't leave arsenic alone, and other people who would sell themselves into slavery for a long cool drink of ether'" (310). There is also a rather amusing instance of what might be called the baffling clue: a coroner, faced with a body that has apparently drowned, observes: "If it weren't a patent impossibility, I'd say he might have frozen to death" (331). It turns out not to be an impossibility: the man had in fact died by being put in a freezer and was only later dumped into the ocean. But this novel distinguishes itself by its sensitive characterisation of a young woman, Galatea (Galley) Lawrence, whose mother calls in Archer to find her after she has been missing for months. Galley is gradually transformed from an object of pity and sympathy—raised by a puritanical mother, she naturally reacts by becoming man-crazy—into an object of horror and disgust, for it is she who has connived everything in the case, including the central murder and the very hiring of Archer himself.

The Barbarous Coast (1956)—one supposes the title is a parody of Barbary Coast, the red-light district in nineteenth-century San Francisco, even though the novel is set, as customarily with Macdonald, in southern California—shows the author's increasing grasp both of landscape and of character portrayal. It features some fine prose-poetry as Archer, having been sapped and taken prisoner by thugs associated with the Helio-Graff studios, escapes and trudges along a "dusty private road":

> I stayed off the road, cutting at an angle across the high desert toward the highway. The air was turning chilly. In the darkness rising from the earth and spreading across the sky, the evening star hung alone. I was a bit lightheaded, and from time to time I thought that the star was something I had lost, a woman or an ideal or a dream.
>
> Self-pity stalked me, snuffing at my spoor. He was invisible, but I could smell him, a catty smell. Once or twice he fawned on the backs of my legs, and once I kicked at him. The joshua trees waved their arms at me and tittered. (421)

Passages like this may allow us to excuse the implausibility of a later episode when Archer, facing three hostile men, manages to subdue them all one after the other. As a searing indictment of the corruption of the film industry (a central character, Simon Graff, is based on Darryl F. Zanuck [Nolan 156]) the novel is undeniably effective, even if it concludes with a contrived jack-in-the-box ending whereby a seemingly harmless and ineffectual manager of a club in Malibu proves to be a triple murderer.

Macdonald seemed to hit his stride in the late 1950s and early 1960s—perhaps not coincidentally, the exact time when his troubles with his wayward daughter were reaching an apex, with such novels as *The Doomsters* (1958), *The Galton Case* (1959), and *The Zebra-Striped Hearse* (1962). I am half inclined to believe that the first is his best novel overall, in spite of the

greater popularity and critical acclaim of some later works. *The Doomsters* features a powerful atmosphere of gloom and emotional intensity, chiefly because of its imperishable portrayal of two central figures (apart from Archer himself), Carl Hallman and his wife, Mildred. We are introduced strikingly to Hallman at the very outset, as he breaks out of the State Hospital (where he has been diagnosed as a manic-depressive) and shows up at Archer's house. In a tense confrontation, Archer apparently persuades Hallman to return to the hospital; but on the way there, Hallman knocks Archer out and takes off with his car. A substantial amount of evidence mounts throughout the early parts of the novel suggesting that Hallman may have killed both of his parents in the past and gunned down his own brother, Jerry, soon after his escape from the hospital. But Archer's initial encounter with him, for all that it ended in violence and car theft, leads the detective to believe that Hallman is more a victim than a villain.

The portrayal of Mildred Hallman is equally sensitive and powerful, as she struggles to protect her erratic man-child of a husband from the onslaughts of his own family and of life in general. She suspects that Jerry may have contrived to have Carl put away in order to preserve the family estate: Carl had been appalled to hear that during World War II his father, a former state senator, had obtained land from evicted Japanese-Americans for pennies on the dollar, and Carl expresses a strong inclination to give it back to them. And yet, when it is at last revealed that Mildred herself has committed the four murders, we experience less a sense of righteous vindication than a realisation—keenly articulated by Archer—that many others bear guilt in various ways:

> Mildred was as guilty as a girl could be, but she wasn't the only one. An alternating current of guilt ran between her and all of us involved with her. Grantland and Rica, Ostervelt, and me. The redheaded woman who drank time under the table. The father who had deserted the household and died for it symbolically in the Senator's bathtub. Even the Hallman family, the four victims, had been in a sense the victimizers, too. The current of guilt flowed in a closed circuit if you traced it far enough. (238)

Archer alludes to Tom Rica, a heroin addict who first directed Carl Hallman to Archer and who later concealed a critical piece of evidence; Sheriff Ostervelt, a corrupt police officer who has long been collecting hush money from whorehouses and who also makes an appallingly tasteless pass at Mildred after her husband is critically wounded; and most tellingly, Dr Charles Grantland, one of numerous health care professionals (usually psychiatrists) in Macdonald's work whose vilely unethical behaviour leads to violence, mental anguish, and death. And, for what it's worth, Archer flings off a bit of autobiography at the end—"I'd been a street boy in my time,

gang-fighter, thief, poolroom lawyer" (250)—without elaborating on the surprising assertion.

The Galton Case presents Archer with a challenge of unusual difficulty: to find a man who has been missing for twenty years. He is Anthony Galton, the son of a wealthy widow who believes her time on this earth is almost up. Anthony, who is probably dead, is known to have begotten a son who would be Mrs Galton's heir. When a young man named John Lindsay (whose last name is derived from his foster-father) appears and claims to be the heir, Archer must investigate the claim. He himself is more than sceptical, but Mrs Galton has taken an immediate liking to John and refuses to hear a fair amount of evidence collected by Archer that he is an impostor.

On a superficial level, the novel unites Macdonald's Canadian and Californian upbringing, for one aspect of the case leads Archer to various small towns in eastern Canada where it appears (contrary to his own testimony) that John Lindsay grew up. Archer seems to have discovered definitive evidence that Lindsay is in fact one Theo Fredericks, apparently an impostor; but when Theo bolts with Sheila Howell, the daughter of Mrs. Galton's physician, Archer is compelled to pursue them all the way from California to Canada. It is a credit to Macdonald's narrative skills that, in a dramatic concluding scene, Theo Fredericks convinces Archer that he is in fact Mrs Galton's true heir.

I am not sure that *The Galton Case* raises any profound moral or aesthetic issues; but it is an exceptionally intense and well-crafted hard-boiled novel whose portrayal of all the central figures is vital and gripping. Macdonald, in a foreword to an omnibus of his novels, admitted that he ultimately identified with the young heir who had been shuttled back and forth across two countries by adults who were often seeking their own benefit rather than his:

> One of the things that supported me through my long Canadian childhood was the knowledge, which my mother insisted on, that I was an American citizen by birth. But for good or ill my early days made a Canadian out of me as well. I ended up split along emotional and political lines which nearly corresponded. My sense of self and my sense of territory were both askew. . . .
>
> A central figure in *The Galton Case* is a nameless boy who has taken the name of John (my father's name). When this fictional John made his way to Ann Arbor and entered the University of Michigan, he was following in my footsteps. John and I had other things in common. We shared a sense of displacement, a feeling that, no matter where we were, we were on the alien side of some border. We felt like dubious claimants to a lost inheritance. (*Archer at Large* ix)

The Zebra-Striped Hearse is not quite on the level of its two predecessors, but is a compelling novel nonetheless. This is not because of its utilisation of the vehicle of the title, which Archer (or Macdonald) apparently sees as some kind of indictment of the beat/hippie culture of the day:

> zebra-striped hearse with a broken headlight came in off the highway. It disgorged, from front and rear, four boys and two girls who all looked like siblings. Their hair, bleached by sun and peroxide, was long on the boys and short on the girls so that it was almost uniform. They wore blue sweatshirts over bathing suits. Their faces were brown and closed.
>
> They came in and sat in a row at the counter, ordered six beers, drank them with hero sandwiches which the girls made out of French loaves and other provisions brought in in paper bags. They ate quietly and voraciously. From time to time, between bites, the largest boy, who carried himself like their leader, made a remark about big surf. He might have been talking about a tribal deity. . . .
>
> "Beach bums," the woman behind the counter said. (283–84)

This comes off as a prototypical complaint about wild youth by a middle-aged codger who feels that the world is passing him by. It is not much consolation that the hearse ultimately plays a small part in the final resolution of the case—a resolution that, somewhat implausibly, harks back to the puzzle story by investing great weight in a single small piece of evidence (a missing button off of an expensive coat).

Archer unwittingly continues to play the role of old codger by expressing disdain for the work of an impoverished young painter, Burke Damis, who has apparently run off with Harriet Blackwell in the hope or expectation—at least in the eyes of her stern father, Mark Blackwell, who calls in Archer to find her—of securing a large sum of money she soon expects to receive from a trust. After all the twists and turns of the novel have been navigated, we learn that Mark himself confesses to two murders (including a woman whom he had gotten pregnant years ago) and also claims to have killed his own daughter, whereupon he promptly slits his own throat. But it transpires that Harriet is still alive—and, in a jack-in-the-box ending, that *she* is responsible for the two murders, her father nobly covering up for her.

Tom Nolan—who has written one of the most scintillating literary biographies in recent decades—believes *The Chill* (1964) to be a "masterpiece-in-the-making" (230) and points out both its references to Coleridge (the subject of Macdonald's Ph.D. dissertation at the University of Michigan) and its various autobiographical details. But these elements by themselves are not sufficient to make this work a masterpiece. Nolan is evidently impressed by the portrayal of two of the leading characters in the book, Roy Bradshaw, a dean at a local university, and a woman posing as his mother. We are evidently to be bowled over by the fact that the two turn out to be

lovers (Mrs Bradshaw is not in fact Roy's mother, but because she has pre-
tended to be for so many years, she half believes it); but this revelation is put
off until almost the final page of the novel, hence it lacks the emotive impact
it might otherwise have.

What again distinguishes *The Chill* is simply its vivid characters—
Alex Kincaid, a hapless young man whose wife, Dolly, disappeared dur-
ing their honeymoon; Dolly, another stand-in for Linda Millar, who flatly
declares that her husband "can wait till doomsday, I'm not going back to
him" (223); Helen Haggerty, a young professor who, in speaking of Dolly,
says ominously, "I could tell you things about that girl that would curl your
hair" (230) and predicts her own murder; Dr Goodwin, another in a line of
dubious psychiatrists who outlines the horrible circumstances of Dolly's
childhood, when she apparently witnessed the murder of her mother by her
father; and so on. But because Mrs Bradshaw (later identified as one Letitia
Osborne) and Roy Bradshaw are actually kept offstage for much of the ac-
tion, the identification of Letitia as a multiple murderer impresses the reader
as something of a trick. It may well be true, as Archer says, that "I had
handled cases which opened up gradually like fissures in the firm ground
of the present, cleaving far down through the strata of the past" (271); and
although Archer's investigations of all manner of crimes and derelictions by
various characters years or decades in the past is riveting, the novel fails to
be much more than a case of systematic police work on Archer's part.

The Instant Enemy (1968) draws us with its compelling portrayal of
a troubled young man, Davy Spanner, who has apparently run off with
Alexandria Sebastian, whose father calls Archer to find her. At the outset
Spanner is portrayed as a petty criminal; but as more and more facts (or
suppositions) about his past emerge, he comes to appear a victim of dread-
ful abuse whose proclivity toward violence is entirely understandable. We
learn that, when he was three years old, his father died mysteriously on a
set of train tracks, his head cut off and his young son by his side. What is
animating Davy is the suspicion that that man was not in fact his real father;
he suspects that a wealthy man named Mark Hackett is. A spectacular (and,
in all honesty, not entirely plausible) chain of murders and other crimes fol-
lows upon Davy's kidnapping of Mark's son, Stephen, from his ranch.

In the end, however, the convolutions in *The Instant Enemy* prove al-
most more than the reader can absorb, as we have multiple cases of mistak-
en identity, including a scenario whereby a woman kills her own husband as
well as her son and substitutes another man to take the latter's place. Again,
in the initial reading of it this over-the-top ploy seems superficially plau-
sible, but upon further reflection it—as well as the multiple murders that
stem from it—cause the novel to collapse into absurdity. Macdonald's writ-
ing is as sternly gripping as ever, but the high level of violence and baroque

intricacy of the plot strain credulity to the breaking point.

Much the same could be said of the next novel in the Lew Archer series, *The Goodbye Look* (1969)—the book that Eudora Welty praised. It would take a synopsis of many pages to outline even the bare plot of this work, which focuses on extraordinarily complex interrelations with multiple families. *The Goodbye Look* gains some measure of emotional resonance from its delicate portrayal of another troubled young man, Nick Chalmers, who, when he was eight years old, was "picked up by some sort of sexual psychopath" (80). Nick has now bolted, abandoning his fiancée, Betty Truttwell. John Truttwell, Betty's father and the Chalmerses's lawyer, calls Archer in to find Nick and recover a gold box that he has apparently taken, containing letters written by Nick's father during his involvement in World War II.

The irony of this novel is that it comes to take on the atmosphere of a fantastically complex John Dickson Carr–style puzzle story in its portrayal of bewildering entanglements between the Truttwell and Chalmers families, not to mention two other families who become insidiously involved. The comment by Nick's mother, Irene, that "This may not be an ordinary burglary" (20), is something of an understatement. Archer himself speaks more truly than he knows when he later remarks: "The case I was on seemed as hard to hold in the mind as the vanishing lights and the humming city were" (110). To be sure, there are vivid characterisations here and there, notably of another slimy psychiatrist, a Dr Smitheram; so disreputable is this person that Archer feels no particular compunction sleeping with the doctor's wife.

Mercifully, in *The Underground Man* (1971) Macdonald learned a bit of restraint in plotting, and he tells a relatively simple and straightforward story of a man, Stanley Broadhurst, desperately searching for his father, who ran off when Stanley was about eleven. But in the process Stanley has left his young wife, Jean, and taken his own son, Ronny, to some unknown destination. Archer, conveniently a neighbour of the Broadhursts, begins to investigate; and although what he learns about both the Broadhursts and the numerous other individuals and families becomes after a time a bit hard to follow, the core of the novel remains clear.

Once again, Macdonald reveals sensitivity in the portrayal of a mentally and emotionally stunted youth, Frederick (Fritz) Snow, whose doting mother seeks to shelter him from a world he seems unable to face. Another delicately etched character is Sue Crandall, one more in Macdonald's long line of troubled young women: she had been in the car with Stanley when he drove off with his son, although it is not clear whether she is romantically or sexually involved with him. Ronny is indeed rescued, but Stanley is found buried in a pit near a remote cabin; and Archer's investigations again lead to the unearthing of crimes, sexual irregularities, and other anomalies. The eventual identification of Fritz's mother as the chief culprit (although there

are others) is at once a surprising revelation and an inevitable product of her frantic efforts to shield her son from the consequences of his past actions.

The eighteen novels that constitute the Lew Archer series, along with Macdonald's six other novels and an array of short stories, are undeniably a significant contribution to the hard-boiled crime genre, and a modest contribution to American literature in general. If I hesitate to place Macdonald quite on the same footing as his predecessors, Dashiell Hammett and Raymond Chandler, it is chiefly because he cannot claim either Hammett's role as the founder of the genre or the dazzling witchery of style that distinguishes Chandler's work. Macdonald's prose is on the whole more inclined toward the austerity of Hammett than the prose-poetry of Chandler, although on occasion he can come up with the kind of memorable metaphor or simile that habitually crackles off of Chandler's pages. But it is chiefly his etching of character, and his frank analysis of the emotional traumas caused by long-standing sexual or criminal acts—usually inflicted upon, or at least witnessed by, children or adolescents—that distinguish his work and lend it its aesthetic substance. At times his plotting becomes needlessly complex, and the persistent use of first-person narration in the Archer novels can become monotonous and repetitious. But on the whole, Ross Macdonald deserves his high place in crime fiction. It may simply be that that place isn't quite as high as his most ardent supporters have claimed.

III. THE PSYCHOLOGICAL MYSTERY

MARGARET MILLAR:
SCARS OF THE PSYCHE

Canadian-born Margaret Millar (1915–1994) was far more than the wife of Kenneth Millar ("Ross Macdonald"). Author of twenty-one mystery novels and four mainstream novels, she was, if not the originator, at least the perfecter of what might be called the psychological mystery. The heart of a Millar novel is the intricate web of psychological motivations that not only produces crime, but hideous and grotesque crime. Although some of her early works feature light-hearted, tit-for-tat repartée reminiscent of Evelyn Waugh or Kingsley Amis, the bulk of her novels have an unrelievedly brooding atmosphere of ineluctable tragedy. Even in those works where a sudden surprise twist seems to suggest merely clever ingenuity, we come to realise that the denouement is the logical outcome of the nature of the case and the psychologies of the characters.

The Iron Gates (1945) sets the pattern for many of Millar's subsequent novels, especially with its focus on the female protagonist—no longer young, and burdened with family worries that seem to threaten the domestic bliss she has worked so hard to attain. In this case we are dealing with Lucille Morrow, who has married a widower, Dr. Andrew Morrow, and is struggling to establish a relationship with his two adult children, Polly and Martin, from an earlier marriage. That marriage was to Mildred Morrow, now dead for sixteen years; and the novel opens with a striking account of a dream in which Lucille sees Mildred, her best friend, with a hideous wound in the back of her head. Lucille "awoke, suffocating, sick with horror" (4)—for Mildred had been murdered in the park near the Morrows' house.

And yet, Lucille—the novel is told almost entirely from her perspective—professes to be happy. In spite of the difficulties she has with her stepchildren, she thinks: *"I love you, my dears, my dears. I can afford to love you because I have everything I want and neither of you can take anything away from me"* (9). But the final words of this thought suggest a worrying undercurrent that Lucille can scarcely articulate to herself. It quickly becomes plain that Polly in particular hates and despises Lucille. Lucille herself is clearly plagued with unacknowledged hostilities of her own. In particular, we are puzzled at her continuing obsession with the dead Mildred. Is

it merely that Andrew was passionately in love with her and has never been the same since her death? This would be understandable: what wife wishes to play second fiddle to a dead woman? But there seems to be more to it than this. Looking at a portrait of Mildred, she ponders: "Mildred, whole and happy and done in oils, and changeless, Mildred, still a nuisance after sixteen years" (26).

Nevertheless, Lucille's sudden disappearance, just as Polly's fiancé Giles is coming for a visit, takes us aback. This disappearance occurs after Lucille receives a mysterious box whose contents are not revealed to the reader. Lieutenant Sands, a detective who was featured in some earlier novels, eventually finds her in a hotel, and she is placed in a sanitarium. And yet, her response to this series of events is peculiar: "I am afraid I am going to be killed" (93). This comment has the effect of relieving readers from a suspicion they had come to harbour—namely, that Lucille herself had somehow killed Mildred. For why would Lucille be worried about being killed—presumably by a member of her own family—if she herself were the killer?

It is at this point that murders begin to pile up: first, of a morphine addict named Edwin Greeley, who had brought the mysterious box to Lucille; of Cora Green, Lucille's roommate in the sanitarium, who died from consuming poisoned grapes (sent by Polly for Lucille); and, finally and most strikingly, of Edith Morrow, Andrew's sister, from an overdose of sleeping medication. What could possibly be the connexion that links all these deaths?

The progress of the novel does indeed point to Lucille as the killer of Mildred, especially when a diary is found in which it becomes evident that Lucille "began to covet Mildred's husband and Mildred's money" (212). But Lucille, in the sanitarium, could not possibly be responsible for the other deaths. This is why it is so striking to the reader when Andrew is shown to be the culprit. It was he who had found the diary that made him realise that his second wife had killed his first; it was he who had sent the box—containing a human finger—to Lucille. Indeed, Lucille had not fled the house and come to fear for her life because of this gruesome gift, but because she knew that someone had found her diary and understood her complicity in Mildred's death. And yet, our suspicions are diverted from Andrew himself because of his genuine trauma over Mildred's death. Millar in fact makes a somewhat crude attempt to direct suspicion at Polly, as the one person who expressed unfeigned hostility to Lucille.

The novel has certain other crudities and clumsinesses in mechanics: a convenient train accident that provides Andrew with the means of securing the detached human finger; the convenient fact that Greeley is a drug addict, thereby allowing the physician an opportunity to administer a fatal

overdose; and the initial implausibility of Lucille being frightened merely by a human finger. Nevertheless, the relentless focus on Lucille's fluctuating psychological state has the effect of casting her as somehow the victim rather than the ultimate cause of the events that follow in her wake.

Another troubled woman is the focus of *Beast in View* (1955). At the outset, however, we seem to be dealing with two such women: Helen Clarvoe receives a strange phone call from one Evelyn Merrick, whom she does not know, and Evelyn makes vague predictions of her death or serious injury. Helen calls her deceased father's lawyer, Paul Blackshear, and asks him to find Evelyn; he reluctantly agrees. It is only about halfway through the novel that we learn that Helen was in fact acquainted with Evelyn—indeed, as a teenager she had wished to be like Evelyn, who was outgoing and popular with boys in contrast to Helen's shyness and plain looks. That envy had turned to hatred:

> She lay awake until morning, and the emotion that was strongest in her heart was not resentment against her parents but a new and bitter hatred for Evie.
>
> She did nothing about this hatred. It was buried with her inside the coffin and no one else knew it was there. Things went on as before, with her and Evie, or almost as before. They still shared a crush on the science master with the romantic eyes, they wrote notes in their secret language, and exchanged clothes, and food from home, and confidences. The difference was that Helen's confidences were not real. She made them up just as she'd made up the boys, and the incidents at the dance, for her father. (80)

This passage should have made readers sense that Helen is substantially more disturbed than Evelyn, but the overall thrust of the novel—told largely from Helen's point of view—leads us to identify Evelyn as erratic, oversexed, and potentially dangerous. It doesn't help that Evelyn had been briefly married to Helen's brother Doug; the marriage was annulled in a week, since Evelyn had declared that Doug was a "pervert" (86). Evelyn's mother later clarifies this by admitting that Doug was a "pansy" (85).

But the increasingly violent events—the death of a photographer, Jack Terola (who, it turns out, had had a homosexual relationship with Doug), and the apparent kidnapping of Helen herself, presumably by Evelyn, with the intention of leaving her at a whorehouse—all seem to point to Evelyn. Indeed, Millar induces the reader into thinking that Evelyn may have a split personality. But her flat denial to Blackshear that she had ever telephoned Helen at all gives him—and us—pause. The ultimate revelation—that Helen had killed Terola, in the course of pretending to be the purportedly evil side of Evelyn—comes as a grim and poignant revelation; it culminates in Helen's killing herself with a paper knife.

The sexual undercurrent in *Beast in View* comes to the fore in *The Fiend*

(1964). The focus here is on Charlie Gowen, who—as we learn through tantalising hints scattered throughout the novel—is a convicted pedophile. And yet, because he seems developmentally disabled, fundamentally on the emotional level of a child even into his early manhood, we are inclined to lend him our sympathy and hope that he can overcome his traumas and lead a normal life. The matter is rendered more difficult by the grim cynicism of his own brother, Ben, who is obsessively protective of Charlie and is perhaps unwittingly preventing him from attaining emotional maturity and independence. On the other side is Louise Lang, a librarian who has somehow fallen in love with Charlie and hopes to marry him; the fact that she has a "tiny figure like a girl's with the merest suggestion of hips and breasts" (27) makes us wonder whether Charlie's apparent fixation on little girls is really a thing of the past.

For the novel opens with Charlie's fascination with a nine-year-old girl, Jessie Brant, whose rambunctiousness causes him excessive concern. He mistakenly believes that she lives at 319 Jacaranda Road, which is in fact the home of her best friend, Mary Martha Oakley, the daughter of a woman whose traumatic relationship with her ex-husband, Sheridan, has rendered her suspicious of and embittered against all adult males. And when Charlie sends an anonymous note to her—"In the name of God please take better care of your little girl" (73)—that expresses a naively sincere concern that Jessie might injure herself playing on a jungle gym, events rapidly cascade out of control.

The "detective" in this case is, as in *Beast in View,* a lawyer—Kate Oakley's lawyer, Ralph MacPherson. He has dealt at tiresome length with her battles with Sheridan and is unconvinced that Sheridan is the author of the letter, or is stalking her in a green car that Kate has seen near her house. Nevertheless, Kate is convinced that "Something awful is waiting to happen, it's just around the corner, waiting" (128). We feel so too, but realise that it is Charlie Gowen, not Sheridan Oakley, who may at any time commit some inadvertent act—not out of malice, but precisely out of paranoid concern—that could result in tragedy.

As if this swirl of domestic trauma isn't enough, we are now introduced to the poignancy of a childless couple, Howard and Virginia Arlington, whose marriage is severely troubled by the fact that Virginia herself seems obsessed with Jessie, bringing her presents repeatedly and having her play at her house; it is clear that she wishes Jessie were her own daughter. It is they who seem ultimately responsible for the climactic event: Jessie's apparent kidnapping. For Howard had given Jessie $20 out of frustration that Virginia had bought her an expensive book, and when Jessie leaves her bedroom at night (climbing out the window and down a nearby tree) to return the money, she disappears.

We, of course, knowing that Charlie has been lurking about the neighbourhood frequently and that he has now learned where Jessie actually lives, are fully prepared to blame Charlie for the act. Indeed, now that MacPherson has learned that it was Charlie who had sent the note, and that it was discussing Jessie and not Mary Martha, the reader is set up to regard Charlie as the villain. Charlie, for his part, sees a newspaper account about Jessie and does feel he is somehow responsible; but the manner in which his reflections are expressed casts doubt in the reader's mind as to the exact level of his responsibility. First he thinks, in regard to the police's hypothetical reconstruction of the crime, "It was wrong, he knew it was wrong. It hadn't happened like that. Somebody should tell the lieutenant and set him straight" (205). He goes on: "'I didn't touch her'" (205). So clearly Charlie knows something about the abduction—but perhaps he is only a witness to it, not its perpetrator.

The reader's suspicions now switch to Virginia, who had earlier expressed her wish to see Jessie dead to protect her innocence:

> "We no longer have anything to offer a child. . . . How cruel it would be to pass along such an ugly thing as life. Poor Jessie. . . . She will lose her innocence and high hopes and dreams; she will lose them all. By the time she's my age she will have wished a thousand times that she were dead." (183)

Would Virginia have actually killed Jessie just to spare her the trauma of adult life? But MacPherson ponders certain things that Kate Oakley had said to him and recognises that she had kidnapped Jessie—both because she wanted Jessie as a companion to her lonely and withdrawn daughter, and (as Mary Martha had inadvertently revealed to MacPherson) "so we would never have to depend on bad men like Sheridan and Mr. Brant." For Paul Brant had been carrying on an affair with Virginia Arlington.

The sordid revelations of infidelity, jealousy, and hatred in this seemingly placid suburban community are overshadowed by the delicate but intense portrayal of the hapless Charlie Gowen, who, it turns out, may have been falsely accused of being a pedophile, as the young girl who was his purported victim apparently lied about his sexual assault on her ("she'd tell them he'd tried to make a baby in her" [236]). Although the novel ends a bit abruptly, we are at least relieved that Jessie is still alive and that Charlie may have a chance at a tolerably normal life, although Louise Lang's task in dealing with her adolescent-minded husband is not an enviable one.

One of the distinguishing features of Millar's work is the vibrancy with which she portrays landscape. When she was living in Toronto, she set several novels in the suburbs of Detroit, frigid in the chill of a northeast winter. After she and her husband moved to southern California, that parched

realm—along with neighbouring Mexico—became the setting for some of her most vivid narratives.

Vanish in an Instant (1952) is set in the outskirts of Detroit (specifically, the fictitious town of Arbana, Michigan) and features yet another of her cynical, world-weary quasi-detectives—Eric Meecham, a lawyer hired by Paul Barkeley, to defend his wife on a charge of murder. The focus here is alternately on Virginia and on her domineering and overprotective mother, Mrs Hamilton, who seeks to rescue her daughter at all costs, in some instances usurping Paul's role as her chief defender. The case looks grim for Virginia, for she was found in a drunken stupor in the house of a small-time gangster, Claude Margolis, who appears to have been her lover, and who has been killed. Virginia, however, maintains that she did not kill Margolis.

The sordidness of this scenario is augmented from an entirely different direction by the emergence of a conglomeration of characters who keenly exhibit the struggles of marginal working-class figures in an environment as socially chilling as the weather of that bleak winter. There is Earl Duane Loftus, an obviously dying man who claims that he killed Margolis because, having only a year to live, he felt he could do the most good by killing a bad person; there is Mrs Hearst, the landlady of Loftus's seedy apartment building, who is obviously in love with her tenant; there is Jim Hearst, her husband, a man whose failure to support his family makes him eager for whatever money he can beg, borrow, or steal. In this volatile mix, Meecham steps in with characteristically bland but determined resolution.

It would be profitless to trace the complexities of the narrative, but the novel concludes with a succession of surprise twists: we first learn that Mrs Hearst had formerly been married to Loftus (he had maintained that his wife, Birdie, was dead), then that she was also Claude Margolis's former mistress, then that she had killed Margolis when he had refused her plea for money to help Loftus during his terminal illness. These rapid revelations may seem preposterous when baldly stated, but Millar's deft construction allows each of them to appear both startling and inevitable. In the end, however, what really distinguishes *Vanish in an Instant* is its tremendous atmosphere of gloom and melancholy—the melancholy of wasted lives and futile acts of desperation that lead only to horror and tragedy.

The Listening Walls (1959) is a somewhat less complex work, but it is notable for the vividness of its Mexican setting. Here two middle-aged women, Amy Kellogg and Wilma Wyatt (the latter a recent divorcée), are vacationing in Mexico; but at the very outset the novel takes a grim turn when Wilma apparently jumps over the balcony of her room and dies. Was she pushed? Did she commit suicide? And why was she clutching a silver box in her arms as she fell—a box that she had purchased, oddly, for *Amy's* husband? Amy returns home alone and then, like Lucille Morrow in *The*

Iron Gates, leaves abruptly. She writes a letter, not to her husband Rupert, but to her brother, Gill Brandon, explaining her motivations:

> It is a week now since Wilma died, a week of regret and grief, but also one of reexamination of myself. I didn't come out very well. I am thirty-three, and it seems that I've been living like a child, always leaning on other people. I didn't enjoy it, I just could never get around to not leaning. I never will, if I simply stay here and sink back into the same old rut. I must get the feeling of being alone and being myself. I know that if I had been a mature, responsible person, used to making decisions and acting on them, I would have been able to prevent Wilma's death. If I had not been drinking myself, I could have stopped Wilma from drinking to the point of depression. (42)

This is not the most tactful letter for Amy to have written to Gill, for he has always been hostile to Rupert and thinks him an unworthy husband to his sister. Matters turn for the worse when Rupert claims to have received a letter from Amy stating that she is in New York and has taken her cherished dog, Mack—but Gill notices that Mack's leash has been left behind. At this point Gill comes to the spectacular conclusion that Rupert has killed his wife. Rupert's low-key manner during this turbulent period does little to allay Gill's suspicions.

In this novel, innovatively, there is no true detective figure, unless it is Rupert himself. Gill hires a private investigator, Elmer Dodd, but he plays a relatively small role in the totality of events. Dodd, in fact, declares that the various letters from Amy are unmistakably genuine, and this conclusion has the effect of exculpating Rupert—at least from the reader's perspective. Indeed, Gill himself may have a motive for getting rid of Amy, as by the terms of her will he would get half her estate. This revelation causes Dodd to ponder: *"Very interesting, Mr. Brandon. I know—and you don't know I know—that you've been living beyond your income for some time now, taking bites out of your capital to feed some pretty undernourished investments"* (68). But the idea that Gill would kill his own sister is never presented as a truly viable hypothesis.

The course of the narrative inclines the reader's sympathies to remain throughout on Rupert's side, but we are constantly buffeted by events and revelations that continue to suggest Rupert's involvement in both Amy's disappearance and perhaps also in Wilma's death. In a striking concluding tableau, Rupert and Dodd go back to Mexico and re-enact the final hours of Wilma's life. This is necessary because Amy has come to believe that she, in a state of drunkenness, had pushed Wilma over the balcony; but the re-enactment frightens a superstitious Mexican maid, Consuela, to admit that Wilma had fallen over the balcony on her own. Rupert had in fact hidden Amy away to prevent her from confessing her purported crime to anyone.

But the novel ends on a curious note. Back home and in apparent safety, Amy now confesses blandly to Rupert that she in fact killed Wilma. In all frankness, this final twist does not ring true, either to the character of Amy—a weak, put-upon woman striving to emerge from the shadow of her husband, brother, and best friend—or to the elaborate reconstruction of the incident in Mexico. Why would Consuela—plagued with superstitious terror that the ghost of the dead Wilma has returned—have admitted that Amy had had nothing to do with Wilma's death if Amy had actually been responsible for it? Millar's penchant for twisting the knife in the wound and ending her novels on a suitable note of grim tragedy has, in this case, resulted in a cheap jack-in-the-box trick that is aesthetically unsound.

That can hardly be said for two other novels set in remote regions of southern California, *How Like an Angel* (1962) and *Beyond This Point Are Monsters* (1970). The former is set in the fictitious town of San Felice, in southern California, but much of the action occurs in a far more remote setting—a religious colony called the Tower of Heaven. Joe Quinn, a casino detective in Reno and an unsuccessful gambler, is one of the most unlikely and outwardly disreputable of Millar's unwilling and improvised investigators; but when he is dropped off at the Tower rather than the town of San Felice, he has no option but to seek refuge there. In so doing, he comes upon an elderly woman, Sister Blessing, who gives him a small sum of money (in spite of the fact that private money is against the rules of the colony) to find a man named Patrick O'Gorman. Quinn quickly learns that O'Gorman is dead; his widow, Martha, claims that he died in a car accident, but his body was never recovered.

This is the premise for a searching treatment of the psychological undercurrents within the colony and also among the individuals associated with O'Gorman. Our immediate thought, indeed, upon learning of the ambiguous accident in which he was involved is that he himself is still alive and has ended up at the colony—but if so, how could Sister Blessing be unaware of the fact? And why is George Haywood—a real estate broker and brother of Alberta Haywood, who has been sent to prison for embezzlement—so concerned about Quinn's investigation? When Quinn returns to the colony and tries to report his initial findings to Sister Blessing, he learns that she is being punished for giving him money, and he is unable to see her. Then, when he sees Alberta Haywood in prison, she reacts with rage at the mention of O'Gorman's name: "Quinn wasn't prepared for her reaction. A look of fury crossed her face, and her mouth opened as if she was struggling to catch her breath. 'Then find him. Don't waste your time here, go and find him. And when you do, give him what's coming to him. Show him no mercy'" (118).

* * * *

Matters get further complicated when Martha O'Gorman admits to Quinn that she has received a letter from a man in Evanston confessing to killing O'Gorman, who had picked him up in his car and had then made an "improper advance" (146) on him. Quinn comes to believe that Sister Blessing is shielding O'Gorman's murderer in the colony, and he explains the nature of that colony to a police officer:

> "In order to understand the situation, you have to understand more about the colony itself. It operates as a unit almost entirely separated from the rest of the country. The True Believers, as they call themselves, do not feel bound to obey our laws or follow our customs. When a man enters the Tower he sheds his other life completely, his name, his family, his worldly goods, and, last but not least, his sins. Under our system it's illegal to harbor a murderer. But look at it from the viewpoint of the sect: the victim belonged to a world they no longer recognized, the crime is punishable under laws they don't believe in or consider valid. In her own eyes Sister Blessing was not acting as an accessory after the fact of murder. Neither were the others, *if* they knew about the murder, and that's a big if." (192)

By this time matters have indeed taken a serious turn: George Haywood has taken refuge in the colony but almost immediately dies by jumping off—or being thrown from—the Tower; Sister Blessing also dies after being poisoned with arsenic.

The novel takes a number of further twists and turns until it is finally revealed, first, that the murderer of Haywood and Sister Blessing is one Brother Tongue, a man who almost never speaks, and, secondly and most spectacularly, that Brother Tongue is himself Patrick O'Gorman. He had planned to run away with Alberta Haywood, but she had been caught embezzling, with the result that O'Gorman simply had to disappear—and he did so by taking refuge in the colony. In doing so, he had in the course of time come to forget his own identity in the outside world. When he confronts Quinn at the end of the novel, his widow cries in horror, "Patrick, Patrick! Oh, my God, Patrick!" What is his reaction? "He stared at her, wondering why she looked so familiar to him and who Omigod Patrick was" (254).

The unusual complexity of the scenario of *How Like an Angel* in no way detracts from the careful etching of a succession of lives—Martha O'Quinn, George and Alberta Haywood, and most of all Sister Blessing—scarred by crime and deception. The portrayal of the otherworldly members of the colony is handled with exquisite grace and precision, and without the slightest condescension in regard to their meagre grasp of the realities of a world they have repudiated.

If any flaw is present in the novel, it is in the interior monologue of the murderer that increasingly appears as the novel reaches its culmination. Millar comes close to deliberately deceiving the reader when she presents

a bit of dialogue between Alberta and O'Gorman as they prepare to flee together:

> She knew the time had come when his misery was so great that he would accept any plan at all. "We must make long-term arrangements. We love each other, we have money, we can start a whole new life together in a different place."
> "How, for God's sake?"
> "First we must get rid of O'Gorman."
> He thought she was joking. He laughed and said, "Oh, come now. Poor O'Gorman surely doesn't deserve that."
> "I'm serious. It's the only way we can be sure we'll always remain together, with no one trying to separate us or interfere with us." (232–33)

The artificiality of this discussion appears only at the end. What Alberta was attempting to say was that O'Gorman would have to take on a new identity; but the manner in which she expresses the idea—and the manner in which O'Gorman responds to it—is implausible.

Beyond This Point Are Monsters is set in southern California, close to the Mexican border. Virtually the entire novel is merely the transcript of a hearing to determine whether a rancher, Robert Osborne, should be declared dead. Robert, who had married a young woman named Devon only a year and a half before his apparent death, had been involved in an apparent fight with one or more of his own workers in their mess hall; a great deal of blood was present, and a bloody knife was later found in a field. Devon is convinced her husband is dead, but his mother, Agnes Osborne, is fanatically determined to believe in his continued existence until the matter is settled beyond all doubt.

The circumstances of the case unfold with agonizing slowness, and they are complicated by the murkiness of at least two other episodes involving death—that of Ruth Bishop, a neighbour of the Osbornes who had drowned in a nearby river, and for whose death Robert himself was blamed (he was accused of having an affair with her and planning to run away with her—a scenario apparently confirmed by the discovery of a suitcase found after Ruth's death), and the death, years earlier, of Robert's own father, apparently from falling off his tractor. Without going into the complexities of the exposition, we ultimately learn that Robert had in fact had an affair with Ruth Bishop. More spectacularly, a worker on the ranch, Felipe Lopez, confesses to Agnes Osborne that he had killed Robert in a fight and had thrown the body into the ocean. What is more, years earlier Felipe had seen Robert throw away a bloody 2 × 4 after his father's death: could Robert have killed his own father? In a final appalling twist, we learn that Agnes herself had killed her husband. She now plans to keep Felipe in her home as a kind of replacement for Robert.

This novel is exceptional in featuring no detective at all, although Devon's lawyer, Franklin Ford, plays a small role in the events. Instead, the entire focus of *Beyond This Point Are Monsters* is on the emotional trauma of two women, Devon and Agnes, both in their own very different ways obsessed with the ambiguous figure of the appealing but somewhat irresponsible Robert Osborne, whose dalliance with a much older woman shatters both their images of his stainless character. Without a wasted word, Millar etches the equal determination of both women to achieve a diametrically opposite result in the investigation of Robert's disappearance. And Agnes's refusal to accept her son's death, to the point of seizing upon her son's own killer as a hideous replacement for him, bespeaks the psychosis that has disfigured her in the year following his disappearance.

Millar's most accomplished novel may well be *A Stranger in My Grave* (1963), whose fusion of psychological analysis, complexity of plot, and atmosphere of impending doom is unparalleled in her work. The focus of the novel is largely on Daisy Harker, a troubled young woman whose husband, Jim, and mother, Ada, are puzzled by a recent panic attack that Daisy experienced; in a memorable phrase, it is said that "Jim didn't recognize the color of terror" (7). We are given the substance of a bizarre dream that Daisy had had—a dream in which she had imagined she had seen her own tombstone in a nearby cemetery, with the date of death given as December 2, 1955, about four years previous. The question becomes: what, if anything, had happened on that fateful day?

Daisy hires a bail bondsman, Stevens Pinata, to investigate the matter; he reluctantly agrees, not confident that he, rather than a psychiatrist, is the one to probe the matter. After consulting a newspaper of that date (presumably an evening paper, since a morning paper would have recorded events of the day before), Pinata is struck by the fact that Daisy reacts oddly to a brief article about a young woman named Juanita Garcia. Daisy claims she does not know the name, but why is she so agitated? The reader has already been alerted to the fact that a Juanita is somehow involved in the matter (see 58), and when it turns out that Juanita was a patient at a pregnancy clinic at which Daisy briefly worked, the likelihood is strong that Daisy in fact knew Juanita.

It would be cumbrous to spell out the details of this exceptionally involved plot, perhaps the most convoluted in Millar's work. The quasi-supernatural premise of the novel—a dream that seems to have some prophetic implication—is enhanced by the extraordinarily subtle and indirect way in which successive layers of information are revealed to the reader. The tombstone of Daisy's dream turns out to be all too real—but it bears the name (and presumably the body) of one Carlos Theodore Camilla, a Hispanic drifter who had apparently died of suicide—and, oddly, in possession

of $2000 in cash. But it is later learned that Camilla had had such bad arthritis that, in the judgment of a funeral director, he could not possibly have stabbed himself to death, as the police report claims.

And what of the fact that December 2, 1955 was the last day that Daisy had worked at the clinic, and was also the last day that Juanita was seen? Where does Daisy's shiftless father, Stan Fielding, fit into the scenario? He reappears on the scene after a long absence, his only virtue being his unquestioned love for Daisy. It is no surprise that his ex-wife, Ada—another in a long line of domineering mothers in Millar's work—does everything she can to make him disappear.

The climax—or, more properly, succession of climaxes—comes with the effect of repeated body-blows, making us keenly aware of the psychological trauma under which Daisy has been living. First is the apparent revelation that her husband Jim had had an affair with Juanita and had impregnated her; in compensation, he began paying Juanita's mother $200 a month beginning on that fateful day of December 2, 1955. Jim had in fact told Daisy about Juanita, but she had suppressed the memory. This revelation is overturned later, as Juanita (now a waitress) admits that she never knew Jim; Jim, pressured by a now enraged and determined Daisy, admits that he had lied about Juanita to conceal the fact that he was sterile and was the true cause of their inability to conceive a child.

But what of Camilla? Ada admits to giving the dying man $2000 to pay his funeral expenses, but she denies killing him. It appears momentarily that Daisy's beloved father Stan had killed Camilla, but on virtually the final page we learn that Camilla's death was accidental—and, more significantly, that Camilla was Daisy's father. Ada's frequently expressed prejudice against Hispanics suddenly takes on a very different hue.

The richness of texture of *A Stranger in My Grave* can only be grasped upon reading. The intense focus on Daisy's psychological malaise does not prevent Millar from painting the other characters in the novel crisply and vividly. Daisy may have been "psychically murdered" (30) on December 2, 1955, but that date was only the nexus for a complex concatenation of events in which each major figure was seeking to manipulate events to his or her own ends. We end, as we do in so many Millar novels, with every character shattered by the revelation of acts that display the pain, humiliation, sordidness, and hypocrisy that lies at the root of their personalities.

If there is any flaw in Millar's work, it is the insertion of an adventitious and unconvincing romance element—usually by her improvised detectives—that is perhaps meant to lighten the atmosphere of dreariness and gloom that tends to hover over all her work, but which is not well worked out and seems implausible from the start. Eric Meecham, in *Vanish in an Instant,* falls in love with Alice Dwyer, a maid/companion to Mrs Hamil-

ton. Paul Blackshear makes a sudden declaration of love to Helen Clarvoe at the end of *Beast in View,* but that does not prevent her from taking her own life. In *A Stranger in My Grave,* Stevens Pinata and Daisy Harker fall in love, although it is anyone's guess whether they will be able to pursue their relationship after Daisy's family life has been shattered by Pinata's investigations. Joe Quinn falls quickly in love with Martha O'Gorman, but their relationship is presumably halted by the revelation that Martha's husband Patrick is still alive. Only in *The Fiend* is the romance element—here between Charlie Gowen and the librarian Louise Lang—handled compellingly and effectively. Flawed as both these characters are, there seems at least some minimal chance that they can make something of their lives, and their relationship, after the trauma of the novel's events have subsided.

Stylistically, Millar makes exhaustive use of simile: her favourite words are "as if," and whole conversations can be carried on in interlocking metaphors. This device would become tiresome and monotonous if her similes did not hit home so tellingly and did not resonate far beyond their immediate contexts. Some of Millar's later novels—such as *Ask for Me Tomorrow* (1976) and *Banshee* (1983)—show a return to the pungent humour of her early novels, and her final novel, *Spider Webs* (1986), is a reprise of the framework—a trial or hearing used as a springboard for the psychological portrayal of the central figures—of *Beyond This Point Are Monsters.* But the best of Millar's work is chilling precisely because we see ordinary characters led by some psychological trauma in their past to perform horrible crimes that nevertheless have a sort of twisted logic to them. Her middle-class characters could be our neighbours, our friends—or ourselves.

PATRICIA HIGHSMITH: GUILT AND INNOCENCE

Patricia Highsmith (1921–1995) wrote twenty-two novels and eight collections of short stories over more than forty years of writing, and several of her novels were adapted into well-known and effective films. She gained a reputation even among highbrow writers like Graham Greene for novels and tales that are written with panache, a sense of cumulative suspense, and a certain coldness both in prose and in overall emotional resonance, as if she were an alien entity regarding with bland indifference the curious but only minimally interesting actions of a contradictory, tormented, and fundamentally irrational human species. Some proportion of critics' admiration of her work had to do with the vividness of her cosmopolitan settings, whether it be New York City or fashionable locales in Europe ranging from Paris to Venice to the English countryside. She herself, after graduating from Barnard and working for (of all places) a comic book publisher for several years in the 1940s, spent most of her adult life in Switzerland, and her European settings have the unmistakable ring of veracity and first-hand experience.

In *Plotting and Writing Suspense Fiction* (1966), Highsmith defines herself as a suspense writer, as opposed to a mystery writer. The distinction is clear: she is not interested in concealing the identity of the criminal (her one whodunit, *A Game for the Living* [1958], is clumsy and half-hearted, described by herself as "the one really dull book I have written" [139]), but in watching—and letting us watch—the criminal commit his or her acts and then suffer the inevitable psychological traumas they engender. She portrays ordinary characters thrust into extraordinary situations: people who, with no prior criminal background, commit multiple murder; or, conversely, the innocent victims of crime who themselves become as psychologically shattered as the perpetrators. But the philosophy behind every one of her works is that we are all potential criminals and victims; it takes little to push us over the brink.

It is not clear that Highsmith ever excelled her scintillating first novel, *Strangers on a Train* (1950), which brilliantly broaches many of her characteristic motifs. The premise of this novel is transparently simple: an ar-

chitect, Guy Haines, who is estranged from his wife, Miriam, accidentally meets a disturbed individual, Anthony Bruno, on a train, and Bruno (as he is called throughout the novel) hatches what he believes is a foolproof double murder: he will kill Miriam while Guy will kill Bruno's hated father. Guy, of course, takes all this speculation to be just that; but Bruno, purporting to understand that the two have actually entered into an agreement, goes ahead and kills Miriam and then puts pressure on Guy to kill his father. Guy reluctantly does so, but suffers immense guilt thereafter and ultimately confesses.

The scenario Highsmith has established here is one that, in varying degrees and permutations, she uses in a good many of her works: how is a "normal" person (Guy Haines) to deal with the unnerving and frankly insane actions of a psychopath (Anthony Bruno)? Highsmith relentlessly etches, in chapters alternating from Guy's to Bruno's perspective, the psychological aberration of the latter: he is full of resentment against his dictatorial father; he is, in fact, something of a mama's boy and therefore harbours deep hostility toward women; he has no purpose in life, and it is explicitly stated that the murder of Miriam, in the little Texas town of Metcalf, would give meaning to his life: "Now, on the train to Metcalf, he had direction. He had not felt so alive" (62). Without even knowing his victim, he develops an intense loathing of her ("The little bitch! He hated her already" [61]), and, in classic psychopathic fashion, in his mind "Miriam had become an object, small and hard" (65).

Conversely, the murder has, in Bruno's mind, established an inextricable bond between him and Guy: "The bond between Guy and him now was closer than brotherhood" (97). He is, accordingly, devastated when Guy—who had striven desperately to believe that Bruno could not really have killed Miriam, but who is now forced to acknowledge that he did so—tells Bruno not to communicate with him anymore. But this only encourages Bruno further: he keeps encountering Guy in New York; he threatens to tell the police about the crime; he mails Guy a sketch of his father's house and a plan of how he can most conveniently commit the murder, and even sends him a gun.

The episode in which Guy kills Bruno's father is written with a dramatic tensity that Highsmith rarely equalled—for of course, if Guy goes ahead and commits the deed, he will lose all the reader's sympathy and deserve whatever punishment he receives. Up to this point, it could plausibly be maintained that Guy is merely the victim of a psychopath and that he had only minimal involvement with the death of Miriam; but his actual committing of a murder will change everything. And so it does: the murder does not at all go according to plan, and after shooting Bruno's father Guy is pursued by a butler and, in a passage distinguished for its surreal,

existential narration, falls unconscious after fleeing through a nearby wood. But more significantly, Guy is consumed with guilt:

> He thought of his mother, and felt he could never let her embrace him again. He remembered her telling him that all men were equally good, because all men had souls and the soul was entirely good. Evil, she said, always came from externals. And so he had believed . . . But love and hate, he thought now, good and evil, lived side by side in the human heart, and not merely in differing proportions in one man and the next, but all good and all evil. One had merely to look for a little of either to find it all, one had merely to scratch the surface. (163)

The rest of the novel—when it is not a kind of police procedural whereby Arthur Gerard, a friend of Bruno's father, relentlessly pursues the case until he finally tricks Guy into making a confession that is recorded on a dictaphone—is a systematic exposition of Guy's descent into helpless depression. Even though Bruno dies, apparently by accident (he drunkenly falls overboard and Guy is unable—or perhaps secretly unwilling?—to rescue him), thereby perhaps allowing Guy to escape prosecution, Guy knows that his own conscience will never clear him, and his concluding confession to Gerard takes on something of a spiritual purgation.

It is worth noting that Alfred Hitchcock's film adaptation of the novel, appearing a year after the publication of the novel, is one of his poorest suspense films. Incredibly (given the fact that the screenplay was cowritten by Raymond Chandler), the film portrays Guy pulling back at the last instant from the murder of Bruno's father, rendering the plot a transparent and morally unchallenging good-vs.-evil scenario in which Bruno is ultimately killed and Guy can presumably live on in peace and tranquillity. How Hitchcock and Chandler could have committed such aesthetic errors in altering the fundamental thrust of the novel is beyond one's power to fathom.

Highsmith's remaining novels alternate between those depicting criminals, usually disturbed or actually psychotic, committing crimes and seeking to escape their consequences, and innocent persons fighting against crimes directed against them and on occasion descending to crime themselves. The latter are considerably more interesting from a psychological and aesthetic perspective, but we will give some consideration to the former.

This Sweet Sickness (1960) is the account of David Kelsey, who is hopelessly in love with Annabelle Stanton, but who has been rejected by her. The novel probes Kelsey's gradual descent from mild neurosis—he is portrayed at the outset as spending weekends at a house in the countryside in which he pretends to be leading a life of wedded bliss with Annabelle—to crime and vengeance. Highsmith is clever in depicting Annabelle's husband, Gerald Delaney, as considerably less than successful: David is already con-

vinced that Annabelle does not love Gerald, and that Gerald is poor to boot; and when David actually confronts the couple in their apartment, Gerald is found to be pudgy and almost feminine in bearing—hardly a worthy husband for such a divine creature as Annabelle!

Matters take a turn for the worse when Gerald confronts David at his weekend house (whose existence he had discovered when he had come to David's boarding house and was told about it by Effie Brennan, a young woman who is interested in David). Even though Gerald has a gun, he is beaten up by David and dies. David stuffs Gerald's body in his car and drives to the police station, claiming that he doesn't know who Gerald is but that the man had confronted him with a gun and that David had acted in self-defense. This scenario seems plausible at the outset, but Effie quickly ascertains that David in fact killed Gerald. But David continues to pursue Anne, even threatening to take her away by main force; and she tellingly identifies his central psychological malady: "You seem to live entirely in your own head and you don't know anything at all about other people, the people around you" (131). Later David kills Effie (having mistaken her for Anne), flees to New York to look up a friend, and then—in a scene of excruciating suspense—goes out on a ledge and threatens to jump. He finally does so, and in his fall he reflects on his wasted life: "Nothing was true but the fatigue of life and the eternal disappointment" (249).

The Two Faces of January (1964)—one of several Highsmith novels whose titles are both inscrutable in themselves and seem to have little relevance to the scenario—fuses guilt and innocence in an ingenious manner. Guilt is represented by Chester McFarland, a small-time crook who arrives in Athens with his wife, Colette. He is already fleeing the Greek police, and in the course of a scuffle with a policeman in a hotel hallway he kills him. This is when he meets the nominally innocent Rydal Keener, a young man who—perhaps because Chester reminds him of his father and Colette of a cousin with whom he had a brief sexual affair at the age of fifteen—recklessly agrees to help the couple conceal the body and flee. He and Colette, indeed, almost have a sexual encounter when they are in Crete. It would be fruitless to pursue the numerous plot twists of this novel, but the end result is that Rydal becomes a kind of shadow or nemesis of Chester and his wife, in the course of which Chester inadvertently kills Colette while trying to kill Rydal. The novel takes us from Crete to Paris to Marseille, where Chester is finally shot by the police and, with his dying breath, magnanimously clears Rydal of any wrongdoing in the whole affair. Rydal, for his part, vows to attend Chester's funeral in the potter's field in Marseille.

For all the vividness of the European setting, *The Two Faces of January* has something of an improvisatory feel to it, as if Highsmith did not have a clear idea of where the novel was going or what its fundamental message

would be. Rydal's pursuit of Chester is by no means in the interests of pure justice, for he extorts $10,000 from him at one point and seeks more money later; and he himself dodges the police on numerous occasions, once jumping into the back of a truck to escape police surveillance. In the end it is difficult to come away with any overarching meaning in the novel aside from the mundane suggestion that the consequences of crime are numerous and wide-ranging.

The Glass Cell (1964) keenly depicts an innocent man turning into a guilty one; and its success depends not only on its intense prose and vivid characterisation but on the first-hand knowledge Highsmith brings to play. In this novel of Philip Carter, a man unjustly imprisoned for embezzling whose troubles upon leaving the penitentiary are imperishably etched, Highsmith drew upon correspondence she engaged upon with a prison inmate (she speaks of the matter in detail in a chapter of *Plotting and Writing Suspense Fiction*). The scenes depicting prison life and, even more potently, those depicting her protagonist's uneasy freedom after his release are as compelling as any in her entire oeuvre.

The novel opens with a searing portrayal of the torture—the mutilation of his thumbs when he is strung up for hours—that Carter experiences for some minor infraction. A later scene portraying a prison riot, in the course of which Carter may have killed a man and also had his arm broken, is also grimly powerful. But Carter has other worries: he fears that his long-suffering wife, Hazel, is carrying on an affair with his lawyer, David Sullivan. When, after six years in prison, Carter is finally released, he confronts Hazel, who admits that she briefly had a sexual affair with David for about three weeks some years before. When Carter sees Hazel going to David's apartment at a time when she said she would be elsewhere, his fears that the affair is in fact continuing appear to be confirmed. He later goes to David's apartment and runs into a stocky man fleeing. David tells Carter that that man was going to kill him. Carter himself punches David and ends up killing him himself.

Suspicion does not fall upon Carter, but rather upon Greg Gawill (Carter's former boss, who may in fact have been the true embezzler) and an associate, Anthony O'Brien, who was probably the stocky man seen leaving David's apartment building. Carter is indeed also grilled by the police, but his previous stint in prison allows him to endure their verbal tortures with ease. O'Brien, however, now threatens to tell the police about Carter, as he saw him enter David's apartment. Carter comes to a grim conclusion: "He saw no alternative but to kill O'Brien" (225). He does so. He then goes to Gawill and demands that the latter provide him with an alibi, for he knows that Gawill had in fact paid O'Brien to kill David, but O'Brien had botched

the job. Carter himself feels not the slightest remorse at killing David or O'Brien:

> Well, justice was certainly the wrong word for all of it. An eye for an eye was nearer what he had felt, and yet that was not it, either, because in principle he didn't believe in that. In principle, his killing Sullivan had been an evil act, done in anger. And the fact that he felt no guilt made it worse, in principle and in fact. His killing O'Brien had been a calculated, cold-blooded act done to clear himself of an equally evil act. Carter could admit to himself that both acts were evil, and yet he felt no pangs—or very little pangs—of conscience about either of them, or both of them together. (245)

Carter later endures days of brutal police grilling, but he does not crack. The police have no recourse but to release him. When he meets Hazel just before his release, he realises that she knows what he has done.

In *The Glass Cell* Highsmith's icy, almost affectless prose works, because it so meshes with the temperament of her brutalised protagonist. After what Philip Carter has experienced in prison, the mere act of killing the lover of his adulterous wife, and the man who had himself planned to kill that same person, is at best a brutal necessity. There is almost a sense of poetic justice at play—for didn't David Sullivan deserve to die for seducing his client's wife, and didn't O'Brien deserve to die for being a murderer for hire? Highsmith never states any of this directly, but the reader is clearly meant to draw such conclusions from the course of the narrative. And because, as in so many of her other novels, the exclusive focus is directed upon a single individual—here, Philip Carter—the reader is compelled to see events through his eyes and thereby gain a kind of sympathy for him even as he continues to commit crimes that are, from the point of view of abstract morality, less and less justifiable.

Highsmith's four Ripley novels should probably be studied here, although only the first two are of compelling interest. What Highsmith is attempting to do in these works is to create a *likeable* criminal—not merely one who engages in minor crimes such as chicanery or embezzlement (although, at the beginning of *The Talented Mr. Ripley* [1955], Tom Ripley is in fact involved in a scam whereby he pretends to be an IRS agent collecting taxes purportedly owed by various individuals in New York), but more serious acts including murder, forgery, impersonation, and kidnapping. Highsmith creates this effect in her first Ripley novel by portraying her protagonist as rather unworldly and socially inept; indeed, she states plainly that Tom—when he is sent by Dickie Greenfield's father to hunt him up in Italy, where he is living a carefree life with a charming girlfriend, Marge Sherwood, and bring him back home—"envied [Dickie] with a heartbreaking surge of envy and self-pity" (44). In the early portions of the novel, as

he infiltrates himself into the lives of both Dickie and Marge, Tom feels alternately jealous of both of them and even contemplates killing Marge (63) and, later, Dickie himself (79). The opportunity for the latter accidentally occurs during an outing with Dickie when, on a boat at San Remo, the two get into an argument and Tom kills Dickie by hitting him with an oar and throwing his weighted body overboard.

At this point Tom attempts to take Dickie's place, aided by the convenient fact that he is approximately Dickie's height and build. The charade works for a time—but it does not entirely fool a friend of Dickie's, Freddie Miles, whom Tom is also forced to kill after Freddie expresses grave suspicions of Tom's involvement in Dickie's disappearance. As the police investigation casts increasing suspicion on Tom (who, because he is disguising himself as Dickie, also seems to have "disappeared"), he comes up with the clever plan of asserting that Dickie committed suicide—and, conveniently, had made out a will just before his death leaving everything to Tom. The bumbling of both the Italian police and of an American private investigator hired by Dickie's father allows Tom to escape punishment—and when Dickie's father honours the terms of the forged will, Tom Ripley seems to be on easy street.

The relentless focus of *The Talented Mr. Ripley* on Tom Ripley and his at times desperate attempts to escape punishment for his actions compels readers to "root" for him even though few would have sympathy either for his initial criminal act (the killing of Dickie Greenfield) or for his subsequent efforts to elude justice. The title is something of an ironic misnomer, for Tom really has little "talent" aside from his coincidental similarity in appearance to Dickie and his occasionally inspired contrivances to shift the blame on to others or on to the deceased Dickie himself. The twists and turns of Tom's emotions are vividly etched throughout the novel, from dread of capture ("Tom expected the police to come knocking on his door at any hour of the day or night [208]) to a kind of resigned defeatism ("Tom lived in a peculiar atmosphere of doom and heroic, unselfish courage" [211]). He himself cannot believe his good fortune not only at escaping the noose but at pocketing Dickie's considerable fortune.

The atmosphere of *Ripley Under Ground* (1970) is very different. As the novel opens, Tom is comfortably married by Heloise Plisson, the daughter of a millionaire businessman, and living in a lavish mansion in France. Heloise, of course, does not know of his criminal past, although she is aware that his current status as the owner of a London art gallery was not attained entirely innocently. Matters take a serious turn when a prospective buyer, Thomas Murchison, doubts the authenticity of a painting by the celebrated painter Derwatt, whose work is exclusively represented by Tom's gallery; in fact, Derwatt died years ago, and paintings passing under his name are

being forged by a talented but tortured friend of Derwatt's, Bernard Tufts. Although Tom again engages in impersonation by appearing at the art gallery as Derwatt, Murchison's suspicions are not allayed, and Tom eventually kills him in his own wine cellar and buries the body in the woods near his house.

In the police enquiry that inevitably follows, Tom is kept busy both placating Tufts, who feels increasingly guilty at forging work under the name of his dead friend, and fending off various guests—including Christopher Greenleaf, the young cousin of Dickie—who arrive at his house. In a striking scene, Heloise finds that Tufts has hanged himself in the cellar—but it is only a dummy. Tufts declares that he will no longer paint the forgeries and, in a rage, attacks Tom himself: "I detest you—because all this is entirely your fault" (353). A plausible accusation, indeed. It doesn't help that Tom had previously confessed to Tufts his murder of Murchison and persuaded him to help dig up the body and deposit it in a nearby river. (The police's later discovery of the empty grave adds to their puzzlement.) In an even more harrowing scene, Tufts himself strikes Tom with a stone and buries him in the empty grave, from which Tom must laboriously dig himself out. The novel concludes with Tufts hurling himself over a cliff in Salzburg and Tom claiming to the police that Derwatt himself was the jumper and that Tufts, disconsolate, had also committed suicide.

Ripley Under Ground is engaging but perhaps less gripping than its predecessor, for it simply portrays Tom Ripley as once again improvising various makeshift strategies—up to and including murder—to evade the law or to preserve the profits of his art gallery. If any character emerges as sympathetic and compelling, it is the tormented Bernard Tufts, who has prostituted his substantial skills as an artist for the criminal profits of forgery. Tom's wife Heloise emerges as blandly amoralistic, reacting with little outrage—or even interest—when Tom confesses his murder of Murchison and his impersonation of Derwatt; all she is concerned with is the maintenance of her economic status and the social advantages that accompany it. In the two later Ripley novels, *Ripley's Game* (1974) and *The Boy Who Followed Ripley* (1991), Tom himself becomes rather more conventional, killing only in self-defence, his victims usually being Mafiosi. In the latter novel Ripley actually kills no one. He has become a warmer and more human figure, but a less interesting one.

Of those novels that deal largely with the innocent, we might begin with *The Cry of the Owl* (1962). The focus here is almost exclusively on Robert Forester, an industrial engineer whose sole peccadillo—and it is plausibly presented as such—is looking into the window of a house belonging to a young woman, Jennifer Thierof. Forester is not interested in watching Jennifer undress or any other such prurient motive; rather, he seems naively

taken with the domestic simplicity of her life and wishes he could share it. (Forester himself is in the process of divorcing his shrew of a wife, Nickie.) When Jennifer sees Forester through her window, he immediately apologises and asks her forgiveness. She invites him in and they talk for a while—at one point she even gives him cookies! Jennifer herself is engaged to be married to a rather loutish individual, Gregory Wyncoop. Highsmith has therefore established a scenario whereby readers are urged to see Forester as a basically good but lonely and unworldly man and to hope that somehow he can establish a genuine relationship with Jennifer.

But of course things go awry almost at once. Jennifer tells Robert that she has broken off her engagement with Gregory; Gregory, enraged at learning of her involvement with Robert, storms into her house, whereupon Robert declares: "I have no intentions with Jenny" (49). Not long thereafter, Jennifer confesses her love for Robert (56), but he attempts to persuade her that he is mentally unstable: "It was a mistake to get to know you" (61). But Jennifer continues to pursue Robert. Once, when he is on the way to a dinner date with her, Gregory chases him in his car. They have a fight near the river; there is no clear winner, but Robert remembers pulling Gregory out of the water and leaving him on the shore. But Gregory does not return home—has he in fact died?

It is at this point that the police intervene. Robert himself told the police about the fight, but they later query him more sharply as Gregory continues to be missing. What in fact has happened, as the reader soon learns, is that Gregory is hiding out with Robert's vindictive ex-wife, Nickie. Nickie's new husband, Ralph Jurgen, finally informs Robert about Gregory, who then tells the police; but in one sense it is all too late: Jennifer, convinced that Robert has killed Gregory, has committed suicide.

At this point it is clear that Gregory, if anyone, is the guilty party, both in faking his own death to implicate Robert and, indirectly, in causing Jennifer to kill herself. But matters take a yet more dangerous turn when local residents rise up against Robert: one of them shoots at him through his window and hits him in the arm; later, when Robert is taking refuge with a Dr Knott, the doctor himself is shot and lapses into a coma. There is still more tragedy: Nickie is enraged that Robert has told the police about her involvement with Gregory, for this has led Ralph to divorce her; Nickie and Gregory both come to his house, where a fight occurs in which Gregory accidentally strikes Nickie with a knife, causing her to bleed to death.

The unrelentingly cheerless atmosphere of *The Cry of the Owl* is an achievement of sorts, but Robert Forester is portrayed in such a wooden manner that he fails to evoke much sympathy from the reader aside from the general injustice of his situation. This is one of several novels where Highsmith's deliberately bland, cold prose works against the emotional depth

she is trying to achieve, most notably in the depiction of Jennifer's hopeless love of Robert. Robert is such a faceless individual that one wonders how he could evoke such an emotion from anyone, even such a young and innocent woman as Jennifer. The only successful portrayal in the novel is the evil Nickie, but she occupies a relatively small role in the overall scenario.

A Suspension of Mercy (1965) is a curious and not entirely satisfactory work. Set in rural England, it deals with Sydney and Alicia Bartley, who live in a remote cottage in a small town in Suffolk. Sydney, a struggling American writer who has collaborated with varying degrees of success with a British colleague, Alex Polk-Faraday, on novels and television series, and his British wife are increasingly at odds; Highsmith makes the couple's marital troubles evident at the start, going so far as to have Sydney imagine killing his wife (26). Indeed, when, after a spat, Alicia goes away for some weeks, Sydney thinks it might be amusing to *pretend* to have killed her: he goes to the extent of burying an old carpet in the woods, as if her body were in it. Unluckily for him, his neighbour, an elderly lady named Mrs Lilybanks, sees him carry the carpet away. When she later asks him about the matter, Sydney "looked guilty. He acted guilty" (96).

When it is found that Alicia is not at her mother's house, as she had claimed, suspicion turns upon Sydney, who does little to allay it. After much searching, the police find the carpet—empty, of course. But they now suspect that the carpet-burying is a blind and that Alicia's body might be buried elsewhere. Matters become worse for Sydney when Mrs Lilybanks dies suddenly of a heart attack in his presence; a housekeeper who arrives soon thereafter is convinced that Sydney killed her, but there is no evidence for this.

The reader has known all along that Alicia is in fact staying in Brighton under a pseudonym, and, moreover, that she is having a rather languid and hesitant affair with a man, Edward Tilbury, she met at a party. Sydney eventually figures out Alicia's whereabouts and the fact of her affair with Tilbury—but incomprehensibly fails to report all this to the police, even though it would instantly clear him of suspicion of the murder of his wife. His decision is rendered more inexplicable because the sale of a television series he has been working on with Polk-Faraday is postponed because of the cloud of suspicion under which Sydney lies. But Highsmith—who up to this point has depicted no actual crime in the entire scenario—is forced into this unconvincing tactic because she wishes to load the climax of the novel with some definitively criminal activity.

Sydney learns that Alicia is dead, having fallen—or perhaps having been pushed—over a cliff in Brighton. He naturally suspects Tilbury, goes to his flat in London, and forces him to take sleeping pills. Tilbury, however, does not die immediately; he is taken to the hospital, and Sydney suffers

keen pangs of anxiety until he learns that Tilbury died that night. Even though a witness saw Sydney visit Tilbury's flat, there is insufficient evidence to arrest him; and so the novel ends.

The general point of *A Suspension of Mercy* is, I suppose, Highsmith's by now habitual implication that anyone can turn into a criminal if sufficiently provoked. Perhaps we are to assume that the days and weeks that Sydney spent under a cloud of suspicion of murder somehow led him to commit actual murder. But, as with *The Two Faces of January,* the novel seems to proceed without much direction or focus, and the only scene of reasonable effectiveness—Sydney's confrontation of Tilbury and his forcing him to commit suicide—is insufficient to justify an otherwise meandering and uncompelling narrative.

Somewhat more effective is *Those Who Walk Away* (1967), whose vivid European setting is matched by the two protagonists at its heart. One is Ray Garrett, whose young wife Peggy committed suicide for unspecified reasons in Mallorca; the other is Peggy's father, Edward Coleman, who blames Ray for her death to such a degree that, at the outset, we see him in Rome taking potshots at him. Later, in Venice, Edward tries to throw Ray overboard on a motorboat. Ray survives this attack also—and, in the course of time, begins stalking his own stalker. Because Ray is keeping his identity (and his survival from the boating incident) a secret, Edward falls under suspicion of murder. Matters are eventually reversed when, after a fistfight in a Venice alley, Edward appears to be fatally injured. But, like Gregory Wyncoop in *The Cry of the Owl,* he is in fact in hiding, attempting to suggest he was murdered by Ray. In a later encounter, Edward tries to hit Ray with an iron rod but is restrained. The novel peters out as Ray heads back to his home in New York and Edward, who is not charged with any crime, goes back to his apartment in Rome.

Up to the weak ending, *Those Who Walk Away* develops cumulative power in its portrayal of the tortured relationship—if it can be called that—between a grieving husband and an enraged father-in-law; a relationship in which each party is alternately the pursuer and the pursued. Although it is never stated that Ray had any genuinely murderous designs on Edward, the latter is fueled only by a single-minded quest to eliminate his former son-in-law from the earth: "To kill Ray was the only possible thing to do, his only real satisfaction" (238). That Highsmith can create such a sense of suspense in a scenario where, in the end, no serious criminal act actually occurs is a testament to her skill in establishing the psychological backdrop for potential crime.

A Dog's Ransom (1972) is, next to *Strangers on a Train,* perhaps her most accomplished novel, and certainly one of the best of her works to focus on the corruption of a fundamentally innocent character. At the outset the

novel appears to deal with Ed and Greta Reynolds, a middle-aged couple in New York City who are the recipient of a number of poison-pen letters by someone who appears to envy their relative economic success, although they are hardly wealthy. During a walk in Riverside Park, Ed loses track of his miniature poodle, Lisa; later he receives a letter from "Anon" stating that he has the dog and wants a $1000 ransom. Ed decides not to report the matter to the police, hoping the ransom will satisfy to kidnapper. But after he leaves the $1000 in a designated spot, the dog is not returned. Only at this point does he call in the police.

The novel now shifts its attention to a young police officer, Edward Duhamell, who takes up the case. His suspicions fall on a down-and-outer named Kenneth Rowajinski, who is living on disability in an apartment in the Lower East Side and who the reader knows has already killed the dog. Rowajinski, confronted by Duhamell, claims the dog is with his sister in Queens and demands another $1000. Incredibly, Duhamell leaves Rowajinski to ask the Reynoldses about the man's offer; when he returns, he is told by Rowajinski's landlady that she had demanded that he leave. Rowajinski, now in a hotel, receives another $1000 from Reynolds and actually burns $500 of it, thinking that he might later accuse Duhamell of deliberately letting him go to get part of the ransom money. Indeed, another officer, Pete Manzoni, who deeply resents Duhamell's education and other advantages, spreads rumours about Duhamell and also makes repeated calls at the apartment of Duhamell's girlfriend, Marilyn Coomes, who has a loathing of the police.

Rowajinski is arrested but, to Duhamell's incredulity, is released in a few days. He later accosts Marilyn himself, telling her that Duhamell took some of his ransom money. Duhamell later sees Rowajinski walking back to his new apartment, follows him into the dark lobby of a building, and beats him with a gun. At this point neither the reader nor Duhamell knows whether Rowajinski is actually dead, but news reports the next day confirm that he is. The homicide department now gets involved. Eventually Duhamell is brought in for questioning, as are Ed Reynolds and Marilyn Coomes (both of whom know or suspect that Duhamell killed Rowajinski). None of them break under questioning; but—in a scene that goes well beyond the brutal questioning of Philip Carter in *The Glass Cell*—Duhumall is questioned for days by homicide detectives and even beaten; but he refuses to confess. He is finally sent home. Manzoni visits him there and, in the course of a scuffle, shoots and kills him. Duhamell's dying thoughts focus on his certain knowledge that Manzoni will get away with murder.

A Dog's Ransom is an even more cheerless novel than other of Highsmith's works, and she effectively conveys the helplessness of a naïve, good-hearted young man who is drawn inexorably into crime and its con-

sequences all out of a fervent desire to do what he believes is right. In only two matters can Duhamell be seen to be culpable: first when he unwittingly allowed Rowajinski to slip through his fingers after expending considerable energy and ingenuity in tracking him down, and second—and more seriously—when he gave way to a brief moment of rage and vengeance in hunting Rowajinski down and beating him to death. The latter is, indeed, a serious criminal offence, but even Ed Reynolds—who, when he learns of Duhamell's act, first responds with a "visceral dislike" (183) of Duhamell but later recognises that he has removed an "evil" (184) from the world—finds a certain justification in the deed. For surely it is Rowajinski—ignorant, lonely, full of barely suppressed resentment at a world that in his mind has cast him aside—that is the true culprit in the novel, and Highsmith etches his twisted psyche with unflinching realism and precision; and scarcely less culpable is Manzoni, a corrupt cop whose misogyny and envy are laid bare to the reader.

One of Highsmith's last novels, *Found in the Street* (1986), bears some similarity to *A Dog's Ransom,* and, although not quite as grim or intense as that novel, is a capable piece of work. As in *Those Who Walk Away,* the focus rests almost exclusively on two individuals—Ralph Linderman, a luckless middle-aged man struggling to lend meaning to his life after a succession of misfortunes, and John Sutherland, a successful commercial artist—who become entangled when Linderman finds Sutherland's wallet, stuffed with money, and returns it to him without accepting any money as a reward. Linderman is an aggressive atheist (he has named his dog God) who takes inordinate pride in his honesty in the act; a young waitress, Elsie Tyler, whom Linderman is trying to assist declares succinctly: "He's out to improve the world" (48). Elsie herself becomes involved in Sutherland's life, to the extent of becoming a successful model with Sutherland's assistance. It becomes plain that both Linderman and Sutherland are, in their different ways, in love with the fetching Elsie—as, in fact, is Sutherland's wife, Natalia, who engages in a sexual relationship with her. Linderman's puritanical upbringing—and, as he himself realises, a failed marriage—compel him to see the worst in Elsie's actions, as he thinks she is prostituting herself in her modelling career and probably sleeping with Sutherland.

The action of the novel somewhat belatedly takes a criminal turn when Elsie is attacked in the foyer of her apartment building and killed. Both Sutherland and Linderman think the other may well be the culprit, although Sutherland quickly determines that Linderman could not have committed the deed. Linderman, for his part, repeatedly attempts to implicate Sutherland, but has no evidence that the police find credible. The stage appears to be set for Linderman to take the law into his own hands—and, indeed, the two men do engage in a fight in front of Sutherland's apartment. But when

a lesbian friend of Elsie's confess to the murder, the novel ends quietly, with Linderman reflecting: "the grip of anger against Sutherland that had seized Ralph was easing a little" (272).

This conclusion, although something of an anticlimax, is perhaps the only plausible ending to a novel that might otherwise have lapsed into implausible melodrama if Linderman had taken violent action against Sutherland, or vice versa. As a portrayal of the lives and psychologies of two very different individuals, the novel succeeds in a mutedly effective manner, and to that degree it can be considered a success.

Highsmith, indeed, wrote a number of works—beyond an early, pseudonymous lesbian novel, *The Price of Salt* (1952)—that could be considered mainstream, with a nearly total absence of crime or suspense. Two of them are worth studying here, although they are not among her more successful works. *The Tremor of Forgery* (1969) is largely devoted to a few weeks in the life of Howard Ingham, a novelist who has been sent to Tunisia to work on a screenplay. While waiting for the director, John Castlewood, to arrive, he seeks to absorb the atmosphere of his exotic locale—but both his work and his life are thrown into turmoil when he learns, early in the novel, that Castlewood has committed suicide. He is more disturbed to learn that Castlewood died in Ingham's own apartment, and that he had told Ingham's girlfriend, Ina Pallant, that he loved her. Ina eventually tells Ingham that she slept with Castlewood on at least one occasion.

Crime is not entirely absent from the novel: at one point an intruder comes into his bungalow, whereupon Ingham throws a typewriter (!) at him and apparently injures him, possibly fatally. The intruder, a well-known thief named Abdullah, cannot be found—it is likely that he is dead. Ingham fails to report the matter to the police; but a self-righteous American tourist, Francis J. Adams, repeatedly pesters Ingham to tell what he knew about the incident. He clearly suspects that Ingham killed Abdullah, even if only in self-defence, and relays his concerns to Ina, who has come for a visit. The incident—and Ingham's lack of candour about it—creates tension between the lovers, to the point that Ina chides him for not reporting the incident: "I find it surprisingly callous of you" (222). Ingham now begins to have second thoughts about whether to propose to Ina, and in the end concludes that he cannot marry her. The novel ends on an adventitiously happy note when Ingham learns that his ex-wife, Lotte, is leaving her new husband and envisions reuniting with her.

The lacklustre narration of *The Tremor of Forgery* (the title is derived from a novel of that name that Ingham is working on after giving up work on the screenplay) prevents the novel from coming to life, although its Middle Eastern setting is effectively depicted. As with the protagonist of *The Cry of the Owl*, Howard Ingham is so bland and undistinctive a character

that the novel's focus on him fails to engage the reader, and the mundane conclusion—that Ingham, after all the events he has experienced, has merely concluded that Ina is not a suitable mate for him—seems insufficient to justify a work that could have resulted in a more searching analysis of the ambiguous incidents and unusual locale upon a thoughtful character.

Somewhat the same could be said of *Edith's Diary* (1977). The Edith in question is Edith Howland, who is about to leave New York City for a small town in Pennsylvania, Brunswick Corner, along with her husband, Brett, and son, Cliffie. The novel begins in the year 1955 and proceeds for almost two decades, seen largely through the eyes—and diary—of Edith. But amidst the various traumas and misfortunes she suffers—she is compelled to tend to Brett's increasingly infirm and querulous uncle, George; her son seems to be a layabout who shows little interest in anything aside from masturbation and drinking; and, most serious of all, Brett falls in love with his secretary, Carol Junkin, and eventually moves in with and marries her—Edith perseveres with a kind of stolid resignation. But in her diary she gradually departs from reality and envisions a blissful fantasy life for herself and her family, with Cliffie going to Princeton, getting a well-paying job, marrying a lovely young woman and having adorable children.

But this fantasy life does not render Edith a markedly interesting individual from the standpoint of psychological aberration, even though at one point she reflects: *"I sometimes think I'm going a bit nuts"* (146). Edith's bland reflection in her diary, "I am happy" (189), does contrast strongly with her actual life and temperament, but nothing comes of it. Crime of a sort enters into the novel only tangentially: after years of taking care of George (who, one would think, would have been Brett's responsibility after he moved out), Edith deliberately waits to call the police and her doctor after she sees her son give George a heavy dose of codeine and other medications. Brett pursues the matter, but to no avail, since the body has already been embalmed with no autopsy conducted.

The novel gains some dramatic tensity when a trusted friend of Edith's reports to Brett her opinion that Edith is psychologically troubled. Brett visits her in the company of a man named Pete Starr, who proves to be a psychiatrist. Later Brett comes again with another psychiatrist, actually bursting into her workroom (she is a sculptress) before being ordered out by Edith. Edith's own physician now arrives with the psychiatrist, and a tense meeting ensues. Edith offers to bring down a bust of Cliffie to show them that she is sane and in control of her emotions, but she trips on the stairs as she is bringing it down and dies.

Edith's Diary is again marred by a languid narration that fails to bring its central character to life. Edith is, in all frankness, not a sufficiently interesting figure to be the focus of one of Highsmith's longer novels; the au-

thor's apparently deliberate avoidance of anything that could be construed as overt crime, psychological suspense, or melodrama dooms the novel and virtually all its characters to mundanity. Edith really does need to exhibit considerably more psychological disturbance than merely the fabrication of benign diary entries.

Patricia Highsmith's array of novels feature a number of triumphs—preeminently *Strangers on a Train, The Talented Mr. Ripley,* and *A Dog's Ransom*—and others that forcefully convey her cold-blooded, and occasionally misanthropic, view of human motivation and action. She is among the most cheerless writers in twentieth-century literature, and her jaundiced view of her own species is refreshing in its unvarnished cynicism. At the same time, her tightly controlled prose—while on occasion a bit too bland and affectless to be truly effective—never fails to portray even the most vicious of acts with a kind of quiet elegance, and her tony European settings provide a sophisticated backdrop to her reflections on crime and punishment. While not quite as adept as Margaret Millar in carrying out searching psychological analyses of either her guilty or her innocent characters, she ably suggests that any of the latter could easily turn into the former under the proper circumstances, to such a degree that the very question of who is innocent and who is guilty becomes unanswerable.

L. P. DAVIES: THE WORKINGS
OF THE MIND

The work of Leslie Purnell Davies (1914–1988) is, in its quiet way, some of the most remarkable popular fiction written during the 1960s and 1970s. In a string of some twenty novels Davies combined the elements of mystery, horror, and science fiction in a manner duplicated by no other writer. Moreover, Davies's work is united in a curious way by a single theme—a theme he himself has labelled "'Psycho fiction' . . . fiction based on the workings of the human mind" (Reilly 437). The prototypical Davies novel features a man (his protagonists are all male) who has lost his memory or, more harrowingly, who seems to have had the physical tokens of his past completely wiped out, leaving him adrift in the present with no way to prove his identity. Other Davies novels focus upon possible expansions in the powers of the mind—telekinesis, mind control or psychic possession, and elaborate hypnosis or brainwashing. Davies repeatedly emphasises the logical possibility of all these phenomena, and in only one or two novels is the suggestion of the supernatural not explained away by natural, if at times supernormal, means.

The Paper Dolls (1964), Davies's first novel, initiates the series of works dealing with the expanded powers of the mind. Here we are introduced to a set of quadruplet boys, joined at the arms and separated shortly after birth, whose minds appear linked: at times each knows what the other is doing, and each suffers sympathetic wounds when one or the other is involved in accidents. This itself would be nothing to strain credulity—linkages of this sort are commonly found to exist among children born from the same fertilised egg—but Davies expands the concept by suggesting that the boys (at least the one of them who seems to be their leader) can control other people's minds for a time, inducing hallucinations or even suicidal tendencies. Two of the quadruplets, at widely differing times and places, are found to have been involved in incidents where another boy who had been harassing them jumps from a building or otherwise injures or kills himself. One character remarks: "'It would appear . . . that at least one of the children is possessed of extraordinary powers. Powers that again I am prepared to accept, assuming them to be some kind of development from

certain thought-projectory faculties that one hears mentioned from time to time'" (82). Later the narrator wonders:

> Mutants, were they? I had read of plants that had become altered, mutated—was that the right word?—by radio-activity. If plants, then animals. And we were still animals ourselves. Man the mammal. The genus of Primates. With a brain that we still hadn't learned to use properly. Was that the difference between the children and ourselves? Had they learned the use of that part of the brain that we left idle? (112)

In fact, the matter is revealed to be still more bizarre than this: the four boys are really a single mind in four different bodies. One of the boys, Rodney, tells the narrator: "Tony-me is sleeping. If I wake that part I will think it to Simon-me at the Pillory and to me at home, and then I will think it here so that I can go before it reaches" (135). The narrator, reflecting on this odd language, finally concludes:

> This was dual personality carried to its incredible extreme. Doctor Jekyll working in his surgery at the same time as the evil Mr. Hyde prowled the night streets. Hyde looking through Jekyll's eyes into a microscope at the same time that Jekyll was watching through Hyde's eyes the back-street slut marked down as his next victim. At the same time; that was the difference. Not one man with two interchangeable personalities, but one man with two separate personalities, each housed in a separate body. One man who was two.
>
> And four boys who were one. The Rodney-me part with a talent for writing; Simon-me—physics and chemistry, according to Bart; Peter-me who was an artist. And Tony-me, musician, and other things. The part responsible for the killings. The evil quarter of the multiple personality. The dominant part. . . . (142)

The only flaw in this novel, aside from the almost excessively restrained narrative tone, is the naive suggestion that all the "evil" is concentrated in the boy's leader Tony, leaving the others guiltless and thus free to carry on with their lives after Tony perishes in a fire at the end.

The notion of "dual personality carried to its incredible extreme" links this novel to a later one, *Psychogeist* (1966), marketed as a science fiction novel for no especially compelling reason. Here we are presented with a man, Edward Garvey, with a recurring dream of being a denizen of another planet named Argred the Freeman who has some mission that he must accomplish, if only he could remember it. All this sounds a trifle hackneyed—there are references to the Old People, the Mind-Healers, Old Lorr, the Wise Elder of the Freeman—but this turns out to be by design: Garvey's subconscious is living out the events of an old comic book he had read in youth. One character makes no bones about the comic's literary merit:

"Hardly what one might call a literary gem. The anonymous author had made use of every stock situation with a scant regard for verisimilitude. One received the impression that he had dealt out the various stages like playing-cards from a pack, or from a list tacked for reference above his typewriter. He had included everything; mind-rays, torture, underground places filled with mummies, poison, strange machines, magic—the lot. But the story was, of course, only intended for a juvenile readership." (98–99)

At this point there is nothing particularly remarkable; and one might expect that the rest of the novel will be spent on diagnosing and treating Garvey's schizophrenia. But Davies introduces a fascinating twist. Garvey's subconscious seizes upon the body of a young transient who has died by accident and reanimates it; and this body becomes Argred the Freeman. One character explains:

"There is nothing supernatural about it . . . Not when you come to consider. Schizophrenia taken to its ultimate logical extreme. There were two—what?—beings inside Edward's mind; himself and Argred. All that has happened is that the subconscious being has left him, taking up occupancy in a suitable vehicle.
"It's nothing new. The 'possession' of the Middle Ages—to be possessed of an evil spirit. Hypnotism is another facet. One person's mind temporarily controls the body of another. And reincarnation. . . . A large slice of the world's population implicitly believes that the life-essence, the soul, leaves the dying body to take up residence in a new body. And many psychiatrists believe that the soul is merely another name for the subconscious." (100)

The protagonists must now prevent this putrefying corpse from wreaking havoc in the small community in which it is loosed.

The otherwise inferior novel *The Lampton Dreamers* (1966) continues the pattern. Here the inhabitants of an entire village appear to have the identical dream. Eventually this phenomenon is attributed to the power of a single individual's mind—"will projected by the power of thought" (66). As with several other novels, the suggestion is that this power is latent within us all, hence not supernatural in any real sense: "A diseased, distorted mind? But there was another way of looking at it. A mind that has learned to use itself to the full, employing those parts of it that had become dormant through countless centuries of unuse" (103).

Two novels that give the appearance of involving actual psychic possession are *Stranger to Town* (1969) and *Possession* (1976). These works in some senses are mirror-images of *Psychogeist:* rather than a living individual reanimating the body of a dead man, a dead man seems to have possessed the mind of a living one. In *Stranger to Town,* another not entirely

successful novel, Julian Midwinter arrives at a small town—one he has apparently never visited before—and seems to know things he cannot possibly know: the name of the ticket agent, the configuration of the hotel he is staying at, and still odder things. There is a strong suggestion that Midwinter is being possessed by the mind of Josh Hardman, who died several years before. His wife Amy is a member of the Church of Life's Return, a sect that believes that the souls of the dead return in other people's bodies. Initially the interest in the novel focuses upon the possible truth of this doctrine and the harrowing way in which Midwinter is subtly pressed into taking over Hardman's life, such that his own life and personality are nearly extinguished: he is persuaded to reopen Hardman's business, joins Hardman's cronies for late-evening sessions at the pub, and so on. But the novel suffers a serious letdown when it is implausibly revealed that Midwinter is really a con man, and the conclusion of the novel—involving fraud, blackmail, and attempted murder—is merely routine.

Possession is considerably better, and introduces us to the Brazilian religion called Macumba, which again holds that the dead can reoccupy living bodies. All along, though, doubt is cast as to whether this Macumba mumbo-jumbo is simply being used as an elaborate fraud or hoax; the protagonist remarks: "Black magic and voodoo curses and all the rest have been used as weapons in politics and business before now. I think that what is going on here is something to do with very big business" (83)—the reason for this being the anomalous appearance of several enormously wealthy real estate tycoons in an otherwise sleepy English village. Nevertheless, there are chilling glimpses of an individual who seems to have adopted the characteristics of a man who died in a suspicious accident some weeks before. But when one of those who appears to be staging the whole series of events refers to "the Macumba cover" (136), we seem vindicated in suspecting a natural explanation to the whole thing; but the supernatural—or, rather, some radical advancement of science—is suggested from another direction. A doctor has written a thesis on *Physical Transference by Means of Cell Ingestion of Habit, Character and Memory Patterns in Anguis Fragilis*. The narrator ruminates on this:

> You take your specimen—that's what the notes and the diagram mazes were about—you take your wriggling little specimen and put it in a maze and you teach it by trial and error to find its way to the food. And when it's learned to do that, you put it in a more complicated maze, you give it harder obstacles to master, and when it's learned that, you move it on to the next. And at the end you have a wriggling little monster that is clever enough to find its way without hesitation through your most complicated maze. And then what do you do? You kill it and cut it into pieces and pound the pieces and feed the mash to a new worm, a fresh, ignorant

worm. And you put that ignorant worm in the most difficult maze, and it goes straight to the food without any wavering.

Because what you have done is give it, in the mash, the thoughts and memories and the knowledge, the learned knowledge, of the first worm. Even its habits and idiosyncrasies—for Boyle had written about that, had made notes about one specimen that had its own peculiar way of turning a corner, its own way of approaching the food from one side. And dead, passed on those mannerisms in the mash of its body to the new worm fed on that mash.

Memories, knowledge, character, habits. A kind of immortality. No, not just a *kind*—it *was* immortality.

And what you can do to a worm, you can do to a man. (147–48)

Implausible as this may sound, coming at this point in the story it offers an uncannily precise explanation of events; it is a pity that this novel, like *Stranger to Town,* in the end reduces the notion to a hoax.

Davies's second novel, *Who Is Lewis Pinder?* (1965), introduces us to his most representative series of novels, involving amnesia, brainwashing, or some nameless wiping away of one's past. A man is found in a ditch, dressed in a suit but with no shoes; he has suffered complete amnesia, and cannot even remember how he came to be where he was. Davies quietly but poignantly etches the man's sensations:

He was putting everything down on paper in case anything else were to happen to his memory. Next time the shadows swallowed the past he would have something to go on. He wondered who he was. He wondered if he had a wife and family. He wondered who his friends had been; where he had lived; what he had done for a living; what sort of person he had been. (36)

But as the police investigation proceeds, more and more anomalous facts are unearthed: the man appears to be identified conclusively (by means of a highly unusual birthmark and other characteristics) as four different men, each of whom has been dead and buried for more than twenty years. Davies's narrative skill in presenting this baffling mystery may never have been excelled in later works, and it would be criminal to reveal the ingenious and thoroughly satisfying solution to this novel.

The amnesia theme reaches its pinnacle in *The Shadow Before* (1970), perhaps Davies's best novel. Here a man has an extraordinarily long and complex dream following a brain tumour operation, and it is in the dream that he experiences amnesia. As Lester Dunn—all within the dream—struggles to regain his memory, he must also account for his radically changed circumstances: several years have passed, he has changed his name, he appears to have wealth beyond his dreams, and he seems to have been involved in criminal activity. This turns out to be the case. Dunn had

noticed that a jeweller's shop abutted the rear of his pharmacy, and that it would be possible to tunnel underground to the jeweller's vault. Dunn and his friends have done this and apparently gotten off scot-free. But trouble arises: the husband of Dunn's shop assistant learns of the robbery and begins to blackmail all the parties, and this leads to Dunn's transformation into a murderer and a fugitive.

At this point Dunn wakes up. Enormously relieved to find it all a dream, he attempts to return to his normal life as a struggling pharmacist. But he finds himself haunted by the dream: it seemed not merely lifelike but utterly plausible. Every detail seems to fit, and Dunn has to find a weak link:

> Turn reality back into fantasy, reason told him. Chip away at its foundations as you chipped at that wall. Find the weak places where the stuff of the dream has no solid foundation in the reality of the present. There must be those places. One will be enough. Find one factor in the dream on which you can lay your finger and say: "This was not so in real life." Find that, and the whole fabric of the dream will collapse; your mind will be rid of its presence and the ghost will have been laid. (89)

But as Dunn checks on the various details of the dream in an attempt to dispel it, his actions are noted by his friends and they eventually piece together the substance of the dream; worse, they find the dream so plausible that they compel Dunn to act it out with them. It is at this point—where dream and reality begin to mingle insidiously—that the novel becomes almost unbearably chilling as Dunn is led step by step toward the fatalistic accomplishment of his dream-scenario. The ending of this novel is too good to reveal here.

Some touches in *The Shadow Before* are uncommonly fine. The early portions of the novel carefully delineate Dunn's impoverished circumstances ("A [profit] margin that could be measured in pennies. Trade was bad" [6]), providing both the contrast to the wealth he experiences in the dream and its psychological justification. Indeed, the highly cynical underlying moral of the tale is the ease with which normally law-abiding citizens will take to crime if they feel they can come away unscathed. During the dream his friends notice that Dunn has changed after he came out of the hospital ("'No werewolf-at-full-moon stuff. Nothing you could really put your finger on. Unsettled—that's the word. Dissatisfied with life in general'" [45]); then, during his actual life after the operation, he is also observed to have changed, but precisely because of the dream: the sequence of cause and effect has become monstrously confused. All told, this novel—enormously rich in psychological probing, extraordinarily convoluted in narrative structure, and endowed with a sense of harrowing inevitability—can rank as one of the finest novels of psychological terror of its time, fully equal to High-

smith's *Strangers on a Train* or Millar's *A Stranger in My Grave*.

Each of Davies's major themes appears to have both its "mystery" and its "science fiction" representatives, and the amnesia theme is no different. Here we are specifically concerned with *What Did I Do Tomorrow?* (1972). I have already suggested that the distinction between mystery and science fiction is on the whole an artificial one in Davies, and this novel seems to have been marketed as science fiction only because the lead character, a teenager named Howell Trowman, finds himself drifting from 1969 to a future five years ahead. One moment he is sitting in a chair in his room at school, the next moment he finds himself sitting in an office he does not recognise, and he seems aware that several years must have passed. Like Dunn, Trowman must first set about finding out what has happened to him in the five-year interval, and many disturbing things seem to have occurred: he is working for the chief rival to his father's company; he has done something so heinous that not merely his old friends but his family—even his mother—refuse to speak to him; and he finds a large suitcase of money in his apartment. Trowman's quest, after ascertaining his circumstances, is to discover whether he has actually suffered amnesia or has somehow travelled in time. He is inclined to accept the latter answer: as he was finishing school, he was undecided whether to enter college or go directly into his father's business, and perhaps he has been sent forward into the future to gauge the results of his decision. But a young woman who has befriended him rightly points out the fallacy of this position, enunciating the "determinism paradox":

> "Look at it another way. You say you've been given the chance of looking at what your future's going to be. So supposing you find it's not so hot, supposing you find you came to the wrong decision way back when you were at school—well, don't you see, you can't go back and unchange it all, because it's all already happened. You see what I'm getting at? What's the use of showing you the future when you can't do anything to change it? It's just pointless." (39)

Again, it would be unfair to reveal the resolution of this situation, but Davies manages to make it both suspenseful and satisfying.

A sort of mirror-image to the amnesia theme is the theme of an individual's past being apparently wiped away. Here a character knows who he is and has suffered no lapse of memory, but finds that the physical relics of his past have been absolutely annihilated. What could possibly have caused this state of affairs? The characters are inclined to think that there is some vast conspiracy to obliterate their pasts and, hence, their very identities; but those around them more plausibly put forward the notions of brainwashing, schizophrenia, or some other psychological motivation. Since we see events

through the eyes of the characters experiencing this "identity crisis," we ourselves are cut adrift: we know who the protagonists are, but how can they prove it?

In *The White Room* (1969) Axel Champlee, a wealthy businessman, flees his mansion when he is faced with the fact of his brother-in-law's embezzlement of funds and finds that his sister is urging him to kill him. But in fleeing he has only made matters worse: in the outside world he finds that it is not 1969 but 1979, that the parliamentary district he resides in does not exist, and that a popular writer he had just had dinner with died five years before. Has Champlee also been flung into the future? Or is there some elaborate conspiracy to delude him? If so, why? One of the most powerful scenes in all Davies's work occurs when Champlee attempts to return to the place where he believes his house to be:

> He took out his keys and used the light of a street lamp to sort out the one for the front door. Better to have it ready than to have to waste time fumbling in the semi-darkness of the mews.
>
> They were almost there. Another massive gate, a short stretch of blank wall, and they had reached the corner.
>
> "The house is only a short way down on this side," Axel said in a low voice. "It's the only one on this side."
>
> They turned the corner.
>
> There was no house on the right-hand side, no sign of one, nothing but bleak towering wall with neither window nor doorway to relieve its stark ugliness. And there were no trees on the other side to be glimpsed through their branches. And this was no cul-de-sac, no narrow, dimly lighted mews. This was a wide modern thoroughfare with glaring overhead lights that reached far away into the distance. (72)

This is an almost archetypal moment in Davies: nothing could be more shattering to your sense of personal identity than the sudden awareness that the house you have lived in all your life has vanished and seemingly never existed. Does this mean that your whole life is a lie or a phantasm?

Give Me Back Myself (1971) develops the theme. Stephen Dusack, who has left his native South Africa to pursue his fortunes in England, is in a train accident and finds upon recovering that everyone believes him to be one David Orme, a wealthy industrialist: he is found with Orme's wallet in his pocket, and he has enormous difficulty proving that he is in fact Dusack—or even that such an individual ever existed. The hostel he was staying at no longer exists, his place of employment has turned into some other establishment, and even a call to one of his closest friends in South Africa reveals that the friend barely acknowledges him. Dusack wryly comments on the difficulty of proving his own existence:

"It's frightening in a way just what they've managed to achieve. If anyone were to ask me to prove I was Stephen Dusack, do you know, Fran, I couldn't. I haven't a single solitary thing to show. Even the very clothes I'm wearing must belong to David Orme. And while I couldn't produce a scrap of evidence to prove I am myself, I'm damn sure they could produce a whole mass of it to prove I am David Orme." (82)

But because we have, in the opening chapter, been introduced to the real David Orme, we know that Dusack really is Dusack; but if we adopt the theory of a conspiracy, as Dusack at one point does ("A conspiracy of a kind? But it was a stupid, ridiculous idea that anyone would want to conspire against him, for there was nothing they could hope to achieve by so doing. But what other explanation was there?" [61–62]), we are forced to conclude as Dusack does: "'I'm just a clerk, just an ordinary sort of person'" (94). Why would someone want to do this to him? Some of Dusack's existential reflections are very poignant:

"It's almost as if I'd already started to lose myself. I have to keep stopping to think who I am. It's like part of me is slipping away and something else is taking its place. That's what I'm afraid of—not of being killed—of suddenly finding out that the change is complete, that I'm not the me I've always known, but someone else, a stranger. Someone I don't know wearing me like it was a coat." (115)

The "science fiction" versions of the vanished-past theme are somewhat more conventional, but can still be on occasion very powerful. *The Artificial Man* (1965)—actually marketed as a mystery story, although it is far more clearly a science fiction novel than other of Davies's works so labelled— actually predates the first "mystery" novel on this theme by several years, and seems to have been written close to the time of Davies' first novel on the amnesia theme generally, *Who Is Lewis Pinder?* (1965). The science fiction element in *The Artificial Man* takes some time in manifesting itself: for the first third or so of the novel we appear to be concerned with Alan Fraser, a struggling writer residing in a placid English village in the year 1966 who hits upon the idea of writing a science fiction novel set in the year 2016. Gradually we understand that it actually is the year 2016 and that Fraser, whose real name is Arnold Hagan, is a spy who suffered an accident and lost his memory before he could reveal some vital piece of information learned while behind enemy lines. An artificial past is therefore implanted in his brain, and the novel he is to write will, his superiors feel, reveal the secret buried in his subconscious without driving him mad, as other methods of extracting the information might. In this sense *The Artificial Man* combines the amnesia and vanished-past themes: the latter comes into play as Hagan escapes from the village and encounters a young woman who has never

heard of it, even though she lives only a short distance away (it has, of course, been artificially created for Hagan's benefit). Hagan suffers the same jarring sense of dislocation and lostness that Axel Champlee does in *The White Room:* "'If I wasn't born in that house down there, where did I come from? And who am I? Am I Alan Fraser?'" (72).

Twilight Journey (1967) is one of the best of Davies's novels in its rich texture and constant alternation between dream and reality. The opening is highly bizarre in its incongruous incidents and dialogue. Richard Worbey, having forgotten much about himself except his name, wanders about what appears to be a run-down section of London in the year 1967. He meets the owner of a cafe who treats him to the following discourse:

> "This is a cafe. It is larger than a snack-bar, smaller than a restaurant. A restaurant is often part of a hotel. A hotel is a larger and better-class place than a lodging house. The customers who frequent this cafe are mainly long-distance lorry drivers and workmen. The lorries carry industrial components, foodstuffs—" (14)

We learn eventually that all this is happening in Worbey's mind as a result of "senduction," a new process developed in the twenty-second century whereby information is converted into electrical impulses and fed directly into the brain. The technique was invented by one Clayton Solan as a means of education: an individual can select a given historical epoch—here Late Twentieth Century Urban—and actually appear to experience it while in a sort of hypnotic trance. But it transpires that Worbey is Clayton Solan himself (hence his amnesia, since his subconscious is rejecting the false identity he has adopted), and a crisis is at hand because Solan must be brought out of the trance without driving him mad, as had occurred in a previous case some years before. The novel therefore oscillates between Solan's wanderings in his mind and the efforts to save him.

Solan's dream goes through several stages: at first he experiences the senduction as an ordinary man in the late twentieth century; then his mind transforms the scene to his recent past, replaying the invention of his system; finally, and most fascinatingly, his mind begins to probe into an extrapolated future where senduction has become a tool in the hands of the powerful for purposes of political indoctrination, with a small handful of rebels—including Solan and some of his friends—refusing to submit and living as outcasts, constantly hunting for scraps of food and fleeing from the authorities. It is difficult to bear in mind that all this is taking place simply in Solan's mind: Davies's writing has rarely been as vivid or as carefully crafted. Indeed, the premise of senduction is that it is "more real than real life"; a colleague of Solan's relates his account of why this is so:

"He said it was because our waking senses are so inefficient. Our hearing is poor, our senses of taste and smell deficient. Our eyes are the worst of all, sending back distorted messages to the brain. Optical delusions . . . vistervision and television are only possible because the eyes can't move fast enough to follow a moving dot of light. Clay called our senses the weak link between life and the mind. Take that link away, put information straight into the brain, and we are able to see reality. And because it all happens in the subconscious, the memory of the dream remains vivid and complete without any fading of the memory." (58–59)

And, of course, this is why it is so difficult to bring Solan out of his trance: if he is simply woken up, then he will think that real life is merely a dream, from which he will eventually awaken.

The Alien (1968), like *The Artificial Man*, is also set in 2016, but of course an entirely different set of conditions obtains. John Maxwell emerges from an accident not merely with much of his memory gone but with all his senses subtly disturbed: food tastes peculiar to him, people smell odd and faintly revolting, and he experiences a sensation of foreignness to everything around him. Medical tests (not made known to him) reveal that there is something other than blood in his veins. Two competing alternatives are eventually offered him: he is either a human being who may have sabotaged a medical research establishment two years before or, in fact, he is an alien from another planet. Maxwell, attempting to retrace his past, oscillates from the one to the other, actually resolving on the second until at last he is shown to be a product of elaborate brainwashing. At the beginning a scientist conjectures on the possibility of life on other worlds:

"It has to be assumed that on a planet such as ours, based upon the carbon, hydrogen, and oxygen molecules—I think those were the three— life could be expected to develop much along the same lines as life on our world. But perhaps with minor differences. And it also has to be assumed that there are planets where civilisation is much older than ours—their technologies accordingly more advanced. Their means of propelling space vehicles would be far in advance of ours, not confining their exploration to their own planetary system as we are still confined to ours." (9–10)

The first part of this utterance is, of course, preposterous, since even the existence of carbon, hydrogen, and oxygen on another planet would not be remotely sufficient to trigger the evolutionary stages leading to life-forms similar to those on earth; one can only hope that Davies intends this notion to be seen as the absurdity it is.

The bulk of Davies's work falls into the above patterns, but some cannot well be encompassed in them. A few novels can be dismissed fairly readily: although they are entertaining, they do not in any way add to his otherwise systematic explorations of the anomalous workings of the mind. *Dimension*

A (1969) and *Genesis Two* (1969) are two competent science fiction novels, some of whose features may be observed later. The former is of interest in being a sort of science fiction variant of the locked-room mystery, as a scientist who disappeared from a locked laboratory is found to have discovered another world coexisting with our own, "although occupying different vibratory planes" (9). Less interesting is *Adventure Holidays, Ltd.* (1970), a tale of suspense and espionage whose only merit lies in the evocation of Davies's adopted homeland of Wales, where he moved in the mid-1960s. It was marketed as a young adult novel, although it is scarcely different in tone or style from his other works; if anything, the narrative tone is still more subdued and phlegmatic than in other novels. *A Grave Matter* (1967) is similarly ineffective, being a fairly orthodox detective story involving the discovery of the graves of two long-dead children in a small country town. By focusing almost exclusively upon the police investigation of the matter, Davies fails to probe thoroughly the psychological dimensions of the plot, which remain nebulous and unconvincing.

Assignment Abacus (1975) calls for some notice. Here we have a man, Boyd Maskell, flown by helicopter to a remote mansion in Scotland for what he believes is a high-level business meeting, who quickly finds himself alone and virtually cut off from the rest of the world. Here the psychological interest is in seeing whether Maxwell can retain his sanity in this isolated position, where bizarre, irrational, and sometimes supernatural-seeming incidents are occurring, and whether he can ascertain why he has been put in this anomalous position in the first place. The seemingly fortuitous appearance of a hiker, Bernard Fairfield, adds to the confusion: has Fairfield in fact stumbled into the situation by accident or has he been planted there? Much of the novel is harrowing in its depiction of the physical and psychological isolation of the protagonist and of his steadily weakening self-control and grasp of reality. At one point he is close to snapping:

> His one thought now was to get away from this place while he was still capable of rational thought and behaviour. Half of him knew that what had been happening was reality made to appear unreal and impossible. But the other part was already beginning to accept that he had been experiencing hallucination. There was no way of telling just how much more his divided self could take. (77)

Two other novels by Davies are what might, for lack of a better word, be called quasi-occult. *The Reluctant Medium* (1966) is structured more like a conventional detective story than other of Davies's novels: David Conway, although not a detective but an "industrial consultant" (11), is urged by a friend to investigate some strange happenings at the home of Matthew Rawson, since on the surface it seems that one of Rawson's business enemies

has come back from the dead to harass and possibly kill him. Conway finds himself grudgingly and unwillingly accepting the supernatural until a car nearly kills him and other attempts are made on his life; this odd mix causes Conway to reflect:

> "It can't be a mixture; it's got to be one thing or the other. That's how I see it. If there was proof that just one of the natural accidents wasn't an accident, then we'd be dealing with some sort of criminal activity. You know what I'm trying to say. Or if there was proof that one of the supernatural incidents wasn't faked, then we'd know we were up against—"
> (110)

The conclusion is obvious. This reminds me of one of Dr Fell's reflections in a radio play by John Dickson Carr:

> Let me make it clearer. Suppose you tell me that the ghost of Julius Caesar appeared to Brutus before the Battle of Philippi and warned him of approaching death. All I can say is that I know nothing about it. But suppose you tell me that the ghost of Julius Caesar walked into the cutlery department at Selfridge's, bought a stainless-steel knife, paid for it with spectral banknotes, and then stabbed Brutus in the middle of Oxford Street. All I shall beg leave to murmur, gently, is: rubbish. You cannot mix the two worlds like that. . . . This was a human crime, planned by a human being. (Quoted in Joshi 116)

Sure enough, the events of *The Reluctant Medium* are finally explained by natural means, and the séances and other spiritualistic oddities are accounted for by elaborate trickery. But Davies—inexplicably to my mind— feels the need to tack on a supernatural "out" (perhaps he was thinking of Carr's much better effort of this sort, *The Burning Court*), and the novel ends meretriciously on a note of portentous mystery.

If we do not feel inclined to take this supernatural denouement very seriously, we are obliged to do so in Davies's late novel *The Land of Leys* (1979). It is odd that, after a series of some twenty novels in which (with the exception of *The Reluctant Medium*) all seemingly supernatural events are emphatically explained either as sleight-of-hand or as possible (and plausible) extensions of our current knowledge, Davies concludes his fictional work by resolutely embracing a fairly conventional occultism. A survey of Davies's work will show how anomalous this sudden reversal is:

> *The Paper Dolls:* "The four children were abnormal but not supernatural" (169).
> *The Artificial Man:* "'You must understand that what is happening to him is in no way supernatural'" (201).
> *Psychogeist:* "'There is nothing supernatural about it'" (100).

The Lampton Dreamers: "'We have to assume that it [mind control]'s an ability inherent in all of us'" (67).

The Shadow Before: "Nothing—he didn't want to use the word, but there was no other—nothing supernatural" (104).

Assignment Abacus: "Nothing supernatural, nothing hallucinatory" (39).

But all this changes in *The Land of Leys.* Here we have a conventional psychic detective trying to get to the bottom of some weird goings-on in a little English country town. Amnesia is also involved—Andrew Leigh is jolted to find that for months after his brother's death he has apparently been leading another life for half of every week—but it is dispelled very quickly, as Leigh discovers with little difficulty what he had been doing in his other life; and once this is resolved it plays no especial role in the matter. The focus of the novel is the attempt of Kale Manfred, the ponderous psychic authority, to probe the mysterious occurrences in and around the lavish home of Dr John Harvester. All the old standbys are unearthed: crucifix, holy water (a little sheepishly, it must be admitted: "'I am going to ask you now to humour me and do as I ask without wanting to know why'" [111]), pentacles drawn on basement floors, the works. And of course Manfred sophistically argues for the equivalence of science and magic: "'I believe that every manifestation of what people call the 'supernatural' can be explained in terms of science. If not today, then tomorrow'" (100). This is an old argument, and I suppose we shall be waiting a long time for an explanation of how a crucifix and holy water can be efficacious against phenomena that are acknowledged to predate Christianity and even the human race. And when Manfred says, "'A printed circuit, something we are all familiar with, is able to create, intensify, and store power. This is magic we all accept'" (101), he falls into another elementary trap: the "magic" of the circuit has been explained scientifically and can be understood with sufficient training, whereas no amount of training can allow one to understand how or whether pentacles drawn on the floor have any effect. There are a certain number of mundane natural events in *The Land of Leys*—Leigh and others again undergo various attacks on their lives, obviously caused by a human agency—but the novel is designed to lead up to a grand supernatural climax, complete with the near-sacrifice of an innocent and tempting virgin. It is neither a satisfying nor representative end to Davies's fictional oeuvre.

Some general features of Davies's work can now be observed. His primary virtue is narrative drive. In the skilful manipulation and execution of a convoluted plot, in pacing, in the gradual revelation of the climax Davies has few equals. In *The Paper Dolls,* for example, we learn first that the odd boy Rodney Blake is one of twins, and only later the more remarkable fact that he is one of quadruplets. Analogously, in *Who Is Lewis Pinder?* the

succession of Pinder's different identities is slowly revealed one after the other, and through Pinder's own eyes, so that doubt becomes impossible. It is adeptness in narration that is the principal feature in Davies' two best novels, *The Shadow Before* and *Twilight Journey.* The power of his work is all the more surprising in that his prose style is merely workmanlike, tending toward the glib and facile at times. In other words, it is purely the incidents—and their clever articulation—that produces his intense readability. Robert H. Waugh has remarked on the number of fantaisistes—as opposed to science fiction writers—who have developed a rich, perhaps eccentric prose style to augment or even create realism and believability (Waugh 1), but Davies is a notable exception. He relies upon the inherent fascination of his conceptions, as well as an atmosphere of utterly mundane reality as a backdrop for them, to lull the reader slowly and imperceptibly into belief. Perhaps only Algernon Blackwood has achieved such powerful effects with so undistinguished a style. But in a few notable instances Davies can create horrific scenes of great intensity. The image of the rotting corpse of Clive Murchison calmly going about his business as Argred the Freeman in *Psychogeist* is not soon forgotten:

> The head was hairless, the flesh—what had once been flesh—drawn tightly over the naked skull, gleaming dully like polished brown leather. The face—what had once been a face—was dead, the cheeks hollowed, chin and nose grotesquely elongated, only the deeply sunken eyes alive, glittering points in dark pools. And the body—bones—nothing more than the skeletal shape it seemed—encased in that same dried, brittle brown parchment as the head. The fiction of a living mummy. . . . (173)

In *The Artificial Man* Arnold Hagan's metabolism speeds up hideously as a result of the tinkering that was done to his brain, until he becomes nearly all brain:

> There were limbs at the base, almost hidden by the grass, thin, spidery arms and legs, shriveled, shrunken almost out of existence, matching the hideous mockery of features, the eyes, ears, nose, and mouth that were little more than indentations in the yellow-white, blue-veined parchment flesh. A being—a thing that was a brain and little else. A brain that had no need to see, to hear, to eat. Progression. They had said. Into the future. And was this ultimate man? (244)

In *Dimension A* we encounter a mistlike entity—a combination of "animal cells, plant cells, dust. All stirred together in a gigantic test-tube and acted upon by forces beyond our comprehension" (125)—that proves to be one gigantic cell. And yet, these instances themselves confirm that it is purely the vigour of Davies's ideas that produces the sense of awe and wonder in his work, not any skilful mastery of prose.

In some of his early work Davies was regrettably given to introducing an adventitious love element, so that his protagonists were safely married at the end of the novel. Davies restrained this element of conventionality in his later work, although he was still fond of creating a mild sexual tension by the inclusion of females accompanying the male protagonist. These protagonists are all cut from the same mould—quiet, reserved, rather meek except when compelled by circumstances into action—to such a degree that one cannot help supposing they are reflections of the author.

Davies's settings are also somewhat repetitive, and occasionally we grow tired of all the charming little English country towns we constantly find ourselves in. But he can paint the scene both realistically and, now and again, almost lyrically, as in *The Lampton Dreamers:*

> The hamlet at its foot, indistinguishable from here—for it must be two miles away across the fields—was Lampton. He had been there once, to visit Francis Quain; and Francis, with a great air of ownership, as if he had lived there with his sister for all his life instead of barely two years, had walked him along the lane, pointing out landmarks. Past the church and the handful of thatched cottages that clustered tightly in the shadow of its squat Norman tower; past the cluttered, faded fronts of three tiny shops and the Green Man of Lampton that, for all the dignity of title and white benches on cobbled forecourt, was nothing more than two cottages joined into one; past the small building that was an odd mixture of new blue bricks and old russet-red and had once been an open-fronted smithy but was now, so Francis had said, the home of Lampton Ware souvenir pottery; then over the toy bridge that spanned a stream that usually dried up in the summer, and then along the lane that led upwards, past more cottages and a farm, towards the slopes of the Pike. It had been a grand tour that had lasted all of fifteen minutes. A village of perhaps three-score people—pretty enough, hardly picturesque, just one like a thousand others. (9–10)

Nevertheless, it is refreshing when the scene varies to a slightly futuristic London in *What Did I Do Tomorrow?* or, more grippingly, a hideous dystopian future envisioned by the mind of Clayton Solan in *Twilight Journey.*

A recurring image of Davies's amnesia novels is the protagonist's sudden and seemingly irrational sense that his face is somehow different, unrecognisable, or subtly changed. This obsessive image is found time and again:

> The face that stared back at him was suddenly that of a stranger. (*The Artificial Man* 8)

> For some obscure reason, he found no satisfaction—no assurance, even—in the sight of his own face. (*The Alien* 18)

A man's face is the most familiar thing to him there can ever be. He knows every small crease, the exact shade of flesh, every infinitesimal blemish. And because he shaves almost every morning of his life, he knows exactly the feel and texture of the beard to be removed.

Something was wrong . . . (*The White Room* 47)

Hurriedly he retraced the few steps to the window of gaudy shirt-pyramids to stare with a mixture of fascination and disbelief at the stranger in the blue suit that was his own reflection in the background mirror.

Certainly older—teenage gawkiness replaced by a kind of maturity—no doubt now about this being the future—no taller, but broader, with features that if taken singly were pretty much as they had always been, but if taken collectively, produced a face that was markedly different from the one that had looked back at him from the locker-room mirror only a couple of hours ago. (*What Did I Do Tomorrow?* 20)

. . . that face in the oval glass. Not shrunken, distorted, as he had feared by its feel, but as it had always been—narrow features; soft, almost feminine lines—a visionary face, not that of a hard, knife-edge, on-the-ball executive. There had been times when that deceptive appearance had served him in good stead. Soft wing of dark-bronze hair silky on poet's white brow. And here he was wasting time gazing Narcissus-like at his own face . . . (*Assignment Abacus* 87)

As a strategy for unsettling the reader, this image is potent: not only is "a man's face . . . the most familiar thing to him there can ever be," but it is our preeminent token of identity; so that if our face is not as it should be, then there is nothing in our personality or identity that cannot be lost or disturbed.

In the course of his work L. P. Davies probes, without providing or attempting to provide any definite answers, certain fundamental questions about human identity: What is a human being if his memory has been erased? What are we if our pasts have somehow been eradicated? How do we go about proving that we are who we say and think we are? Could we at some time have undergone some sort of indoctrination or brainwashing such that we think we are someone else? These are the most interesting questions we find in Davies's work, although it becomes obvious that other, lesser matters also concern him: in several novels the ultimate culprit is money or big business, as wealthy industrialists engage in elaborate hoaxes—including toying with people's minds or ruthlessly killing them—for the sake of gain; and several of the futuristic novels elaborate the notion of political indoctrination by a ruling oligarchy. These lesser themes are presented too bluntly and obviously to be effective—we know too clearly whose side the author is on—but the general amnesia theme that both brings Davies's work into a curious unity and distinguishes that work from all others in the field

will remain his signal contribution. Perhaps, beyond his narrative skill and his powerful conceptions, it is the way in which he unites the three normally disparate genres of mystery, horror, and science fiction—or, rather, how he displays the complete artificiality of such distinctions in the face of compellingly original conceptions that draw a little from each but are the property of none—that is Davies's greatest achievement.

IV. SOME CONTEMPORARIES

P. D. JAMES: THE EMPRESS'S NEW CLOTHES

It is a peculiar but instructive experience to read P. D. James (1920–2014) after reading the American hard-boiled writers. This most posh, refined, and restrained of contemporary British mystery writers presents as extreme a contrast to the Hammetts, Chandlers, and Macdonalds of the world as could possibly be imagined; but, at least to my mind, not in any way to her advantage.

It has become a truism to say that James was the most distinguished detective writer of her era, but there are substantial reasons to question this facile judgment. Especially in contrast to the hard-boiled writers, her prose is stiff, even stilted, her characterisation laborious and formulaic, and her plots executed at times with excruciating slowness (with the result that she has written some of the longest mystery novels of anyone since Dorothy L. Sayers—but in no sense does their length augur richness or profundity). There is very little originality in any of her works, and the customary plot elements she manipulates in novel after novel might have come from Agatha Christie's bottom drawer. And how James could have gained a reputation as a deft stylist—Marcel Berlins's flamboyant comment "She writes like an angel" is regularly plastered over her book jackets—is beyond mystifying. She makes obvious efforts to write in the manner of two of her favourite novelists—Jane Austen and Evelyn Waugh—but she lacks the deft wit and insight into character of the one and the mordant cynicism of the other.

Two comments in James's coy autobiography, *Time to Be Earnest* (1999), get to the heart of her deficiencies as a writer. In speaking of her father, she writes that he was "intelligent, reserved, sarcastic, deeply distrustful of sentimentality, fastidious and with little ability to show affection" (8). This is about as exact a characterisation of James's own literary persona as could be imagined. And of the painter Lucian Freud she writes: "He paints what he sees with total honesty if little humanity. I should like to own a Freud" (71). There is, for all the verbiage devoted to character portrayal in her novels, little humanity in James's writing: what she (as well as her followers) seems to consider sharp-edged dissection of characters' faults and foibles frequently comes across merely as mean-spirited contempt.

James's first three novels—*Cover Her Face* (1962), *A Mind to Murder* (1963), and *Unnatural Causes* (1967)—are perfectly competent but entirely undistinguished. All feature Adam Dalgliesh, a professional policeman working as a Chief Inspector at Scotland Yard (he would later be promoted to Commander and, still later, to head of a division that handles particularly sensitive cases, usually involving murder). This role at least allows Dalgliesh to avoid the implausibility of an amateur detective conveniently on the spot when a murder occurs, although in *Devices and Desires* (1989) that is in fact exactly what happens.

Cordelia Gray, a private detective, is featured only in *An Unsuitable Job for a Woman* (1972) and *The Skull Beneath the Skin* (1982), but proves to be a slightly more interesting character than Dalgliesh. At the beginning of the former novel she is seen working for Pryde's Detective Agency; but, at the age of twenty-two, she all but witnesses the suicide of her boss, Bernard G. Pryde, who had been diagnosed with cancer. It is noted that Pryde had been employed by the "Metropolitan Police in the C.I.D. with Superintendent Dalgliesh" (16). In any event, Gray decides to run the agency herself, something that surprises a local barmaid: "It isn't a suitable job for a woman" (21). Variations of this heavy-handedly unfeminist comment are repeated throughout the novel like a mantra.

Gray's first client is Sir Ronald Callender, a microbiologist and conservationist who seeks her help—and why shouldn't he, as she charges the bargain-basement rate of £5 a day? (38)—to ascertain why his son, Mark, killed himself eighteen days earlier. Later on there are some uninteresting references to Gray's identification with the dead man: "She believed Mark Callender had been murdered because she wanted to believe it. She had identified with him, with his solitariness, his self-sufficiency, his alienation from his father, his lonely childhood. She had even—most dangerous presumption of all—come to see herself as his avenger" (118). Of course, Mark had indeed been murdered, and the culprit is his own father.

The novel gains interest only in its final chapters, when James abruptly shifts the tempo from Gray's rather plodding interrogation of those who knew Mark to something approaching the standard hard-boiled novel, for all that it is set in the rarefied precincts of Cambridge. First we learn that Mark, when a friend found him suspended from a makeshift noose in his cottage, "was dressed like a woman in a black bra and black lace panties" (187). Could this mean that Mark was a cross-dresser and died by accident while acting out some solitary sexual scenario? Before Gray has time to consider this possibility, she is mugged and thrown into a well; and her arduous efforts to emerge from it (the well cover proves to be quite heavy) provide what few moments of drama and suspense the novel has. She is in fact rescued by someone else, but later engages in a car chase with a

suspect—Chris Lunn, Sir Ronald's lab assistant and driver—leading to his crashing the car and dying.

Gray confronts Sir Ronald well before the end of the novel, telegraphing the revelation of his guilt in the murder of his son. It appears that he killed his son and dressed him in women's clothing to make it look like suicide; Mark had found out that Sir Ronald's "wife was not his mother, that the money left to her and to him by his grandfather had come by fraud" (223)—a revelation that, if made public, would of course jeopardise Sir Ronald's lucrative position. One Elizabeth Leaming, bursting in, kills Sir Ronald—she is Mark's true mother. Gray then engages in the frankly criminal act of conspiring with Leaming to make Sir Ronald's death look like suicide. But the crafty Adam Dalgliesh sniffs out the shenanigans and questions Gray sharply at the end; she is saved only when, by a convenient *deus ex machina,* it is learned that Leaming has killed herself, thereby eliminating any possible witness to Gray's transgression.

There is nothing in the plot or execution of *An Unsuitable Job for a Woman* to distinguish it from dozens of other mysteries of its or an earlier era, but Cordelia Gray does emerge as a shrewd and dynamic figure. The refinement of her portrayal continues in *The Skull Beneath the Skin,* although it is an even poorer novel overall. Here we find that Sir George Ralston wants Gray to investigate death threats to his wife, the famous actress Clarissa Lisle, who is a bit on the nervous and jumpy side. She is to play in an amateur production of *The Duchess of Malfi* on a conveniently isolated island, Courcy Island. As we are mechanically introduced to one character after the other in successive chapters, we again seem to have landed in a routine Agatha Christie novel, where everyone has some more or less compelling reason for wanting Lisle dead. After Lisle is in fact murdered, a policeman makes note of the scenario: "It is a fallacy to suppose that a small circle of suspects, all known to each other, makes a case easier to solve. It doesn't; it only makes failure indefensible" (163).

The pace of the novel, especially at the beginning, is almost intolerably slow; and James succumbs to the hackneyed suspense-building device of having Gray reflect ponderously: "We are here together, ten of us on this small and lonely island. And one of us is a murderer" (244). In the course of the novel we are drawn back to the 1940s, when Ralston was involved in the killing of some German spies—and the butler, Munter, predictably proves to be the son of one of them. But this is a red herring, and the focus ultimately shifts to Simon Lessing (Lisle's stepson, a seventeen-year-old whom Lisle had pressured to have regular sex with her) and Ambrose Gorringe, the owner of the house where the suspects have come. It was Lessing who actually killed Lisle by throttling her, and Gorringe who smashed her face in out of revenge (she had been blackmailing him for abstruse reasons).

Once again, James tries to engender drama and suspense toward the end by having Gray and Lessing caught in an underground chamber where Gorringe has locked them; she manages to swim to safety (with help from a convenient fisherman), but Lessing dies. The novel ends with Gray's doubt as to whether Gorringe will ever be convicted for his crimes.

As for the Adam Dalgliesh mysteries, they gain only in verbiage with the passing of years. Dalgliesh remains a cipher throughout the first seven novels in which he appears—and, perhaps (in spite of James's grimly determined efforts to portray his life, loves, and avocations), in all of them. James seems not to want to make him the dominating figure of the standard detective tale, but the result is that we never gain any real understanding of him as a person. In the first three novels that feature him Dalgliesh has a fleeting and sporadic love affair with Deborah Riscoe, a suspect in *Cover Her Face*. And yet, as if admitting that she cannot complete with Lord Peter Wimsey's love affair with Harriet Vane, James describes the relationship in such an oblique manner that it never gains shape or coherence; and Dalgliesh's desire to propose marriage to Deborah at the beginning of *Unnatural Causes* is completely mystifying. It is no surprise that at the end of the novel Dalgliesh learns she is abandoning him, taking a job in New York.

Elsewhere in the Dalgliesh corpus we learn that he is the son of a pastor, that he had a wife and infant son who both died in childbirth, and—most grotesque of all—that he is a published poet. In light of his nebulous character, this becomes merely an odd and unassimilable detail. And James makes the disastrous mistake of including, in *Unnatural Causes,* a horrible scrap of doggerel, written in a poetic style about eighty years out of date, as an example of Dalgliesh's verse:

> *Remember me, you said, at Blythburgh*
> *As if you were not always in my mind*
> *And there could be an art to bend more sure*
> *A heart already wholly you inclined. (214)*

There is more, but this is all I can endure to quote. We breathe a sigh of relief when we learn in *A Taste for Death* (1986) that Dalgliesh has given up poetry (25)—but, alas, he promptly returns to it in his next adventure, *Devices and Desires* (1989), where a new book of poetry, *A Case to Answer and Other Poems*, "has been published to considerable acclaim . . . and to even wider public interest" (9). There is more doggerel by Dalgliesh in *Death in Holy Orders* (2001): "Buried at last who was so wise, / Six foot by three in clay he lies" (296). And, to cap it off, there is this bit of pretentious twaddle about his poetry in *The Lighthouse* (2005), in reference to the attitude of a new lover, Emma Lavenham, about him:

. . . was it that she knew as well as did he that his job fuelled the poetry, that the best of his verse had its roots in the pain, horror and pathetic detritus of the tragic and broken lives which made up his working life? Was it this knowledge that kept her silent and distanced when he was working? For him as a poet, beauty in nature, in human faces, had never been enough. He had always needed Yeats's foul rag-and-bone shop of the heart. (230)

I suppose this passes for profundity among detective writers.

Dalgliesh had met Lavenham, an academic, in *Death in Holy Orders*. He proposes to her—by letter!—at the end of *The Murder Room* (2003), and they are married at the end of the final Dalgliesh novel, *The Private Patient* (2008). But since Emma herself has not been portrayed in any systematic or insightful manner, we hardly know or care how this relationship will work itself out.

James, especially in the Dalgliesh novels, is fond of setting murders in artificially isolated environments—a hospital, a psychiatric clinic, a forensic laboratory, a lonely island off the English coast—in a manner that immediately brings the cosy mysteries of the 1930s to mind. Incredibly, in *Time to Be Earnest* she criticises those mysteries for their deficiencies in forensic knowledge (33f.); her own certainly are free from that failing, but read like plodding police procedurals at times, involving a relentless and laborious accumulation of evidence by Dalgliesh and a number of his colleagues. The end result is a sense of repetitiousness in all her novels: they nearly all fall into the same pattern, involving first a murder (and usually more than one— sometimes up to four), police interrogation of witnesses, discovery of clues, breaking down of alibis, and resolution of the crime. And they are all narrated with "total honesty if little humanity," so that few of the characters come to life as they proceed on a marionettes' dance mechanically staged by the author.

With *A Taste for Death* James initiated a two-decade long period, ending with the final Dalgliesh novel, of very, very long novels—the longest of them being *Devices and Desires, Original Sin* (1994), *A Certain Justice* (1997), and *Death in Holy Orders*. All these books are nearly twice the length of the average detective story and substantially longer than Dorothy L. Sayers's longest, *Gaudy Night*. Is there any justification for any of them? It does not strike me that there is. It would seem that James, buoyed by the flattering reviews of her earlier books, resolutely decided that she was, by God, a *novelist* and not merely a maker of detective stories, and she would prove it by a ponderous torrent of words. But there is no profundity to be found anywhere; all we have is the police investigation previously described—an investigation that is conveniently made more extensive and complex as the bodies pile successively up—and a final solution that at times seems to emerge like a jack-in-the-box. *Devices and Desires* tries to

make hay with the idea of nuclear power (there are frequent references to Chernobyl), but in the end nothing comes of this diffuse discussion. *Death in Holy Orders* takes place in a seminary, but there are no interesting discussions of religion or secularism.

A Taste for Death is not entirely unsuccessful in portraying a troubled M.P., Sir Paul Berowne (in fact a Minister to the Crown), who seems spiritually troubled and is killed, along with a tramp, in the vestry of a church in London. This is the first case for Dalgliesh's new unit, meant to handle politically sensitive criminal cases. Among his assistants are Chief Inspector John Massingham and Inspector Kate Miskin; and James tries to make something both of Massingham's inveterate sexism (he doesn't think women should be in the police force) and of Miskin's grimly determined escape from a lower-class upbringing in a "council house" (the British equivalent of a project). But James's characterisation of both is so superficial and stereotyped that they do not emerge as viable characters in their own right.

James has a bit more fun with Ursula Berowne, Paul's mother, a ruthless matriarch whose sole purpose is to keep her family (and herself) in upper-class luxury. As is common in James's later novels, there are all manner of sexual irregularities among the characters: both Paul and his wife, Barbara, are carrying on affairs, and Barbara's lover, Stephen Lampart, is a gynecologist who runs a clinic that may be illegally aborting babies for the purpose of sex selection. There is also a hackneyed portrayal of a wild-eyed leftist radical, Ivor Garrod, and sundry other uninteresting characters. The novel gains a certain dramatic interest at the end when Miskin is momentarily held hostage by the murderer (Dominic Swayne, Barbara Berowne's brother) in her grandmother's flat; she eventually subdues him (with some help from the police, who burst in as she is wrestling with him), but not before Swayne has killed the grandmother.

The only thing approaching poignancy in this bloated and slow-moving novel is a fleeting passage in which Dalgliesh ponders the finality of death: "The woman's eyes had glanced at the photograph once only and then stared ahead, denying knowledge, denying truth. There were some realities which the mind refused to accept even in the cause of retribution, of justice. You can't bring them back. It was the cry of the whole defeated, anguished, grieving world" (267). Not terribly profound, but expressed well. But it can hardly justify the relentless verbiage inflicted upon us.

Devices and Desires begins an annoying habit of earmarking a particularly odious character for death almost from the beginning, and also surrounding the victim with all manner of individuals who conveniently have a motive for committing the murder. This was already a contrived device in the Agatha Christie novels, and James does nothing to enliven it with originality. In this case the targeted victim is Hilary Roberts, who works at the

nuclear power plant. Among the suspects are: Alex Mair, who operates the plant and had an affair with Hilary, which he broke off; Neil Pascoe, an anti-nuclear-power activist worried about a libel suit that Hilary has initiated; Ryan Blaney, whose family Hilary wants to evict from the cottage they occupy; and so on and so forth. In the end the murder is pinned on Alice Mair, Alex's sister, who is allowed to kill herself.

Original Sin presents the obvious victim in the form of Gerard Etienne, director of a storied publishing company (Peverell House) who wishes to move the company out of its historic but expensive building, Innocent House, but is furiously opposed by various surviving members of the Peverell family. Predictably, he has had an affair with one of the head editors, Frances Peverell. This novel begins the implausible piling up of bodies that we find in several later James novels—a litter of corpses that, in the ordinary course of events, would have generated enormous press coverage and a tsunami of police investigation, but which in these novels is merely accepted as an unfortunate effect of the killer's attempt to evade detection. Here, two people are killed, a third almost killed, and the killer is allowed by Dalgliesh to kill himself.

James tries to enliven the overall scenario by continuing to portray the various detectives investigating the case as real people, but not much is gained by the endeavour. Kate Miskin has shed the odious John Massingham but is saddled with an underling, Daniel Aaron, who is acutely conscious of his Jewish heritage. There is also a crude attempt to create an atmosphere of foreboding:

> Sometimes at the end of the day, when the light began to fade and the river outside was a black tide, and footsteps echoed eerily on the marble of the hall, she would be reminded of the hours before a bad thunderstorm, the deepening darkness, the heaviness and sharp metallic smell of the air, the knowledge that nothing could break this tension but the first crash of thunder and a violent tearing of the skies. (104)

We are almost back to the era of "It was a dark and stormy night."

And, as with *The Skull Beneath the Skin,* we learn that the "original sin" of the title is an incident out of World War II, where Gerald Etienne's father had betrayed the family of Gabriel Dauntsey (the murderer), causing their deaths. In a purportedly ironic twist, it transpires that Gabriel and his sister Claudia (whom Dauntsey had also killed) were only adopted. Stricken with remorse, Dauntsey wanders off and drowns himself in a pool.

In *A Certain Justice* the lawyer Venetia Aldridge is, from literally the first page, earmarked as a murder victim. By this time James had perfected what would become the jejune device of beginning a work with an obvious statement that a murder has been or will be committed: "When, on

the afternoon of Wednesday, 11 September, Venetia Aldridge stood up to cross-examine the prosecution's chief witness in the case of *Regina v. Ashe,* she had four weeks, four hours and fifty minutes left of life" (3). Aldridge is intensely unlikable—either because she is aggressively feminist in all but demanding that a woman be appointed to be Head of Chambers (i.e., the Middle Temple, one of the four Inns of Court in the English bar), or because she has a troubled relationship with her wayward daughter, Olivia, or because, as a defence lawyer, she has cleverly allowed certain defendants who were almost certainly guilty to be acquitted. All these characteristics come back to bite her.

Part of her comeuppance comes in the form of Garry Ashe, whom she has just freed from a murder indictment but who she herself believes is probably guilty of the crime. He forthwith takes up with Olivia, and they quickly become engaged. What we learn only much later is that this romantic entanglement was—with incredible implausibility—staged by a cleaning woman at the Middle Temple, Janet Carpenter, who gave Ashe her life savings of £25,000 to seduce Olivia; in this way, Carpenter can gain revenge on Aldridge (who had earlier secured the freedom of a suspected murderer who had then gone on to murder Carpenter's granddaughter). When Carpenter herself dies, evidently a suicide, the case seems solved. But Dalgliesh quickly realises that her death is murder, as James pulls out the hackneyed ploy that Carpenter, being left-handed, could not have slit her own throat with her right hand.

The crimes are then pinned on to Garry Ashe himself, who has bolted with Olivia to parts unknown and, along the way, killed a former tutor along the way. It is here that the novel at last gains both compelling dramatic interest and psychological insight: the hunt for Ashe, seen largely through his own eyes, keenly portrays his seriously troubled childhood and his mental aberration. But, although Dalgliesh ascertains that Ashe had killed Carpenter and the tutor, he had no motive for killing Aldridge. This murder is eventually affixed to Desmond Ulrick, a fellow lawyer. This revelation is handled with a certain cleverness: earlier on we had been strongly led to suspect Ulrick because Aldridge's father, a headmaster at a private school, had seemingly driven Ulrick's brother to suicide; but Ulrick admits that the headmaster was not in fact responsible for his brother's death. This allows us to drop our guard and remove Ulrick from the list of plausible suspects— but Ulrick then states, in a bold confession to Dalgliesh, that Aldridge had damaging information on another lawyer, Simon Costello (the husband of his niece), leading him to kill her. Aldridge makes this confession because he knows that there is no evidence to convict him or even bring him to trial. And that is how the book ends.

Death in Holy Orders is set at St. Anselm's theological college, where,

we learn, Dalgliesh had stayed briefly at the age of fifteen. It is not clear whether this setting betrays any indication of James's own religious preference. In *Time to Be Earnest* she makes it plain that she was raised as an Anglican ("I was born and bred in the distinctive odour of Anglicanism . . . I early grew accustomed to its services" [84]); but when Iris Murdoch asked her, "Are you a Christian?" she states: "I began my usual confused reply to this question. I said that I regarded myself as one and was a communicant of the Church of England, although I had difficulty with some theological doctrines and could hardly claim to be a good Christian" (232). The matter is not of any particular importance, because the issue of religious faith rarely plays any significant role in her novels, even *Death in Holy Orders*. But I hope I am not alone in being disturbed, even aghast, at the incredible sympathy James in this novel extends to one Father John Betterton, who was found guilty of molesting some boys and spent three years in prison. Throughout the novel James is shockingly lenient on his derelictions: ". . . the offences had been more a question of inappropriate fondling and caresses than of serious sexual abuse . . . He [Father Martin] was torn with pity every time he saw Father John almost creeping about his duties, taking Communion but never celebrating, finding St. Anselm's a refuge rather than a job" (41–42). Not one word of sympathy is accorded his youthful and no doubt traumatised victims.

In any event, we are concerned here with an astounding succession of murders, or at least deaths: first, the death of a pupil at the college, Ronald Treeves, found buried in the sand near the seashore; then with the evident murder of Margaret Munroe, who works at the college; then with the murder of Matthew Crampton, the archdeacon; then with the death (probably murder) of Agatha Betterton, John's sister. It transpires that one George Gregory, an instructor, is the murderer of the latter three, for various reasons; Treeves—whose death his father, a wealthy businessman, had asked Dalgliesh to investigate—was in fact a suicide. (There are several more suspicious deaths in the past that figure into the case.)

This novel contains more hints of aberrant sex than is common in James's work. She clearly felt the need to pepper her recent novels with such hints in order to counteract her stodgy prose and slow-paced action, which might alienate her younger readers. Here, aside from Betterton's molestations, we have a gardener and his half-sister happily engaging in sexual relations, and this same half-sister—who at one point declares she is writing an article on the Black Mass (364)—has also had sex with Ronald Treeves, leading to his suicide. There is even mention of a semen-stained cloak. The novel concludes with Dalgliesh wrestling with Gregory in the frigid waters off a shore road, but they are both rescued.

James's last three Dalgliesh novels are minimally shorter than their pro-

lix predecessors, but not by much; and they again fail to engender any innovations in the methodology or execution of the detective story or to raise themselves to anything approaching works of depth or aesthetic richness. *The Murder Room* betrays all the flaws that her previous novels exhibited: the setting in an artificially isolated locale (the Ducayne Museum in London, specifically the "murder room" of that museum, devoted to the more notable murders of the 1920s and '30s); the identification of the murder victim at the outset (Neville Ducayne) because of the large number of people who want him dead; mechanical portrayals of one character after the other, which completely halt the narrative flow; a proliferation of dead bodies (two murdered, a third seriously injured); and, to top it off, a suggestion of lasciviousness (Neville's sister Caroline runs a sex club for the wealthy and decadent in an apartment next to the museum). And, again, there is the relentless police investigation by Dalgliesh and his colleagues that, with excruciating slowness, turns up enough clues to pinpoint the murderer—Muriel Godby, the secretary-receptionist at the museum. Even this point is handled badly: Muriel killed Neville for (in her mind) causing her sister's death some years before, and she was also "besotted" (396) with Caroline, who was having a bitter dispute with Neville about keeping the museum open; but this latter point is not at all emphasised in the text, and it leaps out at the reader as a baffling and unaccountable surprise.

The Lighthouse is troubling for many reasons, chief of which is that it seems to draw heavily on the plot of *The Skull Beneath the Skin*. Here too we have the scenario of a finite number of suspects on a remote and virtually inaccessible island (Combe Island, off the coast of Cornwall), and a suggestion that the motive for the murder had its origin in events stretching back to World War II. This latter point, as in the earlier novel, proves to be a red herring. When the famous novelist Nathan Oliver (who—not to beat a dead horse—is once again identified almost from the beginning as a widely disliked figure and therefore targeted for death) is killed, suspicion momentarily lands on Dr. Raimund Speidel, a German ex-diplomat who admits that he had wished to query Oliver about events on the island toward the end of the war, in which his father and other German officers had gone missing. In the end this element has little to do with the murder, which is pinned on one Dan Padgett, a handyman who discovers he is Oliver's son, but who had been scorned and ignored by his self-obsessed father.

But James commits another gaffe in the identification of the murderer. In the course of the novel Dalgliesh falls ill: he thinks it is the flu, but it proves to be a much more serious ailment, SARS. Largely incapacitated, he is forced to leave the bulk of the investigation in the (entirely capable) hands of Kate Miskin. But then, well before the end, Dalgliesh "suddenly . . . saw the answer to the puzzle" (345), because he—in some mysterious and never-

explained fashion—deduces that Padgett is Oliver's son. This is armchair detection with a vengeance! A purportedly dramatic scene in which Padgett seizes a young woman and drags her up to the lighthouse, threatening to hurl her over the railing to her death but is prevented from doing so by Miskin and another police officer, does not salvage this unsatisfying novel.

Nor need we waste much attention on *The Private Patient*, one more tired rehash of standard James scenarios: the isolated setting (a high-end clinic for cosmetic surgery); a limited number of suspects; hackneyed elements out of old-time detective fiction (shenanigans with wills, a taped confession by the murderer, a series of murders based on the commonplace motive of extortion, and so on). Here the identity of the murderer is telegraphed long before the end, sapping the novel of any significant element of suspense and dramatic revelation. It is not a notable end to the Dalgliesh saga.

It is entirely understandable that James's final novel, *Death Comes to Pemberley* (2011), written when she was about ninety, would be a wooden pastiche of her idol, Jane Austen. Indeed, it is specifically a "sequel" of sorts to *Pride and Prejudice,* set some years after Elizabeth Bennet has married Fitzwilliam Darcy and settled in his lavish home of Pemberley. Elizabeth's sister Lydia shows up at Pemberley, hysterically claiming that her husband, George Wickham, has been murdered by his friend, Captain Denny. In fact, it is Denny who is dead, his body found in a wood near the house. Wickham was found bending over the body, lamenting that he has killed him. This seems to be a straightforward confession, but the young lawyer Henry Alveston thinks otherwise. Although Wickham is convicted for the murder, a later confession by one William Bidwell, a young man living in a cottage in the wood and stricken with a fatal illness, states that he had killed Denny with a poker because he thought Denny was the man who had "attempted an assault on [his sister Louisa's] virtue" (238). The core of the actual mystery plot would scarcely occupy the space of a novelette, but James pads the novel with a ponderous pastiche of Austen's prose idiom and various other plot twists involving illegitimate children, requited and unrequited love affairs, and so on.

If I have been less than enthusiastic about the work of P. D. James, it is chiefly because so many readers and critics seem to have been snookered by her highbrow writing style and mountainous verbiage into thinking not only that she is a pioneering mystery writer but also a serious novelist. Both elements of that formulation seem to me to be entirely false, even grotesque. There is, as I have suggested, not a single feature in James's work that can be said to be an original contribution to detective fiction—these features have been used and reused over and over again for the past hundred years by detective writers great and small. And the notion that she has somehow

transmuted the mystery novel into some sort of higher form is largely a product of critics' bamboozlement over her pretentious and pseudo-literary idiom and her dogged attempts to portray character in page after page of description that really reveals nothing about the characters in question and fails to bring them to life.

There is, indeed, a horrible lack of humanity in her work. Writers much inferior to her on the literary scale, such as John Dickson Carr, have produced works far more engaging than hers as popular fiction; and other writers, such as Margaret Millar and Patricia Highsmith, display an infinitely greater insight into character and can express that insight in a fraction of her wordage. P. D. James may have ended up as Baroness James of Holland Park, but there is no earthly reason to consider her a queen of crime writing.

RUTH RENDELL: THE PSYCHOLOGY OF MURDER

In a long and productive career, British writer Ruth Rendell (1930–2015) published seventy-six books—about as many as Agatha Christie and John Dickson Carr—including twenty-four novels featuring Inspector Reginald Wexford, twenty-eight crime novels that have no recurring detective, fourteen novels written under the pseudonym Barbara Vine, which focus chiefly on psychological investigation of characters involved in a crime scenario, three novellas, and seven short story collections. She predictably won a great many awards in the crime/mystery field and was generally regarded as the leading crime writer of her generation, along with P. D. James.

I do not pretend to have read anything close to the complete corpus of Rendell's writings. I have bypassed the short stories altogether and have read seventeen of her novels, a mix of the novels written under her own name and those written under the Barbara Vine pseudonym. My selections have not been entirely random, as I have focused on those books that have generally garnered praise among critics or have been nominated for or received awards in the mystery field.

Rendell's prolificity is not incompatible with a relatively high level of quality. Generally speaking, those writers—especially in the mystery field—who write a great many books tend to be scorned by critics as hacks, as if the mere act of setting a lot of words on paper is indicative of inferiority; but in reality, those authors who are so scorned—Agatha Christie (in spite of her immense and ongoing popularity), Edgar Wallace, Erle Stanley Gardner, among others who could be named—were inferior writers to begin with and would not have produced good work even if they had laboured painstakingly on a relatively small number of books, as Dorothy L. Sayers, Dashiell Hammett, and Raymond Chandler did. John Dickson Carr wrote about as many books as Christie, but in my judgment his work ranks significantly higher than hers. Many other authors covered in this volume wrote twenty, thirty, or forty novels, but their work is not at all undistinguished.

Rendell, in short, is more than capable as a writer—and, in contrast to her contemporary and countrywoman P. D. James, makes few pretensions at lofty literary status. Her prose is at worst workmanlike and at best com-

pelling and hypnotic; her ability to draw character is admirable; and her skill at plot-weaving, while necessarily inferior to that of a puzzlemeister like Carr, is notable. The Barbara Vine books are distinguished by a penetrating analysis of aberrant psychological states that rivals Patricia Highsmith, and this characteristic carries over at times to novels written under her own name.

And yet, her first novel involving Chief Inspector Reginald Wexford, *From Doon with Death* (1964), is so slight and rudimentary that it is as if the publisher had some kind of preternatural insight into Rendell's subsequent career and issued the book based on its promise rather than on its own merits. We are here introduced to the small town of Kingsmarkham, in Sussex, where the majority of the Wexford novels take place. The plot focuses on the disappearance of a seemingly conventional middle-class housewife, Margaret Parsons, as she leaves one morning to go to the grocery; her body is found two days later. The case revolves around books found in the attic of her home—expensive books of poetry inscribed from someone named Doon to Margaret.

In our oversexualised age, few readers today will have failed to guess that Doon is actually a woman; but evidently in 1964, at the very dawn of the sexual revolution, this conclusion would still have been regarded as something shocking and aberrant. But the clues are all too obvious. When one Fabia Quadrant, a schoolmate of Margaret's, grudgingly admits that she was well acquainted with her but didn't know of any boyfriends of hers at the time; and when a letter that Margaret had written to a cousin (169f.) makes no mention of Doon's gender, the solution to the riddle becomes obvious, and there is little surprise when Fabia herself is identified as Doon and as the murderess.

At the outset we are given a description of Wexford, along with his customary sidekick, Inspector Mike Burden:

> He was taller than Burden, thick-set without being fat, fifty-two years old, the very prototype of an actor playing a top-brass policeman. Born up the road in Pomfret, living most of his life in this part of Sussex, he knew most people and he knew the district well enough for the map on the buttercup-yellow wall to be regarded merely as a decoration. (18)

Not very interesting—and, to be honest, Wexford does not become any more interesting in the remaining novels involving him. We later learn that he has a wife, Dora, and two grown daughters, Sheila (a well-known actress) and Sylvia, who has more than her share of difficulties with various husbands and other male companions. But none of this makes Wexford himself a more compelling figure. Some minimal interest is provided when, in *The Veiled One* (1988), Sheila—then participating in anti–nuclear power

protests—is apparently the target of terrorist attacks, as her car is blown up (Wexford himself comes close to being killed in the incident); but it later transpires that the target was someone else altogether. In *Road Rage* (1997), Dora is one of several persons who is kidnapped, and the dramatic tension created by this scenario is memorable; but she is ultimately released unharmed.

It is, I suppose, a mercy that Wexford is not endowed with the corny idiosyncrasies that turn so many other fictional detectives (Hercule Poirot, Lord Peter Wimsey, even Gideon Fell) into ludicrous caricatures; but he remains as bland and faceless as figure as James's Adam Dalgliesh (who is himself disfigured by his preposterous poetry-writing). He is simply a dogged and tenacious policeman, relentlessly interviewing suspects and assessing evidence until some insight (not always evident to the reader) allows him to pierce through the fog of obfuscation that Rendell generates and gets his man (or, surprisingly often, his woman). He is down-to-earth, enjoying more than his share of drinks at his favourite pub and speaking in salty language just on this side of vulgarity. As a family man, he is constantly worried about his wayward daughters, who never seem able to settle down to the comfortable middle-class married life that he has achieved.

Mike Burden, who figures in most of the Wexford books, is no more compelling. He is something of a hothead, often fixating on the guilt of a given suspect without adequate evidence, thereby creating some sparks with his superior. At times he reveals himself to be a bit of a chauvinist, and he is thrilled when his wife gives birth to a son. He tends to do more of the legwork than Wexford, as is only fair given his subordinate position. Later novels feature a female police officer, Karen Malahyde, but she too remains colourless.

A sexual element is predominant in a Wexford novel written more than two decades after the first one, *An Unkindness of Ravens* (1985). When a businessman named Rodney Williams goes missing after he leaves Kingsmarkham for Ipswich, his wife, Joy (a neighbour of Wexford's), notifies the police. Once his body is found—he died of stab wounds—a second wife, Wendy, emerges. It appears that Williams had two entirely separate families, with teenage daughters from both wives: Sara (from Joy) and Jennifer (from Wendy).

Rendell engages in a somewhat malicious caricature of feminism in this novel. An Oxford professor has set up a group of radical feminists named ARRIA (Action for the Radical Reform of Intersexual Attitudes) (169). The professor, Caroline Peters, states the objective of the group: "Basically, [we] have as little contact with men as possible. Defy men by intellectual and also by physical means" (169). As if this is not heinous enough, a member of the group declares: "Edwina [a student at Oxford] said in order to prove

herself a true feminist a woman ought to kill a man" (175). Well, this doesn't sound good at all!

On the flip side, evidence appears to emerge that Rodney Williams himself is attracted to underage girls. Wexford's wife Dora states that he once made a pass at their fifteen-year-old daughter. Even the most sexually accommodating of us would be shocked to hear that Williams had sex with his own daughter, Sara—but at the end Wexford dismisses this as a fantasy on her part. Amidst all the sexual insinuations, the trauma of two women facing the prospect of a bigamous husband, and various other shenanigans by which Rendell cleverly casts a smokescreen over the central issue, it is a genuine surprise when we learn that Williams's daughters, Sara and Jennifer, teamed up to kill him. But even this revelation is not tied to sexual irregularities, for Sara's motive in killing her father rested on his refusal to pay her way to medical school, because doing so would have involved revealing his true income—and his bigamy—to the authorities. And Rendell gets in one final twist as Wexford stumbles on the solution when he realises that he has misinterpreted the remark of a witness ("Those two women knew each other" [318]) as referring to the two wives, not the two daughters. So perhaps feminism (which has been properly insistent that females who have reached the age of eighteen should be called women and not girls) triumphs after all!

In *The Veiled One* Wexford becomes involved in the case in a strikingly direct fashion: as he is leaving the parking lot of a shopping mall around 6 P.M., he fails to notice a dead body lying near a car! The corpse proves to be that of Gwen Robison, a middle-aged retired woman. Much effort in the novel is spent trying to connect Gwen with Clifford Sanders, a disturbed young man whose mother, Dorothy, discovered the body while waiting for him to pick her up at the mall. Clifford admits that he himself saw the body, but feared it was his mother: "Then I thought someone was doing it to . . . mock me" (68). The nature of Clifford's psychological malady is never fully explored, but he spends much time talking to Mike Burden, who is monomaniacally fixated on his guilt; Clifford finally admits that, in spite (or perhaps because) of all the sacrifices his widowed mother has made on his behalf, he hates her (205).

To make short shrift of a novel with multiple twists and turns, the crime is pinned to Dorothy Sanders, who in fact also killed her husband and father-in-law; but before that revelation, we are treated to the spectacular scenario of Clifford killing his own mother and coming to see Mike Burden covered in blood. Gwen, far from being an innocent victim, turns out to have been a blackmailer—even though this revelation is based on evidence presented so late in the novel (on p. 296 of the 312-page paperback edition) that it could rightly count as evidence withheld from the reader. It is also in

this novel that Sheila Wexford seems inexplicably targeted by a terrorist, in the course of which her car is blown up and the Wexfords' house is seriously damaged. But in the end the target of the attack proves to be a lawyer who was prosecuting Arab terrorists.

Rendell blunders into other sociopolitical issues in other Wexford novels. *Simisola* (1995) treats the fraught issue of persons of colour in England, but does so in a manner that is not notably illuminating. The case revolves around the disappearance of Melanie Akande, the daughter of Wexford's own physician, Raymond Akande, a black man from Nigeria. When a young black woman is found dead, Wexford assumes it is Melanie—but Akande, examining the body, emphatically states it isn't, Akande's wife Laurette blows up and hurls imprecations in Wexford's face: "You damned hypocrite! You don't have prejudice, do you? But when you find a dead black girl it's got to be *our* girl because we're black!" (181). In fact, Wexford had at the outset of the case ruefully admitted the ubiquity of racism, as he discusses the matter with Burden:

> "We're all racists. . . . Without exception. People over forty are worse and that's about all you can say. You were brought up and I was brought up to think ourselves superior to black people. Oh, it may not have been explicit but it was there all right. We were conditioned that way and it's in us still, it's ineradicable. . . . Black people were known as Negroes. When did you ever hear anyone but a sociologist like my daughter Sylvia refer to white people as Caucasians?" (12)

None of this is particularly profound or insightful; and in fact, the bulk of the case deals with the murder of a white woman, Annette Bystock, who worked at an employment office and who had apparently talked with Melanie. The timing of her death and Melanie's disappearance cannot, in Wexford's eyes, be coincidental. Later we learn that Annette was having an affair with a married man, but this proves irrelevant to the case. Wexford believes there is greater relevance in Annette's remark to her cousin, "There was something happened through work and I think maybe I should go to the police" (104)—but at this point Wexford still believes the matter is associated with Melanie. But that connexion is blown up when Wexford finds Melanie alive, living with a young white man, Christopher Riding, who had dated her years before.

In the end, racism does enter from a different direction when it is determined that the dead girl is a Nigerian woman named Simisola, who had been brought over by the Riding family from their home in Kuwait and forced to work as a virtual slave. Both Christopher and his father Swithin had repeatedly raped her. She had managed to escape and found her way to the employment office, explaining her situation to Annette Bystock. Bystock is

killed by a hitman hired by Swithin Riding. The resolution of the case raises issues of overall proportionality: the Ridings are fairly minor characters who only enter the narrative in the final quarter—perhaps, indeed, the final fifth—of the book, so it is not entirely satisfying that the murders are pinned on them. Nevertheless, the novel is consistently gripping.

Road Rage (1997) addresses the issue of environmentalism—but again, it does so in a manner that suggests Rendell is less than enthusiastic on the subject, if the caricature of radical environmentalists found in the novel is any gauge. Here we see the citizens of Kingsmarkham up in arms about a bypass road that would destroy a butterfly habitat and cause other environmental damage. As work continues on the project, the "badly decomposed body of a young girl" (10) is found; it proves to be that of a young German hitchhiker, Ulrike Ranke. It is in this novel that Dora Wexford, travelling by taxi to see her daughter Sheila after the birth of the latter's daughter, Amulet, goes missing. Suspicion coalesces around a taxi company, Contemporary Cars, that seems linked to several other disappearances, including that of a fourteen-year-old boy, Ryan Barker, and an elderly couple, the Struthers.

Later the *Kingsmarkham Courier* receives a letter from a group called Sacred Globe, whose mission is "saving the earth from destruction by all means in our power" (68). Still later, someone from this group calls the Mike Burden household and demands that work on the bypass be discontinued, otherwise the hostages will be killed one by one. Dora Wexford is then released—but only so that she can tell authorities that "suspension won't be enough. They want cancellation" (147). Although Wexford suspects one of the leading protesters of the bypass, Brendan Royall (a former pupil of Burden's wife Jenny, a schoolteacher), it is only toward the end of the novel that Wexford ascertains that the culprits may be those who are personally affected by the bypass—perhaps their view would be spoiled by it, for example. Why Wexford did not make this fairly obvious deduction at the beginning remains unclear; but in the end the kidnappings are found to be the work of the Struthers themselves, who only posed as hostages: the value of their property would be reduced by as much as 50% if the bypass was completed. So in the end it is not radical environmentalism (even though Conrad Tarling, a protest leader who calls himself "King of the Wood" is tangentially involved) but crass monetary concerns that the two murders in the book.

A later Wexford book, *Babes in the Wood* (2002), once again has a sexual subtext, as well as that of religious fanaticism—but I remain unconvinced that these issues have been treated with any seriousness or complexity. Here we are concerned with the disappearance of two teenagers, Giles and Sophie Dade, and their babysitter, a woman in her thirties named Joanna Troy. Later Joanna's body is found in her car. We learn that Giles is involved

with a fundamentalist Christian cult, the Church of the Good Gospel, that stresses sexual purity for its adherents. Is the fact that Joanna appears to have had eyes for the children's father, Roger Dade, of any significance? What of the fact that Joanna had had to resign from a teaching job because she was accused (falsely, it seems) of stealing £20 from the backpack of a sixteen-year-old boy, Damon Wimborne? There are even suggestions that Roger Dade sexually abused his daughter, Sophie, who hates him.

In the end, not much is made of any of this. Wexford does conclude that the case was really "about the conflict between the Good Gospelers and Joanna Troy—or, rather, people like Joanna Troy in the larger sense" (304). What he means is that Joanna was a kind of pedophile, sexually attracted to adolescent boys—among them Damon Wimborne and Giles Dade himself. On that fateful night when she was babysitting, she had boldly come into Giles's room and stripped naked. In spite of his religious indoctrination, he had become aroused and had sex with Joanna. He promptly confessed his "sin" to the pastor of his church, Jashob Wright, who sent another church member over to the house to kill Joanna. This person did so by throwing her down the stairs. Giles and Sophie are found safe, having fled to, respectively, a grandmother and her ex-husband.

The crime/suspense novels not involving Wexford published under the Rendell name are generally superior to the Wexford novels, and also form a natural transition between those relatively conventional detective stories and the Barbara Vine novels. The first of them is *To Fear a Painted Devil* (1965), although it does not rank high among her output. Here we encounter the standard detective scenario of a multiple cast of characters, many of whom are conveniently endowed with a motive to kill the murder victim, one Patrick Solby. The parties in question all live in a largely enclosed development, and a surprising number of affairs between the various married couples are unearthed. One of the characters flatly states: "Patrick had a good many enemies, you know. Quite a lot of people must be glad he's dead" (83). The detective is a physician, Dr Max Greenfield, who brings his medical expertise to bear in determining that Solby was killed by a beekeeper who contrived to have him killed by a bee (Solby is allergic to bee stings).

Not a great deal better is *The Face of Trespass* (1974), where a married woman named Drusilla Janus (a less than subtle allusion to the Roman god Janus, who has two faces), sets a trap for her former lover, Gray Lanceton, by murdering her husband and framing him. But the plot is full of obvious holes, and a contrived happy ending whereby Drusilla is brought to justice does not help matters. *Make Death Love Me* (1979) is only marginally better. This novel deals with a bank manager, Alan Groombridge, who is weary of his stifling middle-class life, especially his wife Pam and his

children Christopher and Jillian. An element of class consciousness enters the picture by virtue of the fact that fifteen-year-old Jillian, already sexually active, is involved with a boyfriend whose lower-class friends, Marty Foster and Nigel Thaxby, set about robbing Alan's bank. They do just at the time when Alan himself is thinking of making away with £3000 and bolting. In the ruckus, both the robbers and Alan walk away with a wad of cash; the former also take away another worker at the bank, Joyce Culver, as a hostage.

The rest of the novel is focused on (a) Alan's establishment of a new identity away from his family, and (b) the trauma of Joyce as she deals with her unpleasant captors. But Alan feels tremendous guilt at Joyce's capture, which he has heard about in newspaper accounts. It is here that the novel turns pivotally on a ludicrous coincidence, where Alan miraculously finds himself in the same pub as Marty and recognises him as one of the robbers. He later tracks him down to a flat that he, Nigel, and Joyce are occupying, although the police are also on the trail. In the end Alan is killed, as are the two robbers, but Joyce is rescued.

Substantially better is *The Tree of Hands* (1984). Here we find genuine and sensitive, even searing, analysis of the disturbed psyches of a number of characters, beginning with Benet Archdale, a single mother who suffers the agony of losing her small child, James, when he dies in a botched tracheotomy. Benet's mother Mospa is in no better psychological shape, for she calmly makes away with another child, Jason Stratford, who had been left momentarily alone by an eight-year-old friend, Karen Isadoro, while he was sitting on a high wall. The intensity of the conflict between Benet and Mopsa—the former realises that the child Mopsa has brought home has been kidnapped, while the latter is ingenuously seeking to provide solace to her daughter with a kind of replacement child—creates an electric atmosphere. Mopsa is terrified of being committed to an institution because of her dereliction, and her hysterics cause Benet to delay bringing the child to the police:

> For a moment she [Benet] had been afraid. The skin on the back of her neck had crept and she had felt the hairs standing erect on gooseflesh. She had been frightened of pathetic, crazed Mopsa. She bent down and got hold of Mopsa's shoulders and shook her, though without much result. Mopsa slithered out of her grasp and drummed her fists on the floor and shouted: "They'll commit me, they'll make you commit me, I'll be certified, I'll never come out, I'll die in there!" (118)

This is one of several novels where several disparate groups of people find their lives intertwined in a web of criminality and wrenching emotional conflict. There are Benet and Mopsa; there is Carol Stratford, a working-

class woman struggling to take care of Jason and two other small children while trying to maintain her relationship with a boyfriend, Barry Mahon; and there is Terence Wand, a disreputable scoundrel who may be Jason's father and who is involved with an older woman, Freda Phipps, and is seeking to steal her property. The end result is an atmosphere of ineluctable doom highly reminiscent of Patricia Highsmith. The reader is fully aware that a multitude of bad things are going to happen in this combustible scenario of interlocking characters. The conclusion is indeed full of twists, turns, and deaths—and in the end Benet finds herself unable to give up Jason and lives happily with him as his caring replacement mother.

Talking to Strange Men (1987) involves only two broad sets of characters but is no less complex and psychologically compelling. Here the two groups initially have not the slightest connexion with each other, but their relations inexorably fuse and lead to horror and death. One group is a seemingly harmless cadre of teenage boys, led by Mungo Cameron, who play at being spies by leaving coded messages in envelopes taped to a pillar of an overpass. The second group consists of a young man, John Creevey, who is attempting to reconcile with his ex-wife, Jennifer; Creevey's sister, Cherry, was murdered eighteen years before in a case that was never solved.

The novel ultimately fails because it is based on too many implausible coincidences and twists of plot. First, John Creevey, finding a taped message, solves the code far too easily, and then begins leaving coded messages himself. Secondly, Cherry's fiancé, Mark Simms, blurts out to John that he in fact killed her, going on to state that Cherry (a woman who was not conventionally beautiful or attractive) "was the biggest whore in town" (125). (It later transpires that Simms's confession is false.) The chapters involving Mungo and his friends go on at excessive length and do not advance the plot significantly. And once again an aberrant sexual element enters in the figure of Peter Moran, Jennifer's boyfriend, who proves to be a pedophile attracted to young boys. He suffers a spectacular death in an abandoned house while pursuing Mungo. Grotesquely enough, just as John thinks he might reconcile with Jennifer, he sees her in the company of—Mark Simms!

The Keys to the Street (1996) proposes a highly intriguing relationship between Mary Jago, a young woman who had donated some of her bone marrow to a leukemia patient, and the recipient of her generosity, a young man named Leo Nash. The sense of a strangely intimate relationship between the pair is keenly etched as they first correspond, then meet, then fall in love ("The knowledge that this fragile, thin, pale man's body contained the marrow from her own bones, a healing elixir that had restored his health, affected her so profoundly that she felt almost faint" [70–71]). Mary is perhaps more welcoming of Leo's intimacy because she has just declared a trial separation from her abusive fiancé, Alistair. Meanwhile, homeless

men are being hideously impaled on the metal fence surrounding a park in the area. After a long and hesitant courtship, the relationship between Mary and Leo finally becomes sexual, and Mary thinks she has found her ideal lover:

> He was as gentle as she, as languid, and—until the end when she, for once, was imperative and demanding—as slow and delicate with his caresses. But at that end she had cried out as those others had always expected her to cry and had held him in an embrace she was fearful of afterward, in case her strength was greater than his. (186–87)

But long before this, the reader has been informed that Leo is part of a gang dealing drugs (138f.). So it is not likely that things are going to end well. And sure enough, they don't: when Alistair, in an act of supreme vengeance, presents conclusive evidence that Leo is in fact dead, the person claiming to be Leo admits to Mary that he is his brother Carl. The murders that occur sporadically through the novel are almost incidental to this searing revelation.

But *The Keys to the Street* is crippled by an appalling verbosity, cluttered with episodes and entire chapters that are entirely inessential to the forwarding of the plot and are not of intrinsic interest in themselves. By the time we reach the end—when a police inspector, William Marnock, disguises himself as a homeless person in order to capture the murderer—we have lost all track of the thrust and focus of this diffuse and unfocused novel, one that sadly suggests that Rendell has grown a little too fond of her own narrative voice.

This same problem dogs a later novel, *Adam and Eve and Pinch Me* (2001), although there are again some compensating virtues. Here the focus is on an incredibly naïve and unworldly woman of thirty-seven, Araminta (Minty) Knox, who was abandoned by her mother at the age of six months and was raised by the mother's friend, Winifred Knox, whom Minty calls Auntie. Still a virgin, Minty is now engaged to a man named Jock Lewis—but is traumatised to hear that he has died in a train crash. Rendell keenly portrays the increasingly serious psychological disturbance afflicting Minty. A germophobe who constantly washes her hands, bathes, and changes her clothes, Minty now thinks she sees Jock's ghost. But it is made clear early on that Jock was only after her money (Winifred had left her expensive home to her after her death), and that the letter from the railroad company announcing his death is clearly a forgery.

It quickly becomes evident that Jock is a predator of women, using his charm to become intimate with them so that he can live off of their wealth. In short order we are introduced to an array of women—Zillah Leach, Fiona Harrington, Natalie Rickman—who were involved with Jock (under vari-

ous pseudonyms—Jeffrey Leach, Jeff Leigh, and so on) to their detriment.

Matters take a serious turn when Minty, hearing the voice of her dead Auntie telling her that Jock is an "imp of Satan" and that "it's your mission to destroy him" (128–29), takes to carrying a large, sharp knife with her, taped to her thigh. She now sees Jock (whom she assumes is a ghost) in a sparsely attended movie theatre—and stabs him to death. She then calmly moves to a different seat and watches the rest of the film! Much later Minty kills an elderly woman on a park bench near her flat, thinking it is the ghost of Jock's mother.

But this quite compelling portrayal of a dangerous aberrant character is so overwhelmed by all manner of other characters (including James Melcombe-Smith, a wealthy M.P. who wants to make a marriage of convenience with Zillah to conceal the fact that he is gay) that we often lose focus on the central issue. By the end of the novel, Minty is hearing more and more voices from the dead:

> Then it was Edna's turn to meet this Mary. At least Auntie's voice wasn't among theirs and Minty knew this was because of the praying and the flowers on her grave. Jock's wasn't, for the same reason. She couldn't do these things for the others, she couldn't spend her life hunting for graves of dead people, which might be anywhere in the country, anywhere in the world. Their invisibility was only temporary. After a while they began to take shape and form, Bert first, thin and insubstantial, not much more than a darkness that shouldn't have been there. How did she know it was Bert? She'd never seen him, never heard his voice, she wasn't even born when he came into Auntie's life and went out of it, but she knew. (350)

But the focus on Minty is dissipated by the distracting subplots and digressions that Rendell has inexplicably added to this bloated novel.

It is widely acknowledged that the novels written under the Barbara Vine pseudonym are among Rendell's best, chiefly because they largely dispense—or appear to dispense—with the detective, and even the mystery, element altogether and become novels of pure psychological analysis; in some cases a crime is not even committed, or at least is not the central focus of the novel. In the end, the distinction between the non-Wexford novels appearing under Rendell's name and the Barbara Vine novels is not significant: *The Tree of Hands* and *Adam and Eve and Pinch Me*, to name only two, could easily have appeared under the Barbara Vine pseudonym and no one would have been the wiser.

A Dark-Adapted Eye (1986) is the first, and among the best, of the Vine novels. At the very outset we are informed that Vera Hillyard was hanged—presumably for murder. After a certain amount of coy evasion, we are led to believe that she killed her much younger sister, Edith (called Eden). Vera (b. 1907) had, indeed, largely taken over the raising of Eden (b. 1922) after

the death of their parents, living in a house in Great Sindon, Essex. While the novel focuses almost obsessively on Vera, it is told in the first person by Faith Longley, Vera's niece and the daughter of Vera's twin brother John William.

It takes some time for the reader to grasp the complexities of the family relationships in the novel, but they are central to understanding the psychology of Vera, which is the true focus of the book. We are bombarded with a series of perplexing queries: Why does Vera's son Francis hate her? Is it because he is attracted to his own first cousin, Eden? Who is the father of Vera's son Jamie, born in May 1944—far too late for him to have been fathered by Vera's husband Gerald, who had come home briefly from the war in early 1943? Most vital of all, what is the fundamental nature of the relationship between these two sisters, who at times act like mother and daughter and at other times like sexual or maternal rivals?

The focus of their rivalry is the boy Jamie. When Vera falls seriously ill in early 1949, she seems desperate not to have Jamie fall into Eden's hands—but that is exactly what does happen. In a traumatic scene, Vera, separated from Jamie for a period of six weeks, comes to see him as he is being cared for by a nanny:

> Unable to contain herself any longer, Vera ran to Jamie and put out her arms. As anyone but she could have foretold, this had the effect of making Jamie cling all the tighter to the brawny, gray-cotton-clad shoulders. He buried his face. Vera gave a piteous cry and the nanny responded by shoving Jamie at her. The ensuing scene was painful to see. Such scenes—and they usually happen when a mother and her child have been separated over a long period—always are painful. Jamie screamed and fought, struggled out of Vera's arms, threw himself at his nanny's lap, bellowed, embraced his nanny's knees. All the while Eden poked and prodded at the fire. Outside it had begun to snow. Fat, fluffy flakes of snow were drifting thickly past those dewed windows. The nanny sat down, cuddling Jamie, and Vera stood trembling with clenched fists. (203–4)

Jamie remains in Eden's care for months. Then Vera concocts a plan—in which she wishes Faith and her husband Andrew to be involved—to kidnap Jamie. She bluntly asserts: "Eden wants to keep him because she can't have children of her own" (216). Then Eden herself falls ill (there is a suggestion that Vera has been slowly poisoning her with mushrooms), providing an opportunity to take Jamie back to her home. At this point Faith states ominously: "I was unpleasantly convinced that she [Vera] was going mad" (224). The culmination is not long in coming. When, after some months, Eden succeeds in getting Jamie back into her possession, Vera comes to her house, takes a kitchen knife from her purse, and stabs Eden in the neck and chest: "Eden vomited blood and died" (255).

But before this climactic scene, we have been told that Eden had mentioned to Faith: "I've told Tony [Pearmain, her husband] everything. I've told him Jamie is my son" (249). By her account, Eden became pregnant in the fall of 1943—but by whom, she refuses to say. Possibly Francis; possibly Chad Hamner, a boyfriend at the time (although later he reveals himself to be gay); possibly someone else altogether. On top of this stunning revelation, we find that Jamie himself remains convinced that Vera is his mother. And there the matter remains, unresolved.

A Dark-Adapted Eye presents one of the most searing psychological portraits in the entire corpus of Rendell's work in the figure of Vera Hillyard—impulsive, vain, snobbish, immensely self-absorbed, and yet not entirely unsympathetic in her passionate devotion to the boy she believes to be (or has convinced herself is) her son. And other figures are also crisply realized, especially Eden, who as a child was coddled and admired for her beauty and other virtues, but who herself has an element of coldness and ruthlessness matching that of her older sister. Francis, Vera's son, is keenly portrayed as one who relishes teasing and provoking his mother: "He hated her, and it was hatred, not something masquerading as hatred, but the real, vicious, luxuriating thing itself" (66).

The sudden twist that concludes *A Dark-Adapted Eye* sets the pattern for other Barbara Vine novels. Whereas throughout the work we are fully aware that Eden will die at Vera's hands and are merely waiting with mingled horror and anticipation for the blow to fall, Rendell pulls a rabbit out of her hat in a way that is anything but contrived or adventitious, but in fact augments and, after a fashion, explains the psychological traumas the central characters are suffering. The pall of ineluctable doom that hangs over the novel from the very first page is only intensified by the ambiguous revelation of the true parentage of the hapless Jamie.

A Fatal Inversion (1987) is perhaps not quite as compelling, and indeed bears some thematic parallels with the earlier *The Tree of Hands,* but remains a success. Here we are concerned with the discovery of the skeleton of a young woman and a newborn baby in a pet cemetery near Wyvis Hall. It is quickly determined that this grisly discovery has to do with something that occurred on the property in 1976, when several young people—Adam Verne-Smith, Vivien Goldman, Rufus Fletcher, Shiva Manjusri, and Zosie (no last name given)—camped out there for the summer with the idea of setting up a commune. The novel continually flits between the past and the present, as some of the characters are desperately concerned that the body (which is found to have died of a gunshot wound) and the subsequent police investigation will jeopardise their current positions and family life.

Zosie is the focal point of the reader's attention, especially as (in 1976) she attempted to kidnap a toddler; Rufus prevented her from doing so, but

only later detects stretch marks on her body, meaning that she must have had a baby in the recent past—what happened to it? Zosie later admitted that the baby was put up for adoption, but she is clearly desperate to be a mother. Shortly thereafter Zosie steals another baby (at the home of a family where Vivien is interviewing for a position as nanny). When she returns with it to Wyvis Hall, the others assume it is the baby put up for adoption, whom she has somehow managed to retrieve—but this charade collapses very quickly, and it becomes evident that the baby is not Zosie's. Just before this, in the present day, Rufus bursts out in anger at Adam: "You shot her, that's why. You fired the bloody gun" (194).

The matter seems simple: Zosie, and perhaps the baby, were killed by Adam, and the only mystery is whether and how Adam will be caught—and whether the others, who bear at least indirect responsibility for the crime, will be implicated. But as the narrative continues to unfold, we discover that the baby died of SIDS (sudden infant death syndrome)—a fact that the others keep from Vivien, who has been particularly insistent that the baby be returned to its family. When Vivien finds the body of the baby, she insists that the death be reported to the police. As she flees the house, it is she—not Zosie—who is shot and killed by Adam.

At this point, the reader begins putting several pieces of information together. Given the novel's alternation between past and present, why has nothing been said about Vivien's present whereabouts and circumstances? Then again, if Zosie is still alive, what happened to *her* in the intervening ten years? As the police relentlessly accumulate evidence, they seem to be closing in on Adam and Rufus; but Rufus still thinks they can evade capture. He blithely says of Zosie that she is now "probably on hard drugs. Or in jail" (289). And perhaps they are in the clear: "This time society fails to take revenge" (290). But this is just whistling in the dark, for the two men's lives have already been shattered. Adam's wife, Anne, has developed deep suspicions of his involvement in the 1976 murder and has ordered him from the house and prohibited him from having any contact with his daughter, Abigail. Rufus, who by a certain irony has become a gynecologist, seems to be in somewhat better shape. As he and his wife greet a family who wishes to buy their house, Rufus finds himself in the presence of the very family (the Titians) for whom Vivien was to have worked a decade before—and the wife calls herself Viv, but is none other than Zosie. The suggestion is that Zosie has taken Vivien's place as a nanny and then insinuated herself into the affections of the man of the house. How plausible this development is can be debated, but it forms a pungent conclusion to a novel whose twists and turns become almost too much for the reader to follow.

Gallowglass (1990) alternates between the first-person narration of Joe Herbert, a developmentally disabled young man, and a third-person narra-

tion focusing on Paul Garnet, currently acting as a chauffeur for a wealthy woman named Nina Abbott. The meaning of the title is clarified early in the text: "In ancient Ireland and the Western Highlands a gallowglass was a chief's servant" (50). In this case, the chief is a ruthless and amoral man named Sandor Wincanton, who has rescued Joe from committing suicide: "I saved your life, so your life belongs to me now" (19). It would seem that Sandor wishes to kidnap Nina and demand a high ransom.

Nina, in the end, proves to be the real focus of the novel, as it develops that Sandor had kidnapped her once before, when she was married to a Prince Piraneso; she is now married to a man named Ralph Apsoland and lives in Suffolk. Joe falls in readily with the plan, as a good gallowglass should; but Paul Garnet—who, it becomes evident, is in love with Nina—stands in the way. Without pursuing the intricacies of the plot—which involves the kidnapping of Paul's young daughter Jessica, whom Sandor proposes to exchange for Nina—the upshot is that, once Nina is in the kidnappers' hands (they have been joined by Joe's sister, Tilly), a dispute among them allows Nina to escape, and the despondent Sandor kills himself by jumping in front of a train—the very method of suicide from which he rescued Joe Herbert.

And yet, the novel concludes unsatisfyingly. Although Jessica emerges unharmed, we later learn in a curiously matter-of-fact manner that Nina gets kidnapped yet again (by some servants who had also been involved in the first kidnapping) and, although the kidnappers demand and receive £2 million from Apsoland, they inexplicably kill Nina and bury her on her own estate. They flee to Italy but are extradited to England. Why Rendell felt the need to tack on this downbeat ending—which, to my mind, is not aesthetically justifiable in relation to what has gone before—is unclear.

In the portrayal of Joe Herbert, Rendell focuses on his sexual irregularities. At one point Joe admits to being in love with Sandor, but not in a sexual way:

> Another thing that isn't true is that being in love means sex, straight or gay. I wouldn't tell anyone this because of the way they all believe that, but I fell in love with Sandor at first sight. I fell in love with him while we were staring at each other, stupefied with shock, on that seat on the Embankment underground station. There's a kind of falling in love that's different, that doesn't mean you want to do dirty things with people, but that you feel about them like, well, God, if there is a God, is supposed to feel about us, or nuns are meant to feel about Jesus. Or like those old servitors and retainers felt about the chiefs of their tribe, gallowglasses faithful unto death. (87)

And yet, at a much later point Joe falls into a "full sexual relationship" (268) with his sister (Joe was adopted, as was Tilly, so I suppose there is

technically no incest here), although he seems uncomfortable with the arrangement. But in all honesty, Joe Herbert, for all his psychological troubles, is not sufficiently interesting a character to serve as the basis of a book in which he has such a major part.

In the last Barbara Vine novel, *The Child's Child* (2013), the crime/mystery element is reduced to a minimum, and the chief focus is on social dynamics and personal conflict. The book is, indeed, two novels in one—or, shall we say, a novel embedded in a novella. In the opening and closing sections, set in 2011, we encounter Grace Easton, who is writing a Ph.D. thesis on unwed mothers in British fiction, chiefly of the Victorian age. She is initially disturbed when her brother Andrew invites his gay lover, James Derain, to live with them in a big house they have inherited from their grandmother, but gradually an uneasy *modus vivendi* is established. The crime element appears when a gay friend of Andrew and James is murdered by "a bunch of thugs who were something to do with the English Defence League" (30). Both of them witnessed the killing; but James is so petrified of having to testify in court (Grace, who tells the story in the first person, writes poignantly: "I've never before come across anyone so imprisoned—for that's what it is—in fear" [36]) that he is all but paralysed. Grace, although not liking him very much, tries to help James by having him assist her in her classwork—and in the course of doing so, they end up having sex. (This is not so surprising, because James later admits he was once married and may be bisexual.) Grace, to her surprise, becomes pregnant, lending her a keen if obvious real-world sensibility to the thesis she is writing.

The core of the novel is a novel, *The Child's Child,* written by a man named Martin Greenwell in 1951, dealing both with a gay man's love affair and his sister's pregnancy at the age of fifteen. The gay man, John Goodwin, feels the need to save his sister Maud's reputation by moving them both away and pretending to be her husband so that the child can be "legitimate" in the eyes of both society and the law. At this point we seem to have become lost in a Victorian novel, even though events begin in 1929 and continue until just after World War II; but the point that Rendell is evidently making is that social changes hadn't extended very far in such matters even at this stage of history, and so the *Tess of the d'Urbervilles* ambiance is appropriate (Grace has named her child, which she knows will be a girl, Tess). The reader begins to wonder whether a crime element will even appear in this phase of the novel—not that that is necessary, for this segment vividly conveys the unthinking prejudice of nearly all the characters at the very thought of homosexuality (especially in men) and unwed motherhood. John and Maud have themselves internalised many of these prejudices—a point keenly made when Maud reacts in fury when her own daughter, Hope, announces at the age of seventeen that she has had an affair with a slightly

older man and has become pregnant.

The crime element does finally emerge when John is killed by his own lover, Bertie Webber. The languid investigation of the crime is concluded hastily and rather implausibly by a police inspector, George Goshawk, leading to Bertie's arrest and conviction for the murder. But this matter is merely a transitory aside in the gripping saga (for that is what it is, covering a period of more than two decades) of John and Maud Goodwin and the people around them.

When the novel finally returns to the year 2011, we have largely lost track of the characters and events that Rendell had narrated earlier. But in a rapid conclusion, Grace's house is invaded by a thug (obviously a colleague of a man named Kevin Drake who is about to go on trial for the murder of the gay man) who ties her up and forces her to reveal her brother's whereabouts. Six months pregnant and terrified that any injury to her might also be injurious or fatal to her baby, she tells the thug what he wants to know. Later we learn that Andrew was indeed stabbed multiple times by several assailants—but in a sop to the reader, he will survive, and presumably Kevin Drake and his compatriots will be suitably punished.

The Child's Child is perhaps the extreme example (at least among the books I have read) of Rendell eschewing the typecasting of herself as a "crime novelist" and seeking to become a mainstream writer. I am not saying the attempt is a failure; far from it. *The Child's Child* is indeed a creditable novel, but not so spectacular that we would have wished Rendell to pursue such a course to the exclusion of her investigations of crime and its social and psychological ramifications.

In spite of the many awards and accolades she has received, I am hesitant to place Rendell in the top tier of crime novelists. Her Inspector Wexford books are routine exercises in detection and fare poorly when compared to the best such novels of the Golden Age of detective fiction. They fail to chart a new course in the form; and however deftly they are constructed, they remain merely clever without being in the least profound. Where Rendell shines is in the psychological analysis of disturbed or aberrant characters, either in novels written under her own name or in those written under the Barbara Vine pseudonym. Even these, on occasion, are less than stellar, but among them are some highly striking works that fuse criminality with abnormal psychology in a manner that is both intellectually convincing and aesthetically compelling. Among her wide and diverse corpus of novels and tales we can find at least a few that stand out as exemplary and memorable; and perhaps that is enough to ensure her literary permanence.

SUE GRAFTON: HARD-BOILED FEMALE

Although Sue Grafton (1940–2017) began writing at the age of eighteen, she did not publish her first novel until 1967; and she did not attain celebrity until she began publishing a series of hard-boiled detective novels whose titles derive rather simplistically from letters of the alphabet. Starting with *A Is for Alibi* (1982), she has as of this writing published the twenty-fourth novel in this series, *X* (2015), all narrated in the first person by a female private investigator, Kinsey Millhone. What exactly she will do when she finishes two further novels is anyone's guess.

The idea of novels that have uniform titles is not at all new to detective fiction. Even if we exclude Sir Arthur Conan Doyle's mechanical use of "The Adventure of . . ." for most of his Sherlock Holmes stories, we can look to S. S. Van Dine, who wrote twelve novels with the formula *The [———] Murder Case* (1926–39), all featuring the snooty and rather annoying detective Philo Vance. Beginning in the 1930s, John Dickson Carr used a roughly similar formula—*The [—— ——] Murders*—for some books written under his Carter Dickson pseudonym. More recently, Harry Kemelman attained celebrity for his series of detective novels (1964–96) featuring Rabbi Small and using the days of the week in the title (after seven novels, Kemelman simply used "Day" in the titles of four subsequent novels). Lilian Jackson Braun wrote a full twenty-nine novels (1966–2007), each beginning with *The Cat Who . . .*

The use of the letters of the alphabet is no more or less contrived a gimmick than any others that have been used; but oftentimes Grafton runs into trouble, either because the precise significance of the title remains opaque or because the title is so general as to be useless as a characterisation of a book. To title a murder mystery *K Is for Killer* does not constitute the height of ingenuity: in this case, the relevance apparently lies in the fact that Millhone, while identifying the killer in question, cannot provide the police with sufficient evidence to convict him, and so she calls a shady lawyer and in effect asks him to rub out the murderer. In *O Is for Outlaw* as many as four distinct individuals could have served as the "outlaw" of the title, and there is not the slightest indication who Grafton intends for the designation.

Titles, as a rule, do—or can—have aesthetic significance, and by forcing herself to use such an artificial schema Grafton has deliberately erased or mitigated the emotive power that a title can have. When we think of some of the more noteworthy novels in this field—whether it be John Dickson Carr's *The Arabian Nights Murder* or Dashiell Hammett's *The Maltese Falcon* or Raymond Chandler's *The Big Sleep*—we find that evocative titles have had at least some part to play in the works' overall effectiveness. The poverty of Grafton's conception—the fact that it is nothing more than a device to induce readers into thinking (falsely) that this is a series of novels that have some intimate connexion with one another aside from the recurring detective—is exhibited by *X,* where she apparently could not devise a suitable *Is for . . .* appendage. (The title is feebly justified by the existence of an estranged married couple, Theodora and Ari Xanakis, and by the existence of a cardboard box with a big X scrawled on top of it.)

But I do not wish to be too hard to Sue Grafton. She is actually a highly capable writer, and a worthy successor to Hammett, Chandler, and Ross Macdonald in the subgenre of hard-boiled crime fiction. The influence of Macdonald in particular is strong in her work, if for no other reason than that she has used his fictitious city, Santa Teresa—purportedly about ninety miles north of Los Angeles—as the setting for nearly all her own novels. The almost byzantine complexity of plot in her more recent novels also echoes the same feature in Macdonald's later work.

The fact that Grafton herself is female, as is her detective, is an unavoidable issue, since, in contrast to the long history of the "cosy" mystery from Agatha Christie to P. D. James, the hard-boiled school was founded by and dominated by male writers—not just Hammett and Chandler, but also James M. Cain and Erle Stanley Gardner (who wrote several such novels and novellas in the 1920s and 1930s before beginning his Perry Mason series), proceeding through John D. MacDonald and Ross Macdonald up to such recent writers as Elmore Leonard and James Ellroy. Grafton is not by any means the only female writer of hard-boiled fiction, but she may well be the most popular and distinctive.

Grafton has to walk a fine line in the portrayal of her detective, Kinsey Millhone, for she must be careful not to make her "soft" (surely that would be a subversion of the very essence of hard-boiled fiction!) but at the same time cannot deny her femininity altogether. In general, Grafton succeeds in this delicate balance, even if it results in Millhone seeming to be a bit more "masculine" in overall bearing and speech than what some conservative readers may be comfortable with.

Millhone is without doubt Grafton's greatest literary triumph—a recurring character who is constantly growing in depth and substance with each passing work, but who nonetheless remains consistent in fundamental

attitudes and temperament. We learn a great deal about her in the course of these twenty-four novels. Her name is pronounced "MILL-hone," with the accent on the first syllable and the final *e* silent. She was born on May 5, 1950 (*R* 222). At the age of five, her parents were killed in an auto accident; young Kinsey was in the back seat but survived. Her upbringing was placed in the hands of her aunt, Virginia (Gin), who for various reasons had an adversarial relationship with the rest of her family. Part of this had to do with the fact that Kinsey's father was a postal worker and therefore not—in the mind of Kinsey's grandmother Cornelia (called "Grand")—a suitable husband for Kinsey's mother. In the course of several later novels, Millhone comes into contact with members of her family, as they attempt to reintroduce her to the clan; but she has become used to being a loner and generally resists.

Millhone has been married twice and divorced twice (as Grafton herself has been). The first of these was a policeman, Micky Magruder; he is a major character in *O Is for Outlaw,* so I shall discuss him later. The second, whose name is given as Daniel (*J* 121), is described by Millhone as follows:

> "Husband number two was a musician, a pianist, very talented. Also, chronically unfaithful and a pathological liar with the face of an angel. It was a blow when he left. I was twenty-four years old and probably should have seen it coming. Later I found out he'd always been more interested in other men than he was with me." (*R* 125)

In the course of the novels, Millhone has intimate relationships with various other (male) characters. In the very first book, she sleeps several times with a lawyer named Charlie Scorsoni, who turns out to be the murderer. At some point she had an affair with a policeman, Jonah Robb, who was at the time estranged from his wife, Camilla; but Jonah and Camilla reconcile, and Millhone is left alone again. Later she has involvements with another private detective, Robert Dietz, who is at least fifteen years older than her, and with a very good-looking police detective, Cheney Phillips; this latter relationship is narrated in detail in *R Is for Ricochet,* but by *T Is for Trespass* the two have broken up. Millhone explains in her customary clipped and tough-gal manner:

> Cheney was adorable, but "cute" isn't sufficient to sustain a relationship. I'm difficult. I know this. I was raised by a maiden aunt who thought to foster my independence by giving me a dollar every Saturday and Sunday morning, and turning me out on my own. I did learn to ride the bus from one end of town to the other and I could cheat my way into two movies for the price of one, but she wasn't big on companionship, and because of that, being "close" makes me sweaty and short of breath.

> I'd noticed that the longer Cheney and I dated, the more I was entertaining fantasies of Robert Dietz, a man I hadn't heard from in two years. What that told me was that I preferred to bond with someone who was always out of town. Cheney was a cop. He liked action, a fast pace, and the company of others, where I prefer to be alone. For me, small talk is hard work and groups of any size wear me down.
>
> . . . We were simply different in areas we couldn't negotiate. I finally leveled with him in a conversation so painful that it doesn't bear repeating. I still don't believe he was as wounded as he led me to believe. On some level he must have been relieved, because he couldn't have enjoyed the friction any more than I did. Now that we'd split, what I loved was the sudden quiet in my head, the sense of autonomy, the freedom from social obligations. Best was the pleasure of turning over in bed without bumping into someone else. (*R* 32–33)

Candid and, in part, self-deprecating as this is, it creates something of the impression that Millhone is indeed just a female version of the gritty, self-sufficient loners who populate male hard-boiled crime writers' novels. But there is more to it than that.

In her very first alphabet novel, Grafton has Millhone state bluntly, "I'm a real hard-ass when it comes to men" (*A* 47). Millhone is female, but she takes truculent pride in not being anything like a "girly girl" whose sole purpose is to entice men with her physical attributes, fancy clothes, and so on. In *F Is for Fugitive* she presents a most unflattering portrayal of herself:

> My hair is dark and I cut it myself with a pair of nail scissors every six weeks. The effect is just about what you'd expect—ragged, inexpert. Recently, someone told me it looked like a dog's rear end. . . . Hazel eyes, dark lashes. My nose blows real good and it's remarkably straight, considering it's broken twice. Like a chimp, I bared my teeth, satisfied to see them (more or less) lined up right. I don't wear makeup. I'd probably look better if I did something with my eyes—mascara, eyebrow pencil, eye shadow in two shades—but then I'd be forever fooling around with the stuff, which seems like a waste of time. . . . I was never taught to be girlish, so here I am, at thirty-two, stuck with a face unadorned by cosmetic subterfuge. As it is, we could not call mine a beautiful puss, but it does the job well enough, distinguishing the front of my head from the back. (*F* 8–9)

There are some exquisite touches here: Millhone has a "remarkably straight" nose—that is, for someone who has had it broken twice (in fisticuffs with lowlife, no doubt). As for clothes, Millhone is equally hopeless—and, again, she takes pride in having only a single dress, a black one that can serve for any formal occasion ranging from a hoity-toity cocktail party to a funeral.

But the matter is not quite as simple as even this. It is not at all the case that Millhone, although female, is constitutionally incapable of adopting the

conventional tactics of a woman to get ahead in a male-dominated world. One of the more striking episodes in *J Is for Judgment* is when Millhone, following a suspect to a hotel in Mexico, enters a room next to the suspect by way of the balcony and finds herself facing the occupant, an elderly American man. She at once pretends to be a stripper (or perhaps an actual prostitute) who has been hired by the man's friends. She actually takes her blouse off, "trailing [it] along the floor like a feather boa" (*J* 29). While the man himself is stripping, Millhone puts her blouse back on and walks out the door. Later in the same novel she states wearily, "Jesus, I could do with a shave" (*J* 147)—but of course she is referring to shaving her legs, not her face.

In *L Is for Lawless* Millhone dresses up as a maid in a hotel in order to get into a woman's room. As she begins vacuuming and dusting, she makes the pungent comment: "Sometimes it's really tough to picture the boy detectives doing this" (*L* 87). Both Grafton and Millhone are fully aware of the predominantly male heritage of hard-boiled crime fiction, and Millhone does indeed find her gender useful in certain situations where the Sam Spades and Philip Marlowes of the world would be left flummoxed, or at the very least would have to find some alternate means of accomplishing their ends.

In terms of her occupation, Millhone served briefly on the Santa Teresa police force, then worked for California Fidelity Insurance as an investigator to verify various insurance claims. She then put in six thousand hours with a private detective firm in order to secure her own private detective's license. At some point she worked for a time in the public defender's office. In *A Is for Alibi* she is charging a mere $30 an hour plus expenses (*A* 17–18); by *J Is for Judgment* she is up to $50 an hour (*J* 3); and her rates rise gradually in later novels. In *W Is for Wasted* Millhone ends up inheriting nearly $600,000 by being the beneficiary and executrix of a man remotely related to her, so that her inveterate money worries—which cause her to be habitually frugal and even, by her own estimation, "cheap"—are somewhat abated.

It is worth pausing over *O Is for Outlaw* (1999), for it not only provides further information on Millhone's first marriage, but also her later reflections on its overall effects on her life and temperament. She married Mickey Magruder when she was twenty-one; the marriage must have been very brief, for she married the musician Daniel when she was twenty-two. The novel's events take place in 1986, or about fifteen years after her breakup with Mickey. Magruder had been forced to leave the police force because of his encounter, when he was off duty, with a person named Benny Quintero, who was later found "beaten and bloody, dumped by the side of Highway 154" (*O* 44). Could Mickey himself have been the murderer? Millhone's

suspicions were raised by Mickey's asking her to supply an alibi for him during a period of four hours when his whereabouts could not be accounted for; Millhone refused and divorced him.

Now, in 1986, Millhone comes upon evidence that Mickey is in all likelihood innocent of the crime—for the simple, if awkward, reason that he was sleeping with another woman at the time. Millhone is irked when she learns of this, but at least her ex-husband is not a murderer. When Mickey is then shot twice and is in critical condition in the hospital, Millhone begins investigating the case—or, rather, the intertwined cases of the death of Benny Quintero and the shooting of her ex—in her usual painstaking manner. After the customary array of bewildering twists and turns, it turns out that Mickey is indeed guiltless in the killing of Quintero, and that another man—a politician who wanted to do away with both to hide a skeleton in his closet—is the culprit. Regrettably, Mickey dies of his injuries, leading Millhone to reflect upon her past life and her relations with her ex-husband. On the whole, the hard-boiled detective school—in accordance with its model, the school of Hemingway—is determined to let actions speak for themselves, and to let these actions reveal fine shades of character and mood; but sometimes a passage like this needs utterance:

> Soon after the wedding, I began to realize he was out of control . . . at least from the perspective of someone with my basically fearful nature. I wasn't comfortable with what I perceived as his dissipation and his self-indulgence. My Aunt Gin had taught me to be moderate—in my personal habits if not in my choice of cusswords. At first, Mickey's hedonism had been appealing. I remembered experiencing a nearly giddy relief at his gluttony, his love of intoxication, his insatiable appetite for sex. What he offered was a tacit permission to explore my lustiness, unawakened until then. I related to his disdain for authority and I was fascinated by his disregard for the system, even while he was employed in a job dedicated to upholding law and order. I, too, had tended to operate outside accepted social boundaries. In grade school and, later, junior and senior high schools, I was often tardy or truant, dawn to the lowlife students, in part because they represented my own defiance and belligerence. Unfortunately, by the age of twenty, when I met Mickey, I was already on my way back from the outer fringes of bad behavior. While Mickey was beginning to embrace his inner demons, I was already in the process of retreating from mine. (*O* 147)

There is a quiet honesty in this passage that manages to etch an entire life in a single paragraph—and does so without sentimentality or self-pity.

I have noted that this novel, although published in 1999, is set in 1986. This is a peculiar phenomenon in all the Millhone novels, where the chronological setting becomes increasingly distant from the time of the books'

writing and publication. In *A Is for Alibi* (1982) Millhone announces that she is thirty-two (*A* 1), which means that the novel in fact takes place in 1982. But time moves very slowly in Millhone's world, and in *N Is for Noose* (1998) Millhone is almost thirty-six (*N* 4); in *P Is for Peril* (2001) she is in fact thirty-six (*P* 15); in *Q Is for Quarry* (2002) she will soon be turning thirty-seven (*Q* 1). And so on. In *X* (2015) the action begins on March 5, 1989.

I cannot help thinking that a part of the reason for this slow progression of time is the patently unfeminist concern with keeping a female private investigator relatively young, however much she may disavow the superficial attributes of womanhood. Hercule Poirot was an old man by the time Agatha Christie killed him off in *Curtain* (1975); Sherlock Holmes ages perceptibly in the three decades during which Conan Doyle wrote his saga. While it is true that Hammett and Chandler did not write enough novels over a long enough period to worry about the ageing of their private eyes, it is nonetheless remarkable that the Millhone books, written over a more than thirty-year period, are compressed into a seven-year span of the investigator's life.

But there may be more to it than keeping Millhone under the age of forty, and therefore able to use feminine wiles in addition to her undeniable intelligence, determination, and cunning. In novel after novel Millhone outlines—and practices—her customary method of investigating, which relies on the extensive use of 3 × 5 index cards to record relevant information (and which can then be shuffled around manually to produce new insights); in *W Is for Wasted* (2013), set in the year 1988, she is still using a Smith-Corona typewriter (*W* 14). In *T Is for Trespass* (2007) she discusses the gradual infiltration of computers into even the society of the 1980s with a tech-savvy character who expresses incredulity at her continued use of the typewriter:

> He half-smiled, as if I were making a joke, and then he wagged a finger at me. "Better catch up with reality. You're missing the boat. Time's going to come when computers will do everything."
> "I have trouble believing that. It just seems so *unlikely*."
> "You're not a believer like the rest of us. The day will come when ten-year-olds will master these machines and you'll be at their mercy."
> "That's a depressing thought." (*T* 242)

In a telling author's note in *O Is for Outlaw*, Grafton directly addresses this point, reminding the reader that in that remote era of 1986 Millhone was "without access to cell phones, the Internet, or other high-tech equipment used by modern-day private investigators," adding significantly: "She relies instead on persistence, imagination, and ingenuity: the stock-in-trade of the traditional gumshoe throughout hard-boiled history" (*O* [xiii]). Nothing

could more tellingly situate the Millhone saga within the century-old tradition of hard-boiled crime writing than this.

The Millhone books all follow generally the same pattern: the investigator is asked to pursue a case (not always involving murder, although one or more murders almost always occur), sometimes in the distant past; Millhone uses all her skills to get to the bottom of the matter, usually by interviewing one suspect or witness after the other; toward the end the pace picks up and Millhone is either forced to dodge a criminal seeking to kill her or to protect some other person similarly endangered.

A curious phenomenon in the books is the frequency with which Millhone is asked to investigate a matter years or even decades in the past. *A Is for Alibi* sets the precedent, in that a woman who had served eight years in prison for killing her husband wishes Millhone to figure out who actually killed him, as she has long asserted her innocence. In *F Is for Fugitive* (1989), set in 1983, Millhone investigates the murder of a teenager seventeen years earlier. *Q Is for Quarry*, set in 1987, has Millhone pursuing leads in the murder of a woman in 1969. Here the very identity of the woman is unknown, so that Millhone first has to ascertain who in fact the victim is before she can focus on how she died. Grafton notes in an afterword that this novel is a lightly fictionalised account of an actual murder that occurred in Santa Barbara in August 1969.

There is a certain implausibility in the readiness with which Millhone is able to unearth ancient details from witnesses whose memories remain remarkably intact even with the passing of decades. I have no idea why Grafton has used this trope so often, unless it be that she can draw upon her own life experiences as one who came of age in the 1950s and 1960s and can therefore accurately and evocatively re-create the ambiance of that now-distant epoch.

The later Millhone novels fuse this continued exploration of past crimes with an alteration of narrative technique. Grafton may have come to realize both that Millhone's repeated narration of her investigations in the first person, lively and pungent as it is, may be palling to the reader, and that such a relentless focus on the person of the detective may hinder her in the portrayal of other characters. And so, beginning with *S Is for Silence* (2005), we find occasional chapters presented in the third person reflecting the perspective of some of these other characters. Grafton is skilled at altering the narrative voice in these chapters so that it is starkly different from Millhone's own narrative tone, and the result is both a deepening of the character portrayal and the presentation of facts of which Millhone is unaware until she solves the case.

This elaboration of the narrative methodology goes hand in hand with the increasing length of the Millhone books. The first ten or fifteen volumes

are quite compact, probably not exceeding 70,000 words. But beginning with *P Is for Peril,* the length of her novels increases substantially, so that by the time we come to *W Is for Wasted,* apparently the longest of the books, we have reached a length of nearly 200,000 words.

It is not entirely clear that this added length has actually resulted in added complexity or profundity. About midway in the series, one begins to notice a rather annoying feature in the novels: a penchant for describing Millhone's actions in painful detail, even when these have little relevance to the advancing action. Consider this passage:

> I woke to the smell of coffee. I was still wearing Mickey's jacket, but someone had placed a heavy afghan across my legs. I put a hand above my head, feeling across the pillow, but Dorothy [a cat] was gone. The door was open a crack. Sunlight made the curtains glow. I looked at my watch and saw that it was close to eight. I put my feet over the side of the bed and ran a hand through my hair, yawning. I was getting too old to horse around at all hours of the night. I went to the bathroom and brushed my teeth, then showered and dressed again. In the end, I looked much as I had when I'd arrived. (*O* 135–36)

It will be observed that seven of these nine sentences begin with "I"—that dangerous pitfall of first-person narration for inexperienced writers, but one that an author of Grafton's advanced years should by no means have committed.

Nevertheless, it is difficult to deny that the later novels are in general more substantial than the earlier ones: richer in character depiction, more complex (at times almost bafflingly so) in plot construction, and yet consistently readable because of their focus on Millhone's tenacity in investigation.

It would therefore be profitless to examine any single novel in detail, for the mere outlining of the plot—even in the earlier, shorter books—would occupy a disproportionate amount of space and would convey the impression that the book is nothing but a series of twists and turns defying reality and plausibility. Some of the later Ross Macdonald novels are indeed open to this criticism, but on the whole Grafton's avoids that pitfall. The course of Millhone's investigation generally unfolds naturally and almost inevitably, and her unearthing of evidence that takes her in a different direction both maintains the reader's interest and sheds additional light on characters whom we thought we had come to know.

If one had to pick a single book in the Millhone series that towers above the others, one might choose *T Is for Trespass* (2005). Here we have an imperishable portrayal of a ruthless, cunning woman who will do anything to secure the financial security she seeks. An opening chapter, told from her point of view, etches the hard life of this woman, who has taken on the name

of Solana Rojas (in fact, she has stolen someone else's identity). The youngest of nine children of a poor immigrant mother whose husband had been "sent to prison on a drug charge and . . . died there, killed by another inmate in a dispute over a pack of cigarettes" (*T* 3), Rojas now finds herself, at the age of fifty-two, saddled with a developmentally disabled son of thirty-five. She presents herself as a trained nurse (the occupation of the woman whose identity she has stolen) and is hired to tend to an elderly man, Guy Vronsky, a neighbor of Millhone's. (Millhone's own landlord, Henry Pitts, is himself in his eighties but quite vigorous, as are several of his siblings of a similar age.) The novel also presents a searing account of elder abuse.

Without pursuing the many twists of the plot, we can focus on how Rojas has systematically moved into Vronsky's house, planting her son (a huge man sardonically nicknamed Tiny) there both so that he has a roof over his head and so that he can provide physical assistance and protection to his mother; she also empties Vronsky's bank accounts and changes the locks. Later, Millhone is astounded to learn that Vronsky's affairs are now being managed by a "conservator" named Cristina Tasinato: the reader is well aware that Tasinato is another pseudonym of Rojas, but it takes Millhone considerable time and effort to come to the same realisation. But as Rojas senses the progress of Millhone's investigation, she cleverly takes out a restraining order on her, effectively stymieing her at a critical stage of the case.

In an unforgettable scene toward the end, Millhone is mugged by Tiny, who is wearing women's clothing. She escapes by the desperate expedient of biting his scrotum, which is covered only by panty house. Enraged, he punches in the windshield of her car and begins throttling her. She escapes only by driving away, pulling out his arm:

> I shoved the stick into first, popped the clutch, and floored it. The Mustang shot forward with a squeal of burning tires. Out of the corner of my eye I could see Tiny's arm and hand, like the branch of a tree driven through a wall by a gale-force wind. I slammed on the brakes, thinking I could shake him off. That's when I realized I was suffering a misperception. Between his own weight and my speed, I'd left him half a block behind. It was only his arm that remained, resting lightly on my shoulder like an old chum's. (*T* 302)

Tiny dies of his injuries. At this point, Rojas's multitude of deceptions has been revealed and she has bolted for the Mexican border; but Millhone knows this will not be the end: "I'd been responsible for the death of her only child and I'd pay for that" (*T* 304). Soon thereafter, Millhone receives a package from Mexico containing a live tarantula. That night, she finds Rojas standing above her as she sleeps—but then Rojas calmly walks out the door. In fact, Rojas was only trying to scare Millhone, setting her up

for some even worse fate. Millhone tracks Rojas to a hotel, where she finds Henry Pitts unconscious, with an IV attached to his arm: Rojas states that she is planning to kill him with a drug. In a subsequent scuffle, Rojas either falls or jumps over the balcony to her death.

An earlier novel, *L Is for Lawless,* is engaging because it is both a hard-boiled crime story and a thriller, with nonstop action that has Millhone flying from Santa Teresa to Dallas to Louisville in pursuit of both persons and evidence. Here, for once, the title is cleverly devised. At first we are led to believe that it refers to the manufacturer of a skeleton key that appears to be the solution to the case (the name is embossed on the key) if it can only be determined what it unlocks; but Millhone quickly determines that there is no such manufacturer of keys. In fact it refers to a mausoleum in Louisville that the skeleton key unlocks, revealing an enormous sum of money, jewels, and other valuable items that has been hidden there for decades. But more broadly, the title alludes to the frequency with which Millhone herself has been repeatedly led to "lawless" acts in pursuit of the case. She has frankly stated in many novels that she is not entirely above bending the rules of the law—breaking and entering in pursuit of evidence, for example—to solve a case; but on the whole she realises that her duty must be to uphold the law in its broadest sense.

K Is for Killer, as I have mentioned earlier, also exhibits Millhone confronting a life-or-death moral conundrum—one that leads her to condemn a murderer to an extra-legal death. The upshot of the novel is that Roger Bonney, whom Millhone has ascertained is responsible for at least three deaths, seems to be getting away with murder. Uncharacteristically giving way to emotion after she learns that a hooker named Danielle Rivers has died of her injuries after being beaten up by Bonney, she thinks to herself: "How could Danielle be dead while Roger was beyond reach?" (*K* 230). Impulsively she calls a shady Los Angeles attorney who claims to be representing the fiancé of a woman, Lorna Kepler, whose death Millhone has been investigating; she flatly tells him, "Roger Bonney killed Lorna Kepler" (*K* 231).

In doing so, Millhone knows she is effectively sentencing Bonney to a horrible death, as there is no question that the attorney will have Bonney rubbed out. At once she is suffused with guilt ("Oh, Jesus. What had I done?" [*K* 231]) and rushes to the water treatment plant where Bonney works to warn him; but instead, Bonney stuns Millhone with a taser and attempts to flee. She later learns that Bonney has gone away with a "guy in the overcoat" (*K* 236)—and is never heard from again.

It is, interestingly, in this novel that Millhone flatly refers to herself as a "misanthrope":

> I probably appealed to him [Henry Pitts] because I was such a mis-
> anthrope. I'd spent two years as a cop and another two years amassing the

four [*sic*—elsewhere she states it is six] thousand hours required to apply for my private investigator's license. I'd been duly photographed, finger-printed, bonded, and credentialed. Since my principal means of employ-ment involved exposure to the underside of human nature, I tended even then to keep other people at a distance. I have since learned to be polite. I can even appear friendly when it suits my purposes, but I'm not really known for my cute girlish ways. Being a loner, I'm an ideal neighbor: quiet, reclusive, unobtrusive, and gone a lot. (*K* 17–18)

Given the tragic loss of her parents and her "exposure to the underside of human nature"—a prototypical characteristic of the hard-boiled detec-tive—her misanthropy is not entirely surprising; but it is still anomalous in our culture for a woman to express such sentiments.

In terms of structure, *U is for Undertow* is perhaps Millhone's most complex novel, featuring a tapestry of distinctive characters, many of whose thoughts, actions, and feelings are presented in disparate chapters told from their point of view (but always in the third person): Deborah Un-ruh, who has her hands full with her wayward son Greg, who has dropped out of college and come home with a young woman, Shelly, who already has a six-year-old child from another man and is now pregnant with Greg's child; Walker McNally, who seems somehow involved with the case of a child, Mary Claire Fitzhugh, who went missing in 1967; and Jon Corso, who is devastated by the death of his mother when he was thirteen ("He knew something black had settled over him like a veil" [*U* 169]) and whose rela-tionship with his father, Lionel, turns sour when Lionel marries a woman with three daughters of her own, causing Jon to feel like an outsider in his own family. The mere outlining of the plot of this labyrinthine novel would require many pages, but it holds the reader's interest consistently and ends satisfyingly, if predictably, with the identification and capture of Corso as the chief culprit.

I am not sure there is anything truly profound or thought-provoking about Sue Grafton's novels; she simply goes about her work—that of being a female hard-boiled writer featuring a female detective—with exceptional skill and deftness. Grafton is sound in focusing her novels not so much on the twists and turns of a plot but on the figure of Kinsey Millhone herself. Her flaws and limitations—her readiness to bend or break the law to suit her purposes; her lack of social skills or experience with her social betters, as exemplified in her owning only a single black dress to wear on formal occasions; her perhaps excessive control of her emotions, as embodied in her clipped, laconic prose—are exhibited for all to see, but not gloried in. And the sassy, slang- and profanity-laced, dryly cynical bearing that Mill-hone presents in her first-person narration is what is most compelling about these novels, all apart from their intricacy of construction or the more than

capable portrayal of other characters who appear in them. Both Grafton and Millhone are women in a man's world—but they preserve just enough femininity amidst their tough-guy persona to succeed in that world on their own terms.

What Grafton will do when she exhausts the alphabet with two further books is anyone's guess. Maybe she can use numbers, of which there is an infinite supply.

BIBLIOGRAPHY

Allingham, Margery. *Black Plumes*. 1940. New York: Bantam, 1983.

———. *The Crime at Black Dudley*. Garden City, NY: Crime Club/Double-day, Doran, 1929 (as *The Black Dudley Murder*).

———. *Death of a Ghost*. 1934. New York: Bantam, 1985.

———. *Hide My Eyes*. 1958. New York: Bantam, 1983 (as *Tether's End*).

———. *Look to the Lady*. Garden City, NY: Crime Club/Doubleday, Doran, 1931 (as *The Gyrth Chalice Mystery*).

———. *The Mind Readers*. 1965. New York: Macfadden-Bartell, 1967.

———. *More Work for the Undertaker*. 1949. New York: Macfadden-Bartell, 1962.

———. *Mystery Mile*. 1930. Harmondsworth, UK: Penguin, 1968.

———. *Police at the Funeral*. 1931. Harmondsworth, UK: Penguin, 1939.

———. *Sweet Danger*. 1933. Harmondsworth, UK: Penguin, 1950.

———. *Traitor's Purse*. 1941. Harmondsworth, UK: Penguin, 1950.

Carr, John Dickson. *The Case of the Constant Suicides*. 1941. New York: Collier, 1963.

———. *The Crooked Hinge*. 1938. New York: Collier, 1964.

———. *The Mad Hatter Mystery*. 1933. New York: Collier, 1965

———. *The Man Who Could Not Shudder*. 1940. New York: Books, Inc., 1944.

———. *The Nine Wrong Answers*. London: Hamish Hamilton, 1952.

———. *The Peacock Feather Murders*. As by Carter Dickson. 1937. New York: International Polygonics, 1987.

———. *The Reader Is Warned*. As by Carter Dickson. 1939. New York: Berkley Medallion, 1964.

———. *The Red Widow Murders*. As by Carter Dickson. 1935. New York: Berkley Medallion, 1963.

———. *The Three Coffins*. 1935. New York: International Polygonics, 1986.

———. *Three Detective Novels*. New York: Harper & Brothers, 1959. [Contains *The Arabian Nights Murder* (1936), *The Burning Court* (1937), and *The Problem of the Wire Cage* (1939).]

———. *To Wake the Dead*. 1938. New York: Books, Inc., 1944.

Chandler, Raymond. *Collected Stories*. New York: Everyman's Library, 2002. [Abbreviated in the text as *CS*.]

———. *The Long Goodbye*. 1953. New York: Ballantine, 1971.

———. *The Raymond Chandler Omnibus*. New York: Knopf, 1964. [Contains *The Big Sleep, Farewell, My Lovely, The High Window,* and *The Lady in the Lake*.]

———. "The Simple Art of Murder." In *The Simple Art of Murder*. New York: Ballantine, 1972. 1–21.

Davies, L. P. *Adventure Holidays, Ltd.* Garden City, NY: Doubleday, 1970.

———. *The Alien*. 1968. Garden City, NY: Doubleday, 1971.

———. *The Artificial Man*. 1965. New York: Scholastic Book Services, 1968.

———. *Assignment Abacus*. Garden City, NY: Doubleday, 1975.

———. *Dimension A*. 1969. New York: Dell, 1972.

———. *Genesis Two*. 1969. Chicago: Playboy Press, n.d.

———. *Give Me Back Myself*. 1971. London: Barrie & Jenkins, 1972.

———. *The Lampton Dreamers*. 1966. Garden City, NY: Doubleday, 1967.

———. *The Land of Leys*. Garden City, NY: Doubleday, 1979.

———. *Man out of Nowhere*. 1965. New York: Signet, 1968 (as *Who Is Lewis Pinder?*).

———. *The Nameless Ones*. London: Long, 1967 (as by Leslie Vardre). Garden City, NY: Doubleday, 1968 (as *A Grave Matter*).

———. *The Paper Dolls*. 1964. Garden City, NY: Doubleday, 1966.

———. *Possession*. Garden City, NY: Doubleday, 1976.

———. *Psychogeist*. 1966. Garden City, NY: Doubleday, 1967.

———. *The Shadow Before*. Garden City, NY: Doubleday, 1970.

———. *Stranger to Town*. 1969. Garden City, NY: Doubleday, 1969.

———. *Tell It to the Dead*. 1966. Garden City, NY: Doubleday, 1967 (as *The Reluctant Medium*).

———. *Twilight Journey*. 1967. Garden City, NY: Doubleday, 1968.

———. *What Did I Do Tomorrow?* 1972. Garden City, NY: Doubleday, 1973.

———. *The White Room*. Garden City, NY: Doubleday, 1969.

Grafton, Sue. *A Is for Alibi*. New York: Holt, Rinehart & Winston, 1982. [*A*]

———. *F Is for Fugitive*. New York: Henry Holt, 1989. [*F*]

———. *J Is for Judgment*. New York: Henry Holt, 1993. [*J*]

———. *K Is for Killer*. New York: Henry Holt, 1994. [*K*]

———. *L Is for Lawless*. New York: Henry Holt, 1995. [*L*]

———. *N Is for Noose*. New York: Henry Holt, 1998. [*N*]

———. *O Is for Outlaw*. New York: Henry Holt, 1999. [*O*]

———. *P Is for Peril*. New York: Putnam, 2001. [*P*]

———. *Q Is for Quarry*. New York: Putnam, 2002. [*Q*]

————. *R Is for Ricochet.* New York: Putnam, 2004. [*R*]

————. *S Is for Silence.* New York: Putnam, 2005. [*S*]

————. *T Is for Trespass.* New York: Putnam, 2007. [*T*]

————. *U Is for Undertow.* New York: Putnam, 2009. [*U*]

————. *V Is for Vengeance.* New York: Putnam, 2011.

————. *W Is for Wasted.* New York: Putnam, 2013. [*W*]

————. *X.* New York: Putnam, 2015.

Greene, Douglas G. *John Dickson Carr: The Man Who Explained Miracles.* New York: Otto Penzler, 1995.

Hammett, Dashiell. *Complete Novels.* New York: Library of America, 1999. [Contains *Red Harvest, The Dain Curse, The Maltese Falcon, The Glass Key,* and *The Thin Man.* Abbreviated in the text as *CN.*]

————. *Crime Stories and Other Writings.* New York: Library of America, 2001. [Abbreviated in the text as *CS.*]

Haycraft, Howard. *Murder for Pleasure: The Life and Times of the Detective Story.* New York: D. Appleton-Century Co., 1941.

Highsmith, Patricia. *The Cry of the Owl.* New York: Harper & Row, 1962.

————. *A Dog's Ransom.* 1972. Harmondsworth, UK: Penguin, 1975.

————. *Edith's Diary.* 1977. New York: Atlantic Monthly Press, 1989.

————. *Found in the Street.* 1986. New York: Atlantic Monthly Press, 1987.

————. *The Glass Cell.* 1964. New York: W. W. Norton & Co., 2004.

————. *The Mysterious Mr. Ripley.* Harmondsworth, UK: Penguin, 1985. [Includes *The Talented Mr. Ripley, Ripley Under Ground,* and *Ripley's Game.*]

————. *Plotting and Writing Suspense Fiction.* 1983. New York: St. Martin's Griffin, n.d.

————. *Strangers on a Train.* 1950. Harmondsworth, UK: Penguin, 1974.

————. *A Suspension of Mercy.* 1965. Harmondsworth, UK: Penguin, 1972.

————. *This Sweet Sickness.* 1960. Harmondsworth, UK: Penguin, 1972.

————. *Those Who Walk Away.* 1967. London: Pan, 1979.

————. *The Tremor of Forgery.* Garden City, NY: Doubleday, 1969.

————. *The Two Faces of January.* London: Heinemann, 1964.

Hiney, Tom. *Raymond Chandler: A Biography.* New York: Atlantic Monthly Press, 1987.

James, P. D. *A Certain Justice.* 1997. New York: Ballantine, 1998.

————. *Death Comes to Pemberley.* 2011. New York: Vintage, 2012.

————. *Death in Holy Orders.* 2001. New York: Ballantine, 2002.

————. *Devices and Desires.* New York: Knopf, 1989.

————. *The Lighthouse.* 2005. New York: Vintage, 2006.

————. *The Murder Room.* 2003. New York: Vintage, 2004.

————. *Original Sin.* 1994. New York: Warner, 1996.

————. *The Private Patient.* 2008. New York: Vintage, 2009.

————. *The Skull Beneath the Skin.* New York: Scribner's, 1982.

————. *A Taste for Death.* New York: Knopf, 1986.

————. *Time to Be in Earnest: A Fragment of Autobiography.* 1999. New York: Knopf, 2000.

————. *Unnatural Causes.* 1967. New York: Warner, 1982.

————. *An Unsuitable Job for a Woman.* 1972. New York: Fawcett, n.d.

Joshi, S. T. *John Dickson Carr: A Critical Study.* Bowling Green, OH: Bowling Green State University Popular Press, 1990.

MacDonald, Philip. *Guest in the House.* Garden City, NY: Doubleday, 1955.

————. *The Link.* Garden City, NY: Doubleday, Doran, 1930.

————. *The List of Adrian Messenger.* 1959. New York: Vintage, 1983.

————. *The Maze: An Exercise in Detection.* London: Collins, 1932.

————. *The Mystery of the Dead Police.* 1933. New York: Vintage, 1965.

————. *Three for Midnight.* Garden City, NY: Doubleday, 1963. [Contains *The Rasp, Murder Gone Mad, The Rynox Murder.*]

————. *Triple Jeopardy.* Garden City, NY: Doubleday, n.d. [Contains *Warrant for X, Escape, The Polferry Riddle.*]

Macdonald, Ross. *Archer at Large.* New York: Knopf, 1970. [Contains *The Galton Case, The Chill,* and *Black Money.*]

————. *Archer in Hollywood.* New York: Knopf, 1967. [Contains *The Moving Target, The Way Some People Die,* and *The Barbarous Coast.*]

————. *Archer in Jeopardy.* New York: Knopf, 1988. [Contains *The Doomsters, The Zebra-Striped Hearse,* and *The Instant Enemy.*]

————. *The Goodbye Look.* 1969. Waverville, ME: G. K. Hall, 2002.

————. *The Name Is Archer.* 1955. New York: Bantam, 1971.

————. *The Underground Man.* New York: Knopf, 1971.

Millar, Margaret. *Beast in View.* 1955. Harmondsworth, UK: Penguin, 1978.

————. *Beyond This Point Are Monsters.* 1970. New York: Avon, 1974.

————. *The Fiend.* New York: Random House, 1964.

————. *How Like an Angel.* 1962, New York: Avon, 1973.

————. *The Iron Gates.* New York: Random House, 1945.

————. *The Listening Walls.* 1959. New York: Avon, 1975.

————. *A Stranger in My Grave.* 1960. New York: International Polygonics, 1983.

————. *Vanish in an Instant.* 1952. New York: Dell, n.d.

Nolan, Tom. *Ross Macdonald: A Biography.* New York: Scribner, 1999.

Reilly, John M., ed. *Twentieth-Century Crime and Mystery Writers.* New York: St. Martin's Press, 1980.

Rendell, Ruth. *Adam and Eve and Pinch Me.* New York: Crown, 2001.

————. *The Babes in the Wood.* New York: Crown, 2002.

————. *The Child's Child.* As by "Barbara Vine." 2013. London: Penguin, 2014.

———. *A Dark-Adapted Eye.* New York: Bantam, 1986.

———. *The Face of Trespass.* 1974. New York; Bantam, 1975.

———. *A Fatal Inversion.* As by "Barbara Vine." 1987. New York: Bantam, 1988.

———. *From Doon with Death.* 1964. New York: Ballantine, 1970.

———. *Gallowglass.* As by "Barbara Vine." New York: Harmony, 1990.

———. *The Keys to the Street.* New York: Crown, 1996.

———. *Make Death Love Me.* 1979. New York: Bantam, 1980.

———. *Road Rage.* New York: Crown, 1997.

———. *Simisola.* 1995. New York: Crown, n.d.

———. *Talking to Strange Men.* 1987. New York: Ballantine, 1988.

———. *To Fear a Painted Devil.* 1965. New York: Ballantine, 1970.

———. *The Tree of Hands.* 1984. New York: Ballantine, 1986.

———. *An Unkindness of Ravens.* 1985. New York: Ballantine, 1986.

———. *The Veiled One.* 1988. New York: Ballantine, 1989.

Sayers, Dorothy L. "Introduction." In *Great Short Stories of Detection, Mystery and Horror: Second Series.* London: Victor Gollancz, 1931. 11–26.

———. "Introduction." In *The Omnibus of Crime.* 1928. New York: Payson & Clarke, 1929. 47.

———. "Introduction." In *The Third Omnibus of Crime.* 1934. New York: Coward McCann, 1942. 1–7.

Symons, Julian. *Bloody Murder: From the Detective Story to the Crime Novel.* 1972. Rev. ed. Harmondsworth, UK: Penguin,1985.

Waugh, Robert H. "Horror: The Accuser of This World." *Studies in Weird Fiction* No. 8 (Fall 1990): 1–11.

INDEX

W

W Is for Wasted (Grafton) 192, 194, 196
Wallace, Edgar 59, 171
Waugh, Evelyn 159
Waugh, Robert H. 152
Way Some People Die, The (Macdonald) 99–100
Welty, Eudora 97, 105
What Did I Do Tomorrow? (Davies) 144, 153, 154
White Cottage Mystery, The (Allingham) 44
White Room, The (Davies) 145, 147, 154
Who Is Lewis Pinder? (Davies) 142, 146, 151–52
Whose Body? (Sayers) 20
"Wild Goose Chase" (Macdonald) 99

Wilson, Edmund 8
Wodehouse, P. G. 21, 31
"Women, Politics and Murder" (Hammett) 70

X

X (Grafton) 189, 194
X vs. Rex (MacDonald) 63–64, 65

Z

Zanuck, Darryl F. 100
Zebra-Striped Hearse, The (Macdonald) 103
"Zigzags of Treachery" (Hammett) 70
Zubro, Mark Richard 15

CPSIA information can be obtained
at www.ICGtesting.com
Printed in the USA
BVHW032013100223
658291BV00002B/368